THE LAST LAYER

New methods in digital printing for photography, fine art, and mixed media

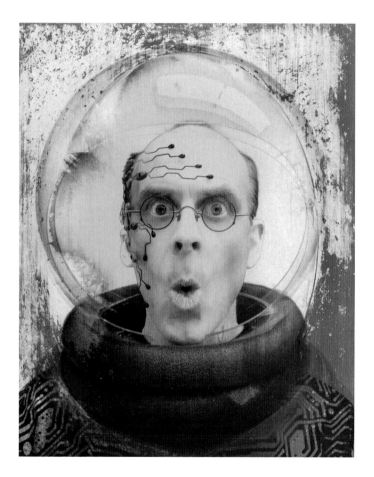

Bonny Pierce Lhotka

New Riders | VOICES THAT MATTER™

The Last Layer:
New methods in digital printing for photography, fine art, and mixed media
Bonny Pierce Lhotka

New Riders

www.newriders.com

New Riders is an imprint of Peachpit, a division of Pearson Education.

To report errors, please send a note to errata@peachpit.com

Copyright © 2013 by Bonny Lhotka

Acquisitions Editor: Nikki Echler McDonald
Production Editor: Tracey Croom
Development and Copy Editor: Jan Seymour
Proofer: Emily K. Wolman
Composition: Kim Scott/Bumpy Design
Indexer: FireCrystal Communications
Cover and Interior Design: Mimi Heft
Front Cover Image: Jan Davis, Bonny Pierce Lhotka

Notice of Rights

Notice of Liability

The information in this book is distributed on an "As Is" basis without warranty. While every precaution has been taken in the preparation of the book, neither the author nor Peachpit shall have any liability to any person or entity with respect to any loss or damage caused or alleged to be caused directly or indirectly by the instructions contained in this book or by the computer software and hardware products described in it.

Trademarks

All DASS products are trademarks of DASS, LLC. Digital Atelier is a registered trademark. Many of the designations used by manufacturers and sellers to distinguish their products are claimed as trademarks. Where those designations appear in this book, and Peachpit was aware of a trademark claim, the designations appear as requested by the owner of the trademark. All other product names and services identified throughout this book are used in editorial fashion only and for the benefit of such companies with no intention of infringement of the trademark. No such use, or the use of any trade name, is intended to convey endorsement or other affiliation with this book.

ISBN 13: 978-0-321-90540-6
ISBN 10: 0-321-90540-7

9 8 7 6 5 4 3 2 1

Printed and bound in the United States of America

NOVEMBER 2013

This book is dedicated to my sons, Doug and Greg,
who have always been involved in my interest in the arts.
Without them I would not be who I am.
They are the light in my life.

About the Author

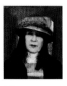 Bonny Lhotka graduated from Bradley University, where she majored in painting and printmaking. In 1986, she added a Macintosh computer to her studio tools, and today continues her innovation with new approaches to her work.

Her artwork is commissioned by, or is included in, several hundred collections including Consumer Electronics Association, Lucent Technologies, United Airlines, Johnson Space Center, Vestas, Crickett, Qwest, U.S. Department of State, Charles Schwab, the City of Denver, Wells Fargo, The Boeing Company, American Society of Clinical Oncology, and a large number of private collections. Her work is shown internationally, and appears in numerous books and articles featuring experimental media. She is listed in Who's Who in American Art and Who's Who in America Women.

In 1997, Bonny organized "Digital Atelier: A printmaking studio for the 21st century" at the Smithsonian American Art Museum and was an Artist-in-Residence there for 21 days. She is the recipient of the Computerworld Smithsonian Award for Technology in the Arts.

Bonny worked with a group of curators to help them envision the potential of digital printmaking in "Media for a New Millennium," a work-tank/think-shop organized by the Vinalhaven Graphic Arts Foundation. As one of three artists of the Digital Atelier, Bonny was invited by Marilyn Kushner of the Brooklyn Art Museum to show a selection of work and demonstrate how to create and combine original digital prints with traditional printmaking and photographic processes.

Over the past decade, Bonny has continued her work as an experimental artist, inventing new processes, materials, and technologies, and combining them with classic fine art materials and techniques. Aside from many one-artist exhibitions, she is in demand as a speaker, educator, author, and artist. Recently, she has worked with major corporations to explore fine art applications for their products. Within this book, Bonny assembles collections of those techniques that you can add to your own studio.

Artist Statement

Throughout my career I've pursued new techniques and technologies, not for their own sake but to further my art. This ongoing push to grow and expand means that once I've produced a body of work with one particular technique, I rarely go back and revisit it unless I can transform it into something new and unique.

Most of my work involves layers, both digital and physical, either placed directly on a surface or moved from one surface to another. This depth and richness comes from piling on too much, and then subtracting until I reach my goal. I used to joke with my sons that if they just chipped away all the excess stone from a rock, they'd find a sculpture inside—that's pretty close to how I work. My biggest challenge is that I'm always so sure I'll find a use for things that I rarely throw them out. I probably still have chips from those rocks stored in a box somewhere.

In my earlier body of work called *Horizons: Altered Reality*, I explore the intersection of reality and abstractions in nature. This common language is created when material and conceptual realities are balanced, and the viewer finds a place to rest and reflect on the timeline of their life—it's a horizon where dreams meet reality.

In much of my recent work, photographic reality captures the moment in time. How I perceive that moment is different from those viewing my work—we're all influenced by the sum of our experiences. And yet there is also a common foundation that we all share. The work uses photographs taken from airplanes, cruise ships, macro photographs, and lazy walks in Colorado, California, Illinois, and Florida. We all can share the majesty of a day of frozen fog along the foothills of the Rocky Mountains, and marvel at the textures that nature brings into our lives.

I use the camera to capture those moments, saving them in my archives until the time when I'm working on a piece and it triggers a memory. Then it's a dash to my image library to collect all the individual elements together to share a thought, an image, a concept—to tell the story that I'm trying to tell. That's the beauty of these processes: They let me use any image, even with technical flaws, if it helps further that tale.

For that's what we all really are—storytellers. A photograph of a bloom pushing through the spring snow tells a tale of renewal and the persistence of life. A classic sunset over the California coast reminds us of that wedding reception where we all got our feet wet. And a still life of dolls, antiques, and toys draws a smile of remembered childhood joy. I wish you the best, as you tell your own unique tales.

Acknowledgments

This book would not be in your hands without my son Doug's help. As with my art, I put too much into my first drafts—there's almost enough for another book sitting in my mind and on the shelf. His understanding of my method of piling on too much, and then removing the excess, sometimes stressed his organizational skills (and made for some interesting video conferences). It's a treat to work with someone who knows my heart and mind so well. And he was a good sport for posing for a series of the new vintage tintypes that are included in Chapter 5. I'd also like to thank my husband for fetching every little thing I needed while writing this book. I'm sure he did not expect to spend the first months of his retirement running errands to bring me lunch, or getting supplies from the liquor store for my chlorophyll experiments (I still wonder what the clerk thought when we bought a case of Everclear).

Epson, HP, and Roland manufacture the printers that I use in this book, and have been very generous in helping me to use their products in unusual ways. My friend Karsten Balsley, a fine woodworker, builds all the nutty structures I come up with. Dave Stevens of Universal Laser Systems generously spent time running experiments on the fiber laser. David Saffir's guidance on how to make digital negatives was invaluable—and led me to understand that there really are not any rules for that process. He said it wasn't easy and he was right.

Let me also send a huge thank you to Russell Preston Brown, Senior Creative Director of Adobe Systems, who consented to be on the cover of this book. I've had the privilege to attend many of his conferences and work with his crew to make lenticular prints, laser images, tintype transfers, and all manner of infectious craziness. Jack Duganne, a friend and digital pioneer, works at these events, too. What a great gathering of friends.

And to all the wonderful folks at New Riders: Nikki Echler McDonald, Jan Seymour, Mimi Heft, Tracey Croom, Kim Scott, Emily K. Wolman, and Glenn Bisignani. You're at the end of this page, but first on my list. Without you, this book wouldn't exist.

Table of Contents

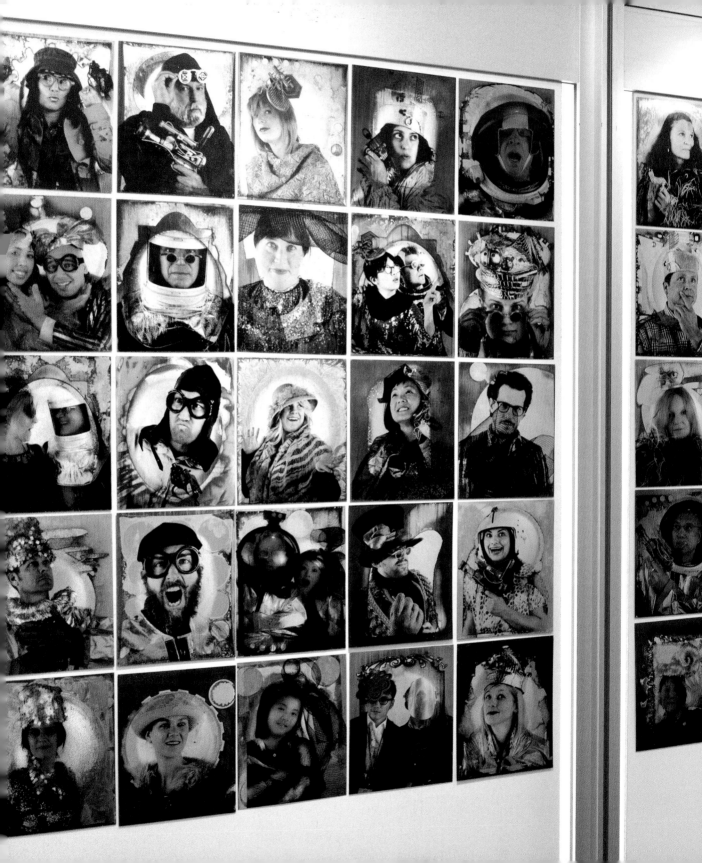

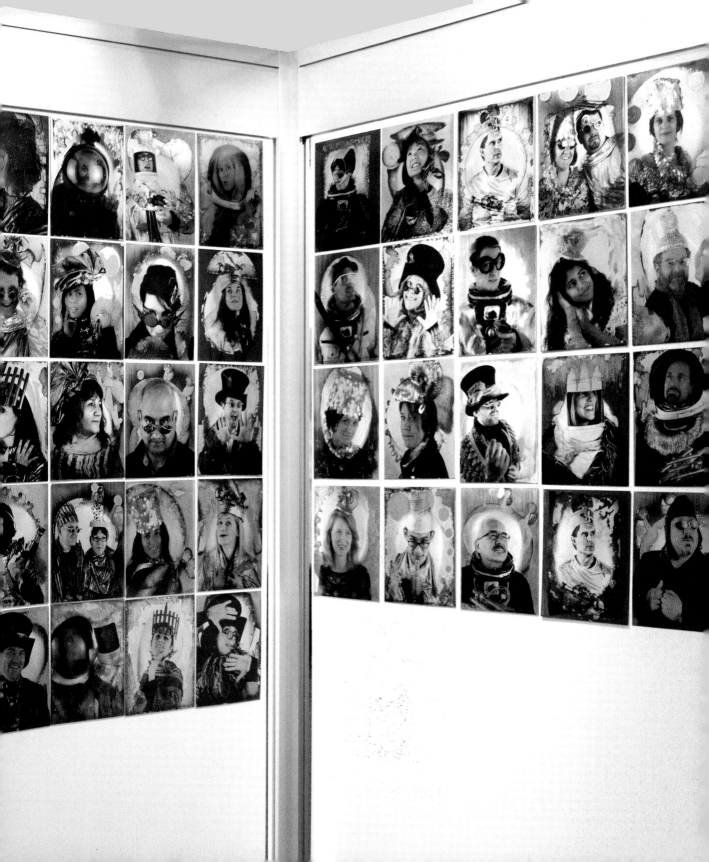

Preface
Alchemy of Printmaking

Jack Duganne

The beauty, romance, and passion of the printmaker is best revealed in this Wikipedia description of printmaking:

> Printmaking is the process of making artworks by printing...Printmaking normally covers only the process of creating prints with an element of originality, rather than just being a photographic reproduction of a painting...Printmaking is not chosen only for its ability to produce multiple impressions, but rather for the unique qualities that each of the printmaking processes lends itself to.

Many people had a hand in directing my path in photographic silk screening. I abandoned premed and 12 years as a medical technologist after an amazing dream I had which centered on a painting of blood cells. On the other side of the UCLA campus from premed, I began working with Max Hein, who was doing remarkable, large, colorful photographic silk-screen prints. My career was then cast in stone, following the appeal of technology-assisted printmaking. Later, I met John Bilotta in his Westwood studio near UCLA where he ran the first digital printmaking studio in Los Angeles, and then connected with Mits Kataoka of UCLA's graduate Department of Design. Here I discovered the Fujix digital printing system, and later, the IRIS printer where IRIS salesman Steve Boulter connected me with printer David Coons. David was creating very large black and white prints for a traveling exhibition of Graham Nash's work (of CSN fame). Working with David out of Graham's garage got me hooked; at that moment, I became a fine art digital printmaker!

At that same time, these revelations were occurring to many other printmakers, including Bonny Lhotka. Bonny saw the digital revolution and inkjet printing as an opportunity to add another set of tools to be used as matrix and plate with different presses, inks, and papers. At the 1992 MacWorld Expo in San Francisco, an infatuation with Encad printers and eventual pairing with HP, Epson, and Roland printers presented that opportunity—and she has never looked back!

Bonny and I met at a trade show and what I saw of her work on display amazed me! It involved many more processes associated with it than just a straight digital print on rag paper. This was my first introduction to the creative forces at play with Bonny's work. Since then, I've had the privilege of working closer with her and learning incredible techniques and processes developed at her studio in Boulder, Colorado.

Bonny Lhotka is a painter who works as a printmaker. She is a hands-on user of any applicable tool available within her creative reach—both real and virtual. In college, she began working with oil painting and acrylic along with collagraph printmaking, where she used every technique within those mediums to create her art. In a quote made to Videor Art Foundation, Bonny says, "I go into the studio every day hoping for an unknown adventure. I start painting without any preset idea and let incidences intuitively dictate my daily work. I think this method is the best for mixtures of painting, printing, and digital imaging. It is the optimization of a 20-year collection of solutions for the multimedia dilemma. I am using the inherent characteristic of acrylic paint to produce a series: the ability to stick to one surface and not to another is just as important for the creation of my work as its flexible nature. I paint a monotype in acrylic paint for the latter combination with my digital file."

A printmaker's studio is a playground where every manner of madness can occur. Bonny uses so many different techniques and types of equipment in her studio that the ability to move from project to project is seamless and fluid. She invents as she goes. For example, she uses electric kitchen deep fryers as pots for boiling solutions into which metal plates, previously treated with stencils and relief materials, become substrates upon which further unique transfer techniques are used to apply photographs and other graphic elements to create, finally, a finished piece of artwork!

Bonny's printmaking equipment includes a 30" x 40" Griffin etching press, a custom 36" x 48" hydraulic press with a floating bed she designed, an HP Z3200 and an HP 9180, a Universal Laser Systems Versa Laser 4.60, a Roland BN-20, and an Epson 9800. She uses ErgoSoft RIP, Adobe Creative Suite 6, and Super Flip! 3-D Genius. Rexam Graphics, Roland, and Arches products are her primary source for media along with the custom substrates she creates for her art.

Printmaking techniques can generally be divided into basic categories including the traditional and digital, or a combination of the two. Bonny uses them all!

In many cases, she invents the techniques to create some of those processes. She is a chemist, engineer, physicist, biologist, inventor, teacher, and tinkerer—but above all, she is an artist!

Bonny is the penultimate teacher. She gives away all that she has developed, in the form of workshops, training sessions in her studio, books, and DVDs. Her explanations are clear and measured, and her presentations are very well planned and understandable. I have all of anything she has published or produced, and whenever the opportunity presents itself to attend an event where I can work together with her or just watch a presentation that she is having, I am there! I had the privilege of having her to my studio for a two-day workshop of film transfers using her DASS film and SuperSauce, both of which she invented and distributes from her website at www.lhotka.com or at the Digital Art Seminars website, www.digitalartstudioseminars.com.

Bonny's vision supersedes all process and invention. Her photography and imagery are awe-inspiring. I am literally taken away and breathless when I observe her new work for the first time. I no longer see the process behind the pieces, only the power of the color and form before me.

As graphicspower.com states, "The Lhotka style is one of complexity resolved by synthesis. What began as a dual interest in water media and printmaking evolved in multi-layered abstract and semi-abstract painting/collages, often of heroic scale."

About Jack Duganne

Master Printmaker Jack Duganne, one of the original architects of digital fine art printmaking and the originator of the term *Giclée*, is currently teaching all levels of Adobe Photoshop at Santa Monica College in the Academy of Entertainment and Technology. Involved in the visual arts since his days as a fine art student at UCLA in the late 60s, Jack established the standards for emerging digital printmaking.

Foreword
A Layered Path

Kathryn Maxwell

Long before most of us recognized the importance of computers in our daily lives, let alone our art practices, Bonny Lhotka added a Macintosh computer to her studio tools. Since that time she has been an innovator and inventor of new materials and techniques that utilize the ever-expanding digital technology in combination with her expertise in more traditional art-making methods.

Current digital print technology has come a long way from the days when Bonny first added that early Macintosh to her studio. Advances in digital technology allow anyone with a desktop inkjet or laser printer the ability to create a form of print at the touch of a button. The images created from the average desktop printer can rival the detail, clarity, and color of photographs printed individually by hand and with the best materials of past decades. Now images can be printed relatively easily, inexpensively, and in never-ending quantities as long as the digital file is intact. These images tend to have a sameness that is in large part due to the unchanging coating of dye or pigment on an unvarying, and generally unlovely, substrate. No artist's hand need touch the print until it is completed; no artist's touch is visible in the final output. For the artist, the labor involved in the creation of digital works, whether with small desktop models or high-end printers, is no longer physical but of the cerebral sort. The artist determines conceptual and visual outcomes on a computer monitor with the aid of ever-changing and sophisticated software platforms, a button is pressed, and a print is completed.

In contrast, traditional lithographs, etchings, relief prints, or screen prints, and the early photographic techniques such as photogravures, collotypes, or daguerreotypes, made laboriously by hand, can have variations in color, ink coating, substrate, or even slight changes in registration. All of these processes are labor intensive, and the artist is intimately connected and physically engaged with the materials used to create the works. The mark of the human hand is self-evident in these older forms of printmaking and photography. Some of these works may even contain physical evidence of the artist's hand through the unintentional incorporation of a fingerprint!

Curators and collectors prize the obviously handmade object due to the imperfections and indication of the human hand evidenced in its form. Purely digital prints, while they may be conceptually and visually brilliant, lack the unique evidence of the artist's hand. There has been a resurgence in the field of printmaking in the most basic but hand-intensive technique of relief printing. Other forms of printmaking have also experienced a renewed interest among artists and the general population as contemporary society becomes more familiar with the materials and techniques of the mediums through YouTube, Do It Yourself TV programs, and blogs or other Internet offerings. Within photography, artists have renewed their interest in tintypes, daguerreotypes, cyanotypes, and other older forms of non-silver photography as a means to connect more directly with the material world and create a sense of object. In *The Substance of Style*, Virginia Postrel asserts that sensory pleasure and meaning are fundamental biological wants, universal human desires. Traditional forms of printmaking and photography combine these two elements beautifully; the purely digital may appeal to the desire for meaning but often denies the want of sensory pleasure for both the artist and the viewer. As new digital technologies allow us to exactly repeat an image over and over again, we as artists and humans cannot relinquish the desire for the unique final layer the human hand can provide on prints, photographs, or other art objects.

Where does this leave the contemporary artist? Must it be a choice between the many advantages of 21st century imaging technology or the sensory pleasure and unique layer of the individual artist's hand? Luckily for us, Bonny Lhotka shares her innovations and inventions with the rest of us, opening new realms of possibilities for artists that combine the digital with the unique qualities of the purely handmade art object. In *The Last Layer*, Bonny continues her artistic dialogue with the digital medium after it leaves the printer, exploring traditional and non-traditional art materials to add the evidence of the artist's hand, the last layer to images. Bonny has devised techniques such as the pearloid transfer that references daguerreotypes with their shimmering, ethereal look. The digital image is combined with real-world materials to become a unique object. There is a sensory pleasure for the artist during the creation of the works with these techniques, but also for the viewer. The contemporary viewer can relate to the images, the handling of the layers and vibrant colors provided through the digitally printed images, yet much of the appeal, the sensory pleasure and evidence of the artist's hand is added in the last layer. One need only view the beautiful reproductions

of Bonny Lhotka's artworks in this book to understand the numerous directions a printmaker, photographer, or other artist might go with these techniques.

The digital revolution has indeed impacted photography and printmaking. With the techniques in *The Last Layer*, artists can create artworks that relate strongly to the contemporary world, but have an appeal that links them to the past. The question now is, what will you do with the techniques presented in *The Last Layer* that makes an artwork uniquely your own? What will be your last layer?

About Kathryn Maxwell

Kathryn Maxwell is Professor of Printmaking and Associate Director for Academic Affairs for the School of Art at Arizona State University in Tempe. Her prints and mixed media artworks have been exhibited in numerous solo and group exhibitions. Her work is also represented in numerous public and corporate collections.

SECTION I

BASICS

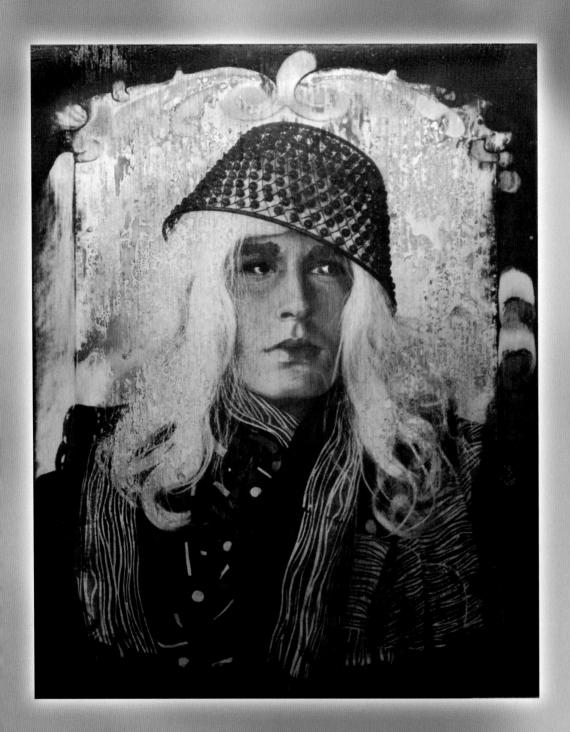

1

INTRODUCTION

A photographer or artist builds images layer by layer, each one adding complexity and meaning to the final work. For the digital artist, those may be Adobe Photoshop or Adobe Photoshop Lightroom layers or edits, and held in digital form rather than a physical surface. Yet in the end, the work must be transferred to a substrate—paper, wood, or even the glass screen an image is projected upon. It's that last layer that makes it a complete work.

With the transition from darkrooms and printmaking into a digital world, the computer has become an important tool on the artist or photographer's workbench, but we've lost that final handwork performed in the darkroom that allowed us to create a truly unique original work. Now, using the techniques in this book we can restore the second half of the process as if we were once again using the darkroom for manipulation, and produce works with individual character.

My art is like life itself. The goal is both the final work and enjoying the process. Recently, I've taken an interest in new processes: using sunlight to create a plate as an interim step before the final photographic image, or blending leaves as a natural photosensitive emulsion. Based on early photographic techniques, my new processes are ethereal, three-dimensional, and unlike anything I've ever done before (see *Blond Bob* to your left). In *The Last Layer*, we'll explore the actual making of light-sensitive materials for developing unique images, as well as techniques to transfer digital images to various substrates, including glass and canvas.

FIGURE 1.1 Quinn Jacobson is one of the few professional photographers who still uses the wet collodion process to create authentic works. This 6½" x 8½" whole plate black glass ambrotype is titled *Rex*.

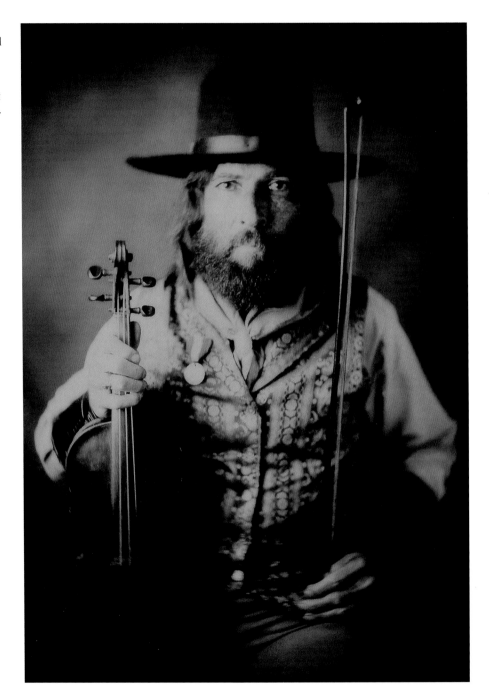

Further, we'll look at ways to make prints that take their inspiration from early processes like anthotype, cyanotype, tintype, daguerreotype (**Figure 1.1**), photogravure, and Polaroid, as well as traditional printmaking processes such as monotypes, collagraphs, and etchings. By applying these classic techniques to modern images, the artist can explore the limits of their creative voice: not simply re-creating the past with new technology but rather building upon history to form a totally unique work (**Figure 1.2**).

Because my new processes eliminate the toxic chemicals used in the past, everyone, including educators, will find that these processes allow for exploring styles that were never before possible, and include simple, inexpensive techniques. Students, photographers, and artists can go back to that personal, hands-on approach, take it further than they could in the past, and add a uniqueness not available in a digital studio.

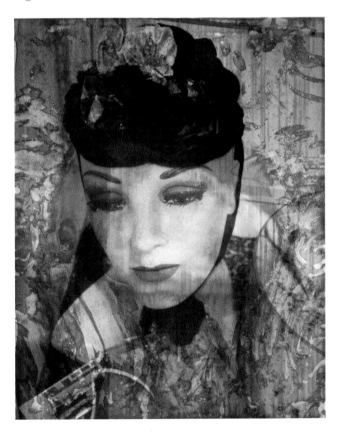

FIGURE 1.2 *Cover Girl* is an 8" x 10" image using new processes.

FIGURE 1.3 This 8" x 10" SuperSauce pigment transfer on aged metal is titled *The Gaze*.

For those of you who have read *Digital Alchemy*, Chapters 2 and 3 will cover familiar ground. But because I've continued to experiment and have learned more tips and tricks, I've updated those sections, so please take a quick look. Everything else in the book involves new processes designed to leverage the last layer to enhance your own creative works (**Figure 1.3**).

Who Is This Book For?

I have designed this book for the photographer-as-artist who can now have the means to find their voice through hands-on techniques. In the past, many photographers found that having the ability to print their own images was cost prohibitive, they simply didn't have the space, or maybe they didn't want to handle and manage the various chemicals. Instead, they left the printing process to a local lab. Those labs do amazing work yet limit the photographer's creative voice by taking the actual printing—the last layer—out of their hands.

Within the past fifteen years, all of that has changed. For the same money it would take to set up a photographic lab, you can now have some of the best digital printers on the market, or for a fraction of that cost, you can own printers that will still produce amazing images. For the processes I'll show you here, the only equipment required is a desktop inkjet printer that uses pigment inks, and a handful of readily available materials and supplies.

But what about talent? And what about the quality of your original image? I'll be the first to admit that these printers cannot produce works that truly replicate the hands-on nature of darkroom geniuses like Ansel Adams and Jerry Uelsmann. Furthermore, with the widespread use of low-quality digital cameras embedded in cellular phones, we're all creating a large number of images that may have outstanding compositions but may lack the technical quality for use in fine photography and art.

My solution? After much trial and error and new discoveries, it is with pride that I offer these techniques in *The Last Layer*. They will allow you as a photographer to take your artistic abilities and work with your best images as well as those spur-of-the-moment ones and produce unique, high-quality works that cannot be duplicated with an app, filter, or software package. And who knows, your finished product could border on genius.

Navigating Through This Book

To use this book, your only prerequisite is the knowledge to create an image (either photography or artwork) and print it on an inkjet printer using pigment inks. Everything I'll show you here begins after that step.

I've organized this book in such a way that you can move mostly at your will throughout the chapters—but with three caveats.

First, read Section 1 in its entirety, as it contains preliminary information and procedures you need to move on safely to the sections that follow. (As I've mentioned, if you've read *Digital Alchemy*, please reread Chapters 2 and 3, as there are some new concepts there.)

Second, for each of the process chapters in Sections 2 through 5, you can choose any process in any order so long as you first read the related introduction chapter that's at the section's beginning.

Third, for each process, I recommend you read through the entire set of procedures before beginning the project. Not only will you need to have everything ready in advance for the time-sensitive steps, but you'll also find that some of the steps assume you have items already prepared (including materials and tools).

You can use *The Last Layer* as a standalone work, though if you haven't already read *Digital Alchemy*, you may be interested in doing so, as it provides additional basic methods of working in digital mixed-media processes.

Final Word

My passion for seeing the marks made by the hand and a desire to have a multi-sensory experience when looking at art leads me to explore and push the boundaries of digital printmaking. I use the long history of artistic and photographic techniques, combined with new technologies, to find solutions to problems I don't yet have. My mind is one giant flea market of thoughts and visions competing for attention. Ideas collide and spawn methods for making prints in new ways—sometimes these ideas work, and other times they are glorious failures.

FIGURE 1.4 From a large studio to a basement workshop, you can use this book to extend your work to whole new levels.

If you were to visit my studio (**Figure 1.4**), you'd find (aside from all the broken blenders and other failures) that it's about half technology and half traditional tools. I do have some equipment in my studio that many readers won't, but those are the exceptions, not the rule. I keep hoping that technology's relentless pace will bring the cost of those UV printers down to where I can afford to have one of the big ones in my own studio (and when it does, watch for another book!). Until then, I'll continue to use those big UV flatbed printers. And fortunately, I use a sign shop that lets me participate in the printing process. You can go to www. thelastlayerbook.com for a list of companies that will print or laser etch images for you.

My last book, *Digital Alchemy*, shared some of the initial and basic processes that transform the digital studio into a physical studio. Now, *The Last Layer* takes that further and is filled with really cool stuff that I've used in creating a new body of work for several shows—and a few additional things that I invented along the way because of strange ideas (like putting leaves in a blender) that pop into my mind.

I now pass along these processes to you adventurous artists, printmakers, and photographers who desire to bring back the hands-on role in creating the physical print. Quite simply, what you'll find in these pages are the techniques that I'm the most proud of, and that I've used to create what I believe is the very best art I've ever done.

Now I invite you to jump in, start experimenting, and see where the creative winds take you. Join me on this adventure into the real world of sensory printmaking.

NOTE: Register your book on www.peachpit.com/LastLayer and get a free bonus chapter. "New Technology and Future Directions" offers my latest explorations into laser cutting and engraving, printing with UV-cured white pigments, and new ideas for creating luminous images with solvent inks reminiscent of orotones of the early 1900s.

2

MATERIALS

You'll have to collect some new materials for your studio in order to try out the processes in this book. These are mostly everyday items that you're likely to have in your studio or home, or that you can find at the corner drug, second-hand, hobby, or grocery store or—in some cases, literally on the trees! There are a few specialty items, like transfer film, that you'll need to buy.

As you work through this book, you'll notice that we'll be using many different materials, including surfaces onto which you'll transfer your image and the transfer mediums themselves. Each of the items you use adds something unique to your artwork. In some cases, you'll be exposing those images to the sun to *develop* them, and in others you may return to the traditional studio to ink a plate and print on an etching press. My goal for you is that in the end you'll gain the experience to go off, comfortably and safely, and experiment with other products of your choice.

For a current and updated list (since products may change from time to time), you can check the book's website: www.thelastlayerbook.com.

For those who have read *Digital Alchemy*, most of the information in this chapter will be familiar, though there are a number of updates. In particular, you should read the sections on alcohol and cleaning substrates.

CAUTION: I'll talk more about safety in the next chapter, but do remember one thing now: You must treat art materials and supplies carefully—don't store your lunch and your art supplies in the same refrigerator!

Image Permanence

Techniques used for preserving inkjet technology are new and until recently have been less than successful, but now there are steps we can take to improve longevity.

Make sure you choose only high-quality pigment inks with high longevity ratings. Brand-name inks are almost always more reliable than cheap refills, so choose the best you can afford. Once you have that good foundation, continue to protect your work by placing it behind UV protective Plexiglas or applying a UV protective coating. Just as with traditional artwork and photography, I also recommend against displaying digital work in direct sunlight. In the last section of the book, we'll talk more about postcoats that can further protect your artwork (**Figure 2.1**).

Also, a good practice is to document all the materials you used in the work so that the conservators will be able to preserve your artwork properly. Public art collections often request that you provide the digital file as an ultimate hedge

FIGURE 2.1 Early IRIS prints faded in a few months, but if stored properly like this one they can last for decades. *Handcart*, 22" x 30" IRIS print, 1993.

against conservation issues. This is a new issue for artists, and you'll need to have some sort of usage rights in your contract to prevent reproductions without your permission. Of course, if you've used these alternative techniques, the digital file cannot completely reproduce your artistic vision—your hand, not the computer, creates the work.

Now for that exception: Some of the processes in this book produce images that will not last—and that's by design. The intermediate images fade with time, so I scan them immediately after they're made, and use that scan to create the final archival work. I create my final chlorophyll print on a UV-cured pigment printer, and often change the size of the final image.

HINT: Some people call it printing, while others refer to it as imaging. Either way, it's what happens when you put blank paper into a printer and get a finished work out of it. But remember, digital printing does not have to be a single event—in some cases it merely creates an intermediate plate used in another step to create the final work.

Substrates

The *substrate* is the last layer upon which you will place your image, either by transferring to it or directly printing on it. The substrate will become part of the final work, and can be a natural or synthetic material that is either rolled or rigid.

Substrate Options

Many of our processes use a rigid substrate that you can frame or mount without requiring the use of glass. I've made works as large as 4' by 8' using these techniques. There are several substrates that we'll use throughout the book.

Pre-stretched canvas or canvas panels are a traditional substrate for many art and photography processes. We'll use these to create compositions with multiple layers of artist paints and transferred images (**Figure 2.2**).

FIGURE 2.2 Use canvas panels to create layered works.

FIGURE 2.3 Both sides of the composite Econolite panels.

FIGURE 2.4 Mill finish aluminum with protective covering.

FIGURE 2.5 Baltic birch made into a variety of boxes.

Econolite is a similar composite panel that is inexpensive and has a corrugated core (**Figure 2.3**). These panels have the front side that is finished at the factory using a high-gloss colored polyester coating, while the back side is unpainted mill finish aluminum. We'll actually use the back side of the panels for most of our processes in this book, but the Super-Sauce transfer (I'll discuss transfer mediums later in this chapter) will also work on the white painted side.

The only challenge is that Econolite panels can be difficult to cut, but you can find precut panels on the Internet, or you can buy them at your local sign shop and have them cut to size. Unfortunately, they're not sold in art supply stores.

Mill finish aluminum is a new substrate that we'll use throughout this book. You can use it directly after cleaning to create a modern print-on-metal style image, aged and distressed to create a rich surface that complements an image, or further prepared to create a new vintage tintype. Look for 0.025" thick sheets—most Epson printers that have a flat feed (both front and rear slots) can handle direct imaging to them. These usually come with a clear protective film that you remove, and often have an oil coating that you also must remove (**Figure 2.4**).

Baltic birch boxes and panels are a good base for many of the processes. Birch is a quality hardwood with a tight, smooth grain. Because it's not dimensionally stable, large panels need some support, or it must be built as a box. I usually make boxes with it, as it eliminates the need for framing and is a clean, modern look for display. You can even gallery wrap your image on the edges as well as the face. Baltic birch is available at your local hardwood lumberyard or woodworking store, and you can usually

find a local frame shop or furniture maker who can assemble boxes for you. Small boxes may be available premade at your local art supply store (**Figure 2.5**).

> *HINT: When working with wood substrates, it's always a good idea to coat the back side with undiluted gesso or acrylic paint and let it dry before beginning. This equalizes the tension and helps prevent curling and warping once you've finished the work.*

One of the most versatile substrates is a plastic sheet. These come in many different materials and colors—look for brand names like Plexiglas. It's almost always cheaper to buy this in the full 4' x 8' sheet and have it cut to size. If you can find a local plastics company, they may even have a scrap bin where you can find cheap, small panels (**Figure 2.6**). There is some extra preparation with these panels depending on your process, so make sure you read the introduction chapter at the beginning of each section.

We'll use low-iron tempered plate glass for the pearloid process in Chapter 18. This glass is colorless and allows the brilliance of the pearl pigment to reflect light through the transferred image. If your printer supports direct imaging, you can find 1.2 mm thick 5" x 7" microscope slides made from optical-grade soda lime glass that work just as well (**Figure 2.7**).

You can use fabrics for several of the photosensitive processes as well as for layered inkjet transfers. Bridal polyester, fine cotton broadcloth, silk, bamboo cloth, and artist canvas are easy to purchase at local yard good stores, art supply stores, and online (**Figure 2.8**).

One of the things I like most about these processes is that I can use the wide range of classic art papers. We'll coat them with photosensitive emulsions as part

FIGURE 2.6 Plastic is a good material for transfers and for making patterns for aging plates.

FIGURE 2.7 Use low-iron glass for pearloid images and larger microscope slides for direct imaging.

FIGURE 2.8 A selection of natural and synthetic fabrics.

of the processes in Section 3. We'll also use stone paper (**Figure 2.9**), a synthetic substrate that is heavy, waterproof, and lies completely flat for the transfer in Chapter 17.

HINT: To get a deckled edge on a straight cut sheet of paper, place it on a cutting board surface. Using a ruler, lightly score one side of the paper—use a very light stroke (**Figure 2.10**). Then gently bend the paper along the score line. Grip the paper with your finger, and tear it about a half an inch at a time (**Figure 2.11**). The final result looks almost like a real deckled edge (**Figure 2.12**).

FIGURE 2.9 Stone paper is good for all mixed media work as well as for straight transfers.

FIGURE 2.10 Score the paper only lightly.

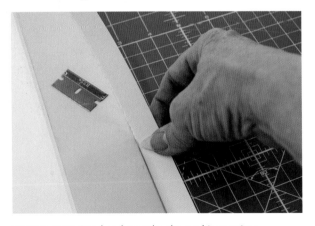

FIGURE 2.11 Bend and tear the sheet a bit at a time.

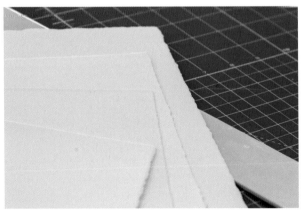

FIGURE 2.12 A deckled edge is another way to make your art look less digital.

Precoats

You'll use a *precoat* to prepare a surface to receive inkjet ink, and to prevent the ink from bleeding together or running off the surface. There are two types of inkjet precoats: ones that are applied at the time the substrate is manufactured, and ones that you buy and apply yourself.

Manufactured Inkjet Coatings

Aqueous inkjet printers (which is what most of us have) need to print on a surface that has been coated with an inkjet receiver in order to keep the ink from bleeding or soaking into the surface. Commercial inkjet papers have this coating already applied, and you can use them directly in your printer (there really is a difference between copier paper and inkjet paper!). Unfortunately, these papers are pretty boring.

Transfer films also have an inkjet coating on them that not only receives the ink, but also releases it when you use the proper process. This property allows us to use more classic artist papers (which are rarely available with inkjet coatings) than we normally could when working with this technology. Otherwise, if you were simply printing directly on them it would cause image distortion and bleeding across the surface. The processes I show you let you take advantage of each of the paper's natural texture and beauty. Using the transfer process with transfer film is the only way you can enjoy that highly prized natural deckled edge that cannot be fed through an inkjet printer, or the hundreds of paper options in shades from white, tan, buff, and every color of the rainbow (**Figure 2.13**). All you need is to be sure the paper you choose has a relatively smooth surface.

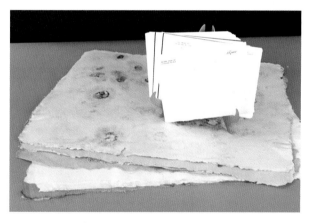

FIGURE 2.13 The transfer processes let you use a range of beautiful papers.

Paintable Inkjet Coatings

An alternative to a transfer process is to use a paintable precoat and apply it to your substrate yourself. These precoats help the target surface grab hold of the ink and bond with it directly from the printer. There are a number of different paintable precoats on the market, each with different properties and usages. Most of these are available on the Internet or from your local art supply store. Make sure that the surfaces are grease free before applying any precoat. I recommend painting two coats on the surface—the first seals the surface, and the second adheres to the dry precoat and then receives the inkjet ink.

CAUTION: Precoats should be completely dry before printing on them. I strongly recommend drying overnight to be safe—a gummy printer head can ruin a day in the studio!

Some of the oldest precoats, back in the early era of digital art, used materials that were difficult to work with and we now wish to avoid, so I and the other artists of Digital Atelier (a group of artists collaborating on new techniques in the dawn of digital art) conceived of the idea to make a paintable precoat available to artists. Most of the products available today are a direct result of our work. Until we had those products, we would wet manufactured canvas and scrape the precoat off for later reuse (you can't do this with modern materials, by the way). We even experimented with plant-based gelatin, but none of them worked for digital imaging. Things have come a long way since then.

Through experimentation, I've developed DASS Universal Precoat II. You can use this paintable precoat for coating custom substrates for direct imaging (including nonporous surfaces such as metal or plastic, or porous surfaces such as paper, rice paper, and gesso-primed canvas), apply it over acrylic paint to allow further printing, or apply it over aged metal plates or to glass for direct imaging.

Each precoat has slightly different properties, which determine things like what surfaces it will adhere to, or how the ink and precoat interact to produce the final color. While Universal Precoat II works for all the direct imaging processes in the book, you can also use the GOLDEN Digital Grounds products for some of the processes. I encourage you to experiment with the various products on the market and find one that works best for you and your goals.

Transfer Film

Probably the most important material we'll use is the *transfer film*. For most processes in this book, you'll print your image onto a specially coated transfer film that releases the image during the transfer (you use a sheet of transfer film only one time). You can also use these films to create digital negatives or positives for making contact prints with light-sensitive polymer plates and emulsions.

There are many different films and coatings on the market, but they tend to come and go over time. Most of the ones I used several years ago are no longer available. To ensure that there's a long-term supply (for others as well as for my own work), I've developed the DASS Transfer Films, available in either sheets or rolls. The rolls have white tape on the edge or a paper interleaf so that they will load properly in HP and other printers, and they work very well with the HP Vivera pigment inks. Epson Ultrachrome, Durabrite, and K3 inks also work beautifully on the film, though Epson printers will need a leader or slip sheet taped to the beginning of the film (unless it has a paper interleaf) in order to load properly (**Figure 2.14**).

IMPORTANT: Make sure you reverse your image before printing on the film so it's right side up when doing the transfers.

With this film, your prints will come off dry to a light touch, and completely dry within a few minutes. You can either transfer them quickly, or you can print in advance and store the images for many months before you use them. It's also relatively resistant to the pizza wheel issue (see Chapter 3), and you can transfer images to other substrates using alcohol gel, DASS SuperSauce, or gelatin (more on these transfer mediums below) and use it to make digital negatives.

There are many other clear coated films on the market, available from both office and art supply stores. While some films work for some of these processes, many of these coatings will not release the ink properly, or will only release it for a short time after you print on it. Even more challenging is that the coatings may change between packages (especially with the cheapest brands), so you can never be sure of what you get. Because of these factors, the DASS film is the only one that I can guarantee works with all the processes in this book. Other transfer films on the market may work as well—again, please experiment with them to determine if they'll meet your needs.

FIGURE 2.14 Transfer film is available is a variety of sheet and roll sizes.

Profiles and Setup

Due to the nature of these transfer processes, it's very difficult to get an exact match to what appears on your screen (even with a calibrated monitor). One issue is that the receiving substrates vary in color and absorbency, which impacts the final appearance. For the Epson printers, the best way I've found is simply trial and error. Try using a printer profile for a heavy watercolor paper and printing a few images on that paper. Then print an image on the transfer film, and lay it on a sheet of the same paper. If they look nearly the same, you're good to go. If not, try another profile until you get results that you like.

HINT: You can follow these techniques and get good results from many printers, as long as they use pigment inks.

Most printers today have the option of using either Matte Black or Photo Black ink. While a few have both in separate cartridges, many require that you switch back and forth if you want to change. That can be very expensive, as the printer purges the other ink every time you switch, so I suggest that you pick one and stick with it. In most cases, it's a matter of which look you prefer in your final work, but some processes (for example, direct imaging in the photopolymer plate process) works best with one or the other (matte ink for that particular process). I'll let you know when it's really important. If you're using Matte Black, try an Enhanced Matte profile as a starting point, and if you're using Photo Black, try a Photo Luster profile.

As you start out though, I recommend sticking with a watercolor or similar paper profile, since it uses Matte Black ink, tends to keep the pizza wheels (see Chapter 3) up off the print on some desktop printers, and may automatically set the platen gap to a wider setting (but don't count on that!). There's no technical reason not to use Photo Black ink, however, so you can experiment and see which you prefer. Make sure the profile you choose does not use gloss optimizer or gloss enhancer. Those coatings cause the prints to exit very wet (the gloss coating takes a long time to dry), which can increase the pizza wheel tracking problem. If your printer driver allows it, you can also slow down the print head or increase the dry time to let the ink dry between passes (**Figure 2.15**).

FIGURE 2.15 Slow the print head to allow the inks to dry.

COLOR MANAGEMENT

Color management is a complex topic, and beyond the scope of this book. But if you want to get reliable color reproduction, it's something you'll need to understand and work with. Here are some good books that you can use.

This is a good introduction to color management:

> *Color Management without the Jargon: A Simple Approach for Designers and Photographers Using the Adobe Creative Suite, Online Video*
>
> http://www.peachpit.com/store/color-management-without-the-jargon-a-simple-approach-9780321686398

These next ones have some hands-on techniques for Photoshop:

> *Adobe Photoshop CS5 Techniques for Photographers: Learn by Video*
>
> http://www.peachpit.com/title/0321734831
>
> *Real World Adobe Photoshop CS5 for Photographers*
>
> http://www.peachpit.com/title/0321719832

And for CS6 information, try these:

> *Adobe Photoshop CS6 Classroom in a Book*
>
> http://www.adobepress.com/store/adobe-photoshop-cs6-classroom-in-a-book-9780321827333
>
> *Adobe Creative Suite 6 Design & Web Premium Classroom in a Book*
>
> http://www.adobepress.com/store/adobe-creative-suite-6-design-web-premium-classroom-9780321822604

For calibration systems, check out either DataColor (http://www.datacolor.com) or Pantone (http://www.pantone.com). Both have basic and advanced color calibration systems—you'll be amazed at how different your work looks on the screen, and how close it looks to the actual prints.

When printing, set your printer at 1440 or 1200 dpi—these higher resolutions allow the ink to dry better. Here in Colorado I've never had an issue as long as I don't use the gloss enhancer, but if you're working in a humid climate, test small prints to determine your particular settings.

HINT: Make sure you leave at least an inch on all sides of your print. This gives you an edge of blank film that you can touch and use when applying the film to your substrate.

HP Large-Format Printers

If you're using an HP Z3100 or Z3200 or similar printer, you can use the built-in spectrophotometer in these printers to create a custom printer profile for the transfer film, rather than picking one from the built-in list (**Figure 2.16**). Once you load the film into the printer, since it doesn't have a paper interleaf, slip a true white sheet of paper under the film and then advance the film/paper through the printer until both have emerged past the print heads (it may take you a couple of tries to get this right). You can also use double-sided tape and then tape a sheet to the underside of the roll of film, but I've found that to be more of a challenge. Once you've loaded the paper, you can proceed with the profiling, using the HP Matte Litho-Realistic profile as a starting point for Matte Black ink, and the HP Photo Black Satin Paper (More Ink) for Photo Black ink. Gloss Enhance should be off for both. Keep in mind that HP does not support profiling of clear media, but this technique will work pretty well.

> **HINT:** If you have problems getting a good profile, you can try leaving the pizza wheels down during the profiling process. Just remember to raise them again when you're ready to print images.

FIGURE 2.16 Create a custom printer profile for the transfer film.

Transfer Mediums

There are two key mediums that we'll use to transfer your images from the transfer film to the new surface.

The first transfer medium that you can use is commercial-grade gelatin, a product that lets you transfer your image to an almost endless variety of surfaces. I'll cover details on this medium later. The processes in this book require commercial photographic-grade gelatin to work properly; food-grade products vary too much to be reliable.

The second medium is DASS SuperSauce Concentrate. This is a unique medium that I developed after years of research and experimentation—there's nothing else that can do all the different things that it does. You can use SuperSauce to transfer images to both porous and nonporous surfaces, and as a final varnish for some of the transfers. When you apply the concentrate as a primer to a nonporous surface and then reactivate it with the SuperSauce Solution, you can do transfers to metal, plastic, and glazed tile.

The concentrate is available as gloss or matte. Both will work for these processes, though when you're working on surfaces like wood or paper, using matte will prevent a sheen outside the image area. I do recommend that you use the gloss concentrate for primer layers, particularly on nonporous surfaces, as it has slightly greater adhesion than the matte version. Matte works best on porous surfaces, but can be used on nonporous surfaces as long as you start with a primer coat of gloss.

We'll start with SuperSauce Concentrate, and make a SuperSauce Solution following the directions below.

To make SuperSauce Solution from SuperSauce Concentrate:

Work with eye protection and appropriate gloves, and if you're sensitive to alcohol, use a respirator and do this procedure in a well ventilated area far away from heat and any ignition source.

1. Pour a 16-ounce bottle of 91 percent (70 or 99 percent will not work) isopropyl alcohol into a dry, wide-mouth 1-quart glass canning jar.

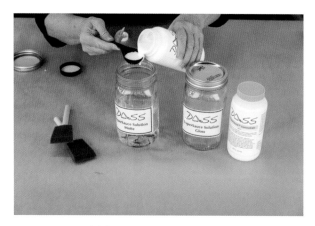

FIGURE 2.17 Add the concentrate to the alcohol—not the reverse!

FIGURE 2.18 A jar of SuperSauce Solution ready for use.

2. Shake the SuperSauce Concentrate (always make sure the lid is on tight!), and then add 4 level tablespoons to the alcohol. Do not put the concentrate in the jar first—you must *add* it to the alcohol, not the other way around (**Figure 2.17**).

3. As you pour in the concentrate, you'll notice that it gets lumpy and falls to the bottom of the jar. Stir the solution right away, and then tightly cap the jar.

4. Cover the jar with a disposable cloth (in case it leaks) and gently shake the solution every 30 minutes for the first four hours. If you can't do this, it'll dissolve overnight on its own. When fully dissolved, it will be a thin syrup and slightly translucent (**Figure 2.18**).

5. Make a SuperSauce Solution label and place it on the jar. Keep the solution stored in the jar with the lid closed tightly to keep the alcohol from evaporating. If you place a piece of plastic wrap or sandwich bag between the lid and the jar, it will be easier to open. If it thickens over time, you can add additional alcohol and remix the solution.

> *HINT: Never add water to the solution—it will turn gummy and you'll ruin the batch.*

HEALING LAYER

After you're done with a SuperSauce transfer to a nonporous surface and have let it dry completely, you may notice some surface imperfections. You can carefully apply another *healing* layer of SuperSauce Solution to the image using a sponge brush, which will heal and fix most minor problems.

In the processes within this book, we'll be applying the solution with a sponge brush. I recommend storing the brush in a second jar, along with enough 91 percent isopropyl alcohol to cover the brush. If you attempt to wash it in water, it will turn gummy and ruin the brush. Make sure you label the storage jar, too!

> CAUTION: *Isopropyl alcohol and SuperSauce Solution are flammable. Follow all safety instructions on the alcohol and SuperSauce Concentrate labels, and only store the products or work with them in a well ventilated area away from heat or ignition sources. Label all your jars and keep them well away from children and pets.*

Additives

For some of the processes, we'll be adding other ingredients to the transfer medium or the inkjet precoat. These may change the properties of the mixture, so don't ever place solution containing them into a microwave (**Figure 2.19**).

Iridescent Powders

Sparkling additives can add interest to an image and increase the apparent luminosity of the art, such as in the pearloid process later in this book.

The other products I use a lot are powdered iridescent colors from Daniel Smith fine art supplies. They're made from mica, and reflect light and different colors. You can also purchase them already mixed into acrylic paint from GOLDEN Artist Colors.

FIGURE 2.19 You can use a variety of additives in your processes.

When working with these powders, it's *very* important that you wear eye protection and an appropriate respirator, as well as take other appropriate safety precautions. The powders tend to go everywhere, and the slightest breeze could give you an iridescent workbench (or worse, an iridescent dog)! Mica particles will float in the air and should not be inhaled.

Other Materials

You'll need basic artist supplies like Liquitex Gesso, brushes, and acrylic paint, along with a whole host of tools that we'll cover in Chapter 3 (**Figure 2.20**). You'll also need some alcohol products.

Alcohol

You'll be using alcohol in several of the processes in this book. You must use it outside or in a very well ventilated area far away from any sources of ignition—it's very flammable.

There are two kinds of alcohol needed: isopropyl (often called rubbing alcohol), sold in most drug and grocery stores; and ethanol (often called denatured or grain alcohol), sold in both hardware stores and liquor stores. Grain alcohol from the hardware store or home center has an additive that makes it unfit for consumption (called denatured in this form). Grain alcohol in its pure form (called ethanol) is the alcohol found in liquor, wine, and beer. I prefer to use grain alcohol from the liquor store rather than denatured alcohol from the hardware store to avoid exposure to the additive (which is very unpleasant to breathe). If available in your

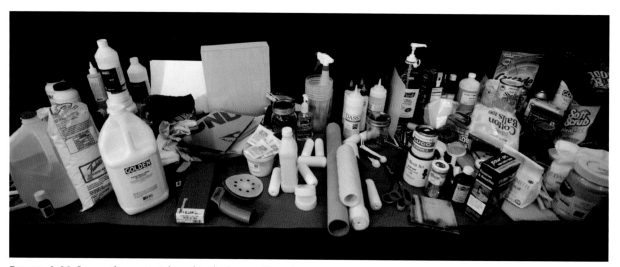

FIGURE 2.20 Some other materials and tools that you'll need.

state, it's sold under a variety of brand names (such as Everclear)—just look for 190-proof grain alcohol (**Figure 2.21**).

Grain alcohol isn't cheap, but if you compare it to the cost of paint, it's about the same price per gallon. Denatured alcohol is cheaper, but the additive makes it so unpleasant to breathe (like acetone or gasoline) that you really should use it only outdoors or under a vent hood rated for combustible fumes. Note that ethyl alcohol from the drugstore will not work for these processes, as it has a different chemical makeup.

HINT: *If you live in a location that does not sell 91 percent isopropyl alcohol, you can mix up a 91 percent solution in two ways.*

- *In a container, mix 1½ cups of 99 percent isopropyl and ½ cup of 70 percent isopropyl to get to a 91.75 percent dilution.*
- *In a container, mix nine parts of 99 percent isopropyl alcohol with one part of distilled water.*

Use one of these dilutions to make the SuperSauce Solution.

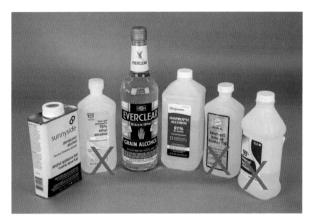

FIGURE 2.21 You'll use several alcohol products in the processes in this book, but not those with the red X.

Cleaning Substrates

Cleaning the surface of your nonporous substrate can be a challenge. The factory oil on the surface of mill finish aluminum is especially difficult to remove with any household cleaning product that I've tried. Instead, make a paste from distilled water, calcium carbonate (marble powder or precipitated chalk), and grain alcohol (**Figure 2.22**).

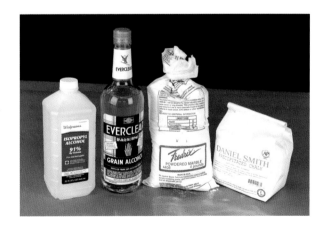

FIGURE 2.22 You can make a good cleaning paste from distilled water, calcium carbonate, and alcohol.

To make cleaning pastes:

There are two different cleaning pastes that we'll use: an economy paste you can use on most substrates, and a high-quality paste that you can use to clean glass without etching or scratching the surface.

Formula A: Economy paste for most substrates

1. Mix equal amounts of distilled water, Fredrix powdered marble dust or Daniel Smith precipitated chalk (also called precipitated calcium carbonate), and 91 percent isopropyl alcohol in an airtight bottle. This mixture has more grit and may scratch glass, but it's very good for cleaning metal.

2. Mix the three ingredients together in an air-tight container and let the paste sit overnight to allow the powder to fully absorb the liquid. Follow all safety instructions on the alcohol bottle.

Formula B: High-quality paste for glass

1. Mix equal amounts of distilled water, Daniel Smith precipitated chalk (calcium carbonate), and 190-proof grain alcohol. Skip the water if you're able to get only 151-proof grain alcohol where you live.

2. Mix the three ingredients together in an air-tight container and let the paste sit overnight to allow the powder to fully absorb the liquid. Follow all safety instructions on the alcohol bottle.

HINT: When using cleaning paste on glass, always make the paste using Daniel Smith precipitated chalk. Fredrix marble dust will cause the paste to scratch the glass.

Wear clean latex or nitrile gloves when cleaning the plate, both to protect your hands from the paste and to prevent oils from your skin getting back onto the substrate (the oils will cause adhesion problems, particularly on glass).

Shake well and then pour a tablespoon of the paste on the metal or glass surface, and rub it by hand with a paper towel (I use the Viva brand as they are very soft and absorbent) until the liquid evaporates. Wipe the dust from the plate and repeat this cleaning two more times. Make sure you wipe the edges really well—it's easy to leave a slight buildup (**Figure 2.23**).

Store the clean plates on edge until ready to use (**Figure 2.24**).

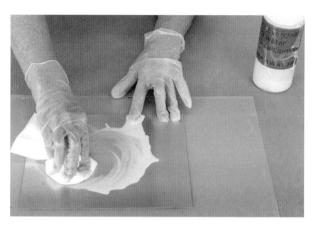

FIGURE 2.23 With your gloves on, scrub the surface three separate times.

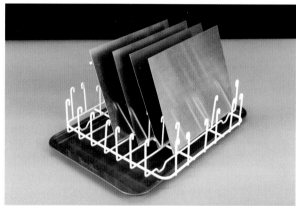

FIGURE 2.24 You can store clean plates on end in a wire rack.

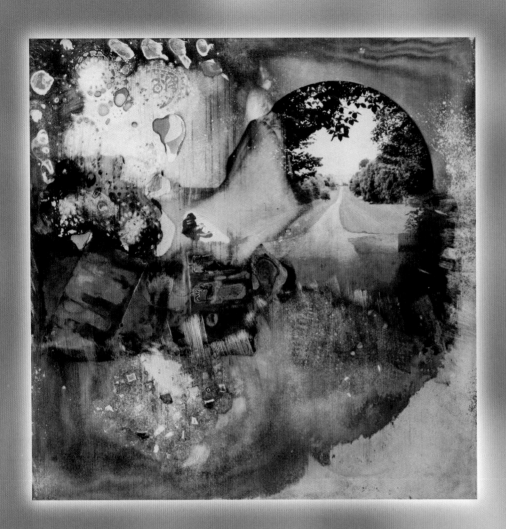

3

EQUIPMENT

n addition to the materials in the last chapter, you'll need some equipment to do the processes in this book. While some processes may require advanced printers, most can be done on a desktop printer, as long as they use pigment inks.

As we go through this section, you'll need to be familiar with creating or installing printer profiles on your particular system (see Chapter 2 for details). You'll also need the imaging software of your choice (I recommend Photoshop and Lightroom), and need to understand how to create and print images in it. I'll give you some specific tips for these processes in this chapter and throughout the book, but if you want more information, I'd recommend the many helpful guides to using Photoshop and Lightroom published by Peachpit Press (www.peachpit.com). I especially like Scott Kelby's books, which are both entertaining and full of practical, hands-on tips.

For a current and updated product list (since products may change over time), you can check the book's website: www.thelastlayerbook.com.

For those who have read *Digital Alchemy*, most of the information in this chapter will be familiar, though there are a number of updates throughout. I recommend reviewing the section on backups, and it's always a good idea to review the safety warning at the end of the chapter.

CAUTION: Again, keep in mind that equipment you use for art should not be used for food preparation or other purposes.

Backups

It is your responsibility to yourself, your sanity, and your artistic legacy to preserve the digital portions of your work in a recoverable format. As image file formats change, it's important to convert them during the period when both old and new are supported. Otherwise, you may have a collection of bits that only a very expensive data conversion service can salvage. It's also very important to place your data on multiple storage devices so that if one fails or becomes obsolete, you have a backup. I try to keep two copies of my important files on two different kinds of media. In the past, I kept one set on an external hard drive, and another on a DVD-R. But with the size of my files growing and the cost of hard drives dropping, I'm switching to just using two different external hard drives—disks are cheap! That avoids the problem with DVD-Rs going bad just sitting on a shelf and having to periodically burn new disks. For extra caution, you could store one of the copies in a fire safe or at an offsite location. I generate far too many images to try to back them up online, but you may want to consider those services as well.

One caution: Be careful relying on some of the modern RAID array devices that use a proprietary format as a sole means of backup. If the company goes out of business, or the enclosure dies, you're either facing an expensive data recovery effort or you may simply be out of luck. Archival copies should be in formats that are as close to universal as possible.

Printers and Ink

I've designed the processes in this book so that you can do almost all of them on your desktop printer, but you can also scale up to larger formats. I use Epson, HP, and Roland printers in my own studio and have found them to be excellent machines. The key requirement is that whatever printer you use must use pigment (rather than dye) inks for the processes to work. Check your manual or the manufacturer's website to be sure. If you find that your transfers have ink left on the film, or a magenta cast, then the printer probably has dye-based ink. Make sure that you use the actual brand-name ink cartridges. I've found that replacement inks (especially the refills) may not produce reliable colors and may vary the amount of ink laid down on the media.

Printer models are changing almost as often as software versions, so check out the book's website (www.thelastlayerbook.com) for more information.

Desktop Printers

Many (but not all) desktop photographic printers use pigment inks, while a number of *all-in-ones* use dye inks. Check your printer specifications to determine which kind you have. One all-in-one printer that does use pigment inks is the Epson NX420 (**Figure 3.1**). This inexpensive printer uses the Durabrite pigment inks. One cool thing about this type of printer is that you don't even need a computer—you can scan photographs and then print them directly on the transfer film. Other new printers, like the Epson R2000 and R3000, allow you to print directly from your mobile device without using a computer at all.

The Epson 3880 is an excellent mid-sized printer that can produce very high quality work. This one uses Epson UltraChrome K3 Ink with Vivid Magenta in 80 ml cartridges. These larger cartridges save a lot of money in ink costs, but you do have to be careful when switching between Matte Black and Photo Black ink. The printer has both, but since they share ink lines, every time you change between the two types of black ink, you'll lose some ink when the printer purges the lines of the other type.

> *HINT: It's important to look at the total cost of a printer when making a purchase decision. Often, manufacturers will sell printers at a very low cost, but then charge high prices for ink. Choosing a printer that is a bit more expensive may save a lot of money in the long run if you do a lot of printing and the ink is cheaper. There are a number of good resources on the Internet that have current "price per page" figures on different printer models.*

FIGURE 3.1 Using an all-in-one printer lets you try these processes without needing a computer.

> *HINT: Some Epson printers don't support printing directly on clear media because the printer can't see the clear film. Simply use some double-stick tape (the kind that releases) to attach a white sheet of paper to the back of the film, and put only one sheet in the printer at a time (**Figure 3.2**).*

FIGURE 3.2 Use a slip sheet to allow Epson printers to properly print on transfer film.

FIGURE 3.3 Pizza wheels may mark your prints.

FIGURE 3.4 Hand load materials in the back slot of a printer.

FIGURE 3.5 Hand load polymer plates in the front slot of a printer.

Some desktop Epson printers, as well as many other brands and models, have what are called pizza wheels or star wheels in them. These are rollers that help hold down a print as it passes through the machine. Unfortunately, they can cause marks on your final print (**Figure 3.3**). The transfer film that I recommend usually will not be a problem if you select a heavy media type in your print dialog box and slow the time between print head passes. If your printer continues to exhibit these issues, you can search the Web for instructions on how to raise or remove them (this may void your warranty—do it at your own risk!).

The Epson 3880 has a slit on the back that you can feed rigid custom substrates through if they are 1.5 mm thick or less. In some of the processes, we'll coat these substrates with an inkjet compatible precoat and then print directly onto the coating. Back loading printers give you much more flexibility than ones that curl the paper when printing, and tend to have less feed problems. To allow for this, you'll need to add a platform in the back the same height as the media feed slot is off the table (about 4" on most models). That raises the flat media so it can be slid directly into the slot. Hand feed the media in and the printer will grab it as if you'd used the regular media tray (**Figure 3.4**).

Note that some printers like the Epson 3880 keep the wheels up when flat loading from the front, so that's another way to avoid the problem—check your printer manual for details. This is particularly useful for loading polymer plates into a printer (**Figure 3.5**).

Large-Format Printers

For larger format printers, the HP Z3100 and Z3200 are great choices, and are what I use for most of my image transfer work (**Figure 3.6**). They work well for printing on transfer film, and have outstanding print quality for photographs. There is an after-manufacture replacement bar for the exit pizza wheels for the Z3100 that keeps them off the media as it exits (contact HP for more information). The Z3200 lets you select (and you should) "Wheels up" when you make your printer profile.

When you build a custom substrate, the Epson 4000 or 9000 series (24" or wider) work the best (**Figure 3.7**). They have a vacuum platen that holds the media down and away from the print heads, with a platen gap of 1.5 mm (see below). And as a bonus, they don't have the pizza wheels. A good example of one of these printers is the Epson 9800, which can print on a variety of custom substrates.

Platen Gaps

The only downside to the HP Z3100 and Z3200 printers is that they have only a 0.8 mm platen gap (the distance between the platen and the print head), and so aren't really suited for custom substrates or direct imaging on thick substrates. If you're using a thicker substrate on a Z3200, you can use the Adjust Profile menu to increase the platen gap to maximum, but it's still only the 0.8 mm maximum. The Epson 4000 and 9000 series printers will generally accept media 1.5 mm thick (about the thickness of a new US penny). Some of the desktop printers that print on DVDs will also handle media that thick (make sure they use

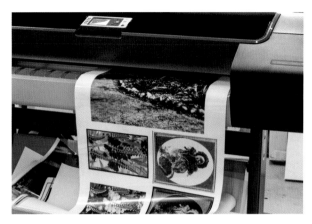

FIGURE 3.6 Transfer film using an HP Z3200 printer.

FIGURE 3.7 Direct imaging on aged metal.

FIGURE 3.8 Caliper for measuring the thickness of a substrate.

pigment inks though). Most other Epson printers will accept either 1.2 or 1.3 mm media (about the thickness of a US dime). Be careful, though, because as models change, these tolerances may differ. Always check your specific printer specifications before using a thick substrate.

CAUTION: Head strikes—letting the print head hit the media— are bad. If you're in doubt, don't risk your printer by using media that's too thick. I carry a digital caliper (Figure 3.8) with me when I shop for new substrates and media. You can purchase this online from an industrial and scientific website. It's expensive, but cheaper than a new printer!

Read the manual to determine how to set the platen gap, and be very careful: many printers reset this to the default after each and every print!

Computers and Software

I've come a long way from that first Apple][+ computer. My new retina MacBook Pro has more computing and graphics power than my Mac Pro of only a few years ago. That's a good thing, too—the image files I work with have grown from a few kilobytes to several gigabytes. The hardware technology has now reached a plateau where the standard machines can do everything I ask of them, and pretty darn quickly (I drink a lot less coffee and tea than I used to—no time for breaks). Tablets are an interesting technology—you couldn't pry my iPad out of my hands—but they generally don't have the computing power necessary to do heavy image processing...yet.

Software has taken advantage of all this computing power—the latest versions of Lightroom and Photoshop are nothing short of amazing. While those are the tools that I use and recommend, you won't need heavy image-manipulation skills to use these processes—in my workshops, we shoot pictures with our iPhones and print directly to an Epson printer with very little manipulation. For most work, though,

DECIMAL AND METRIC

One challenge that you may have is that substrates are usually specified in English or decimal units (inches), while the printer specifications are in metric units (millimeters). You can convert between the two: 1 inch is 25.4 millimeters, and 1 millimeter is 0.0394 inches. **Table 3.1** gives you some examples of various thicknesses, but *always* check with the manufacturer of your printer and substrate, as specifications may change.

TABLE 3.1 Decimal and Metric Equivalents

DECIMAL INCHES	METRIC MILLIMETER	MEDIA THICKNESS
0.015	0.381	
0.016	0.406	Ultra-thin carrier sheet
0.031	0.787	
0.032	0.800	Most HP wide-format printers
0.046	1.168	
0.047	1.200	Many Epson desktop printers
0.051	1.300	Many Epson desktop printers
0.053	1.350	US dime (approximately)
0.059	1.500	Most Epson wide-format printers
0.061	1.550	US penny (approximately)

you'll probably need to be able to do some basic image manipulation and to print using a specific printer profile.

While this is not a book on Photoshop or on creating digital images, one key technique that we'll use throughout this book is how to digitally combine your image with a custom substrate. This lets you have a good idea of what the final art will look like, without actually performing the transfer. I use Photoshop CS6 on a Mac, so your system may be slightly different.

FIGURE 3.9 Open a photograph of your substrate.

HINT: Advanced Photoshop users can also use a mask in Step 3.

COMPUTER AND SOFTWARE RESOURCES: If you need additional help with your computer or software, again I highly recommend Scott Kelby's series of books.

To digitally combine an image with a substrate:

1. In Photoshop, open a photograph of the substrate and place it as your bottom or base layer (**Figure 3.9**).

2. Open your digital image, copy it, and then paste it into the new layer in Photoshop (**Figure 3.10**). Select Multiply to set the new layer's mode. This will blend the two layers to give you a good idea of what the printed or transferred image will look like over the substrate (**Figure 3.11**).

3. Using the Eraser tool (**Figure 3.12**), remove or lighten parts of the digital file and let the base layer (the substrate) show through.

4. Duplicate the substrate layer, and then erase part of the duplicated layer to test where on the substrate you'll want to sand the plate's surface in preparation for when you'll combine it with the print (**Figure 3.13**).

FIGURE 3.10 Paste your digital file onto a new layer.

FIGURE 3.11 Change the layer mode to Multiply.

5. When you're satisfied with the combined image, delete the substrate layer from your file, and then save the image as a different filename. This altered file is what you'll print for use on your substrate (**Figure 3.14**).

6. Merge the layers to see how the final image will look (**Figure 3.15**). When combined, you'll hardly be able to tell the difference between the layers in Photoshop and the layers on the real image (**Figure 3.16**).

FIGURE 3.12 Use the Eraser tool to remove part of the image.

FIGURE 3.13 Test where to sand off parts of the plate to remove the aging.

FIGURE 3.14 The image file ready to print.

FIGURE 3.15 The Photoshop file gives you a good idea of how the transfer will look.

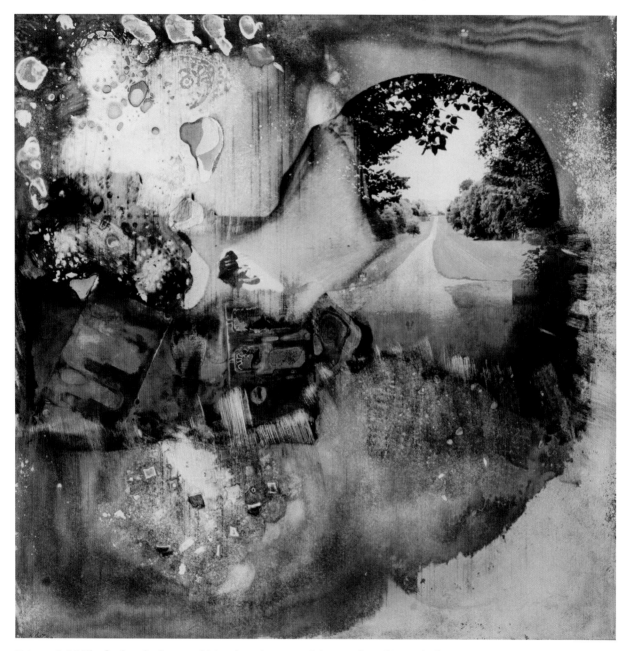

FIGURE 3.16 The final work of art combining the substrate and the transferred image looks very much like the layered Photoshop image. The printed image was altered by hand with a wet paper towel before transferring it.

Other Equipment

There are a number of different tools that we'll need for the processes in this book. I search thrift stores and garage sales for old blenders, mixers, and containers— once you've used any tool for art, you should never use it for food again. Clearly label everything, and keep your materials separate. Do not mix food with photography or art, except at your opening reception!

Appliances

To prepare the light-sensitive emulsion, you'll need a collection of household appliances. A food dehydrator is handy for drying the plant material but not essential. You'll need a food processor or a blender, a scale that measures in grams, a simple coffee press (also called a French press), a microwave, a large roaster oven, a plastic cooler, an electric fry pan, a refrigerator, and an iron. You'll need some way to keep the glass warm when making pearloid transfers (I use an overhead radiant heater), but a warming plate or electric griddle (look for a Toastess Warming Tray— they work great) would work for small sheets of glass. Never use any of these items for purposes other than art, so search the secondhand and discount stores for inexpensive options (**Figure 3.17**).

FIGURE 3.17 Old appliances find a new use.

Work Surface

We're going to get messy. Coatings may flow off panels and onto the table (and maybe even the floor!). You'll need a large table that's completely level—use a level in all four directions and put wedges under the feet (tape them down) as needed. To catch most of the runoff, cover the table with a sheet of polypropylene plastic and tape it to the underside of the table. You can also use a large cookie tray for runoff, as long as it's nonstick. If you're not working in a studio with a concrete floor, you may even want a drop cloth underneath.

FIGURE 3.18 Align your film to your substrate.

FIGURE 3.19 Tape the printed film to the alignment board.

FIGURE 3.20 Roll the film around a tube and move the alignment board aside.

Using an Alignment Board

Nothing is more frustrating than having the perfect image and the perfect substrate, and then rolling down the transfer film and having it off square or misalign. I've developed this procedure after many frustrating attempts to do this by hand. Make sure you do this *before* you coat your substrate with your transfer medium!

To roll your film down using an alignment board:

1. If your printed film has the white edge tape, go ahead and remove it.
2. Place a second panel, the same thickness as your substrate (I'm using a second birch box in this example), on the work surface against the edge of your substrate. This is your alignment board.
3. Place your printed film, printed side down, on the substrate surface (**Figure 3.18**).
4. Tape one edge of the film to the alignment board using blue painter's tape. This is why we leave that extra film around our printed image (**Figure 3.19**).
5. Roll the imaged film around a cardboard tube from the substrate to the alignment board. Make sure that the ink is on the outside of the tube—the ink side is a bit dull.
6. Move the alignment board off to the side and then prepare your substrate with the transfer medium (**Figure 3.20**).

7. When you're ready to do the transfer, move the print and alignment board back up against the substrate, and then carefully unroll the print onto your transfer medium. Make sure you do not let the film flop down at any point or you'll end up with a distorted image (**Figure 3.21**).

8. Carefully press the surface of the film down to the substrate to ensure that it's completely in contact with the transfer medium. By rolling down the film, you'll avoid having bubbles trapped between the film and the surface. Remove the tape, and push the alignment board aside (**Figure 3.22**).

9. After waiting the required time, pick up the far corner of the film and pull off the substrate in the opposite direction you rolled it down. Discard the film (**Figure 3.23**).

> HINT: For small works, tape the film to the alignment board, and then fold it back. When the art panel is ready, use a soft paint roller to push the image onto the surface.

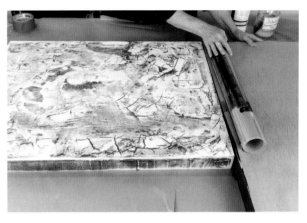

FIGURE 3.21 Move the alignment board back against the substrate.

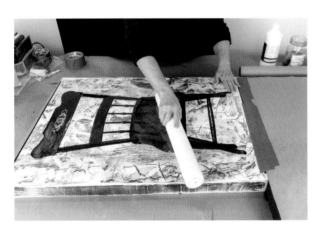

FIGURE 3.22 Roll the film down onto the substrate and press lightly.

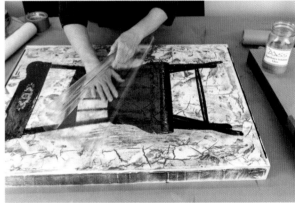

FIGURE 3.23 Lift the film slowly off the substrate.

Coating Applicators

To spread precoats evenly and quickly on a substrate, you need to use a coating rod, bar, or applicator. The best coating applicator is a #50 coating application or Mayer rod (**Figure 3.24**). This is a straight rod and has a stainless steel wire wrapped around it. As you pull the rod, the wire keeps the coating at an even thickness across the entire substrate. It is a bit expensive, but if you plan to coat a lot of smooth paper, metal, or plastic, it's a wise investment.

FIGURE 3.24 A selection of coating applicators.

FIGURE 3.25 Draw the coating rod across your substrate.

Another coating tool we'll use is a foam brush. This is an inexpensive alternative to the coating rod, but the downside is that because there are air pockets in the foam, you can get bubbles trapped in thicker precoats. You may end up applying two coats in most cases. You can also use a stiff bristle brush but you'll get brush marks in the coating (though that may be an effect that you like!). Again, you may need to apply a second coat in the opposite direction. I've found that many of the cheap foam brushes just don't hold up very well, but the ones from Jen Manufacturing are excellent. It's always best to apply just a single coat, so it's worth spending a bit of time practicing.

Don't shake the coating because it'll create bubbles in it. If you accidently do shake it, then pour it through a very fine strainer to filter out the bubbles.

To apply a precoat to a substrate:

1. Put a little double-sided tape on the back side of your substrate, and then press it to your work surface.

2. If you're using a coating rod, apply a thick line of the precoat to your work surface above the top of your substrate. Place your coating rod above that line, and draw the rod across your substrate in one smooth motion. Make sure you hold the rod still without twisting—draw it, don't roll it (**Figure 3.25**).

3. If you're using a foam brush, you can apply a thick line of precoat directly to your substrate, and then lightly spread it across the entire substrate with the foam brush. Make sure that your last run across the substrate is in one direction so that you remove any excess precoat and leave an even, smooth layer.

Other Tools

You'll need all the basics, including measuring cups and spoons, spatulas, and several 1- and 2-quart Pyrex dishes for mixing and heating materials. Canning jars can also work for heating and storing the materials (**Figure 3.26**). You'll also need items such as blue painter's tape, masking tape, duct tape, tack cloth, steel wool, a hobby razor knife, a soft rubber brayer, a wire brush, and strainers. Last, you'll need a polypropylene strainer for the processes in Section 3, though you can use a stainless steel one as well. I prefer polypropylene because the materials don't stick to it as easily, and it slides across the surface without making marks.

Many of these processes require specific temperature measures. While candy or probe thermometers work, I strongly recommend investing in an infrared thermometer. They are accurate, read instantly, and allow you to measure temperatures without handling the materials or containers (**Figure 3.27**).

CAUTION: If your thermometer has a laser pointer on it, follow all safety instructions on the tool.

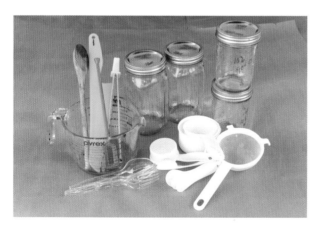

FIGURE 3.26 Canning jars provide a nonreactive airtight seal for storing materials.

FIGURE 3.27 Infrared thermometers accurately measure temperatures, and a Rocket Blaster gently pops bubbles in your coatings.

Many of the coatings can have bubbles after applying them. To pop them, you'll need a Rocket Blaster (shown in Figure 3.27) or something similar to force the bubbles to pop with the air blast. This is available from a local photo supply store and lets you have precise control over how much force you use. A small hair dryer also works well.

To pop bubbles that appear *between* the image and the substrate as you do the transfer, while the transfer is still wet pop the bubbles with a pin. Wait until the surface is dry to the touch (about two hours), cover the image with a polypropylene plastic bag, and then use a foam block or your fingertips to rub the spot down to the substrate.

To heat materials, you'll need a microwave or an electric fondue pot. If you're on a limited budget, I recommend the fondue pot since you have fine control over it and can reheat solutions that have additives (which you can't do with a microwave).

If you really get hooked on these processes, you may want a small refrigerator that can be dedicated to your artwork.

Most of these processes also involve specific times, so you'll need an accurate timer. When I'm working on multiple pieces at once, I have a separate timer for each work. For a single piece, I just use a timer app on my iPhone.

Last, a product you'll need for some of the processes is a random orbital sander. These sand a surface evenly without leaving swirls, and really save your arms and hands.

Safety Equipment: Safety is Your Responsibility

For all of this equipment, always read the labels to make sure it's appropriate for the materials or equipment you're using. Likewise, read and follow all safety precautions on the product labels. In the processes in this book, follow my suggestions under Tools Needed for required safety equipment.

You'll need a good pair of safety glasses or eye shields. While it's tempting to rely on eyeglasses, they are no substitute for real safety glasses. These should wrap around your face and protect you from splashes. Make sure you get ones that are

impact resistant or impact proof. Always wear them when doing any of these processes. They should also provide 100 percent protection from UV light.

Next, you'll need appropriate protective gloves. Make sure you wear them any time you're working with liquids or powders. You'll also need work gloves to wear when sanding materials.

Many of these processes involve fine-powdered pigments or vapors, so you'll need a safety mask suitable for that particular use.

The SuperSauce Solution and isopropyl and grain alcohol are volatile and flammable. Keep them away from heat and ignition sources (including the inside of your car on a hot day), and ensure that you have adequate ventilation. I prefer to use these outside to avoid problems. You should also have a fire extinguisher suitable for alcohol fires available in your studio.

If you have questions about exactly what safety equipment to buy, ask at the store when you purchase the items (**Figure 3.28**).

While sometimes the photographs in this book may show me not using this safety equipment (I sometimes remove it to better illustrate the processes), you should *always* practice good studio safety. In my own work with the real products, I always wear appropriate safety equipment and follow all the instructions on my products and tools.

Many of the products such as precoats, alcohol, or pigments have their own warning labels. Make sure you read and follow all of those instructions and precautions. This is especially true for disposal of product: Follow the instructions on the label, and all local regulations.

Many of these processes push the envelope of the materials and tools involved. If you're not comfortable with them, then *don't do that process*. This is particularly true of direct printing on substrates—there are far too many variables involved to determine if a particular substrate is safe to use in your printer. I've had good luck with the brands and models in this book, but in the end, you need to understand your own equipment and make your own decision.

CAUTION: Keep your art materials separate from anything you use to prepare food. Washing is not sufficient—you need to have two different, well labeled sets of containers, tools, and materials, and even a separate refrigerator, if necessary.

CAUTION: These processes are not intended for use by children. Never leave art materials where kids or pets can get to them.

FIGURE 3.28 Always make sure your safety equipment is appropriate for the materials you're using.

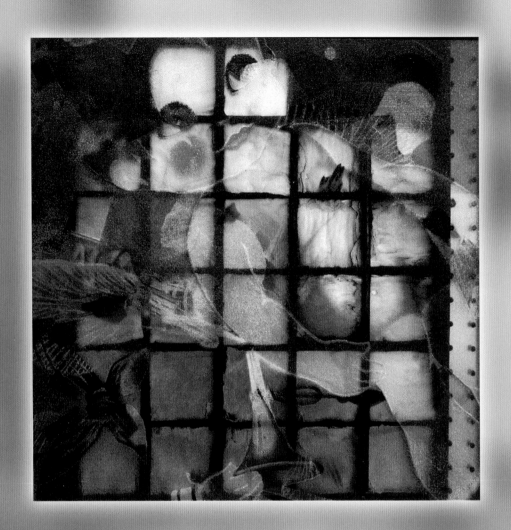

4

FINDING A VOICE

One of the hardest things about being a photographer or artist can be finding a creative voice that reflects the uniqueness of your own spirit. A way you can approach this is by determining which particular medium is right for you—sculpture, photography, painting, printmaking, poetry, film, and song each has their own unique character. One of my sons uses sound to paint mental pictures reflecting dreams and imagination. The other uses written and spoken words (not musical, mind you, as he jokes that on a good day, he can carry a song—in a bucket) to share visions of how the future can be. Both sons use photography to tell stories. And while my daughter-in-law is joining me in the studio using these processes, you'd never guess that her work and mine use the same techniques because we each have our own unique creative voice.

This chapter is an assemblage of ideas that I hope will motivate photographers and artists to assess their work from a new viewpoint. While the work included in this book is a representation of the possibilities, your goal should not be to replicate those images but rather to take the techniques and apply them to create your own signature look.

Be Prepared

The best image is the one you actually take, not the one you missed because your camera is at home. The smartphone revolution has somewhat solved that problem. Hardly a day goes by when I don't take a photograph of some kind, either with my iPhone or my Nikon. Now that everyone has a smartphone camera, we're producing an amazing number of images every day. For most people, these are simply snapshots that will end up on a hard disk or website. The photographer or artist has a different kind of eye, however—they not only see and capture the scene before them but they also visualize what the image can become. In this light, capturing the image obviously is important, but it's what you do with the photograph that really matters. For me, these actions of seeing, capturing, and visualizing are ingredients you can use together or in layers to create a larger message and story.

It helps to keep the story in mind as you take photographs: think not only about *what* you are shooting, but also *why* you are shooting it. We all can benefit from stepping back and thinking about not just a single piece, but about a body of work that we want to create. It may be a series of works through shared composition or subject matter, or with a single technique or techniques. In any case, it's the overall story that we want to tell that's important because this is what launches the creative process.

While basic (or advanced) Lightroom or Photoshop skills can apply filters, make photographs look foggy, replicate toy camera looks, or even turn vibrant colors into black and white images, the best techniques alone will not turn a photograph that contains no thought or planning—and, hence, is poorly composed and without a story—into a piece you'd hang on your wall, let alone in a gallery or museum.

I'm often asked how I develop an idea for a body of work. Where does the spark come from that can carry me through several different pieces over many months?

One great example of finding that spark comes from my pre-digital days. I was attending a Peter Kater concert at the Chautauqua Auditorium in Boulder, Colorado. On that summer night, the old wooden structure engulfed the audience and blocked out all except for the intense performance. The music released my left brain and I found myself mentally painting and developing a completely new process.

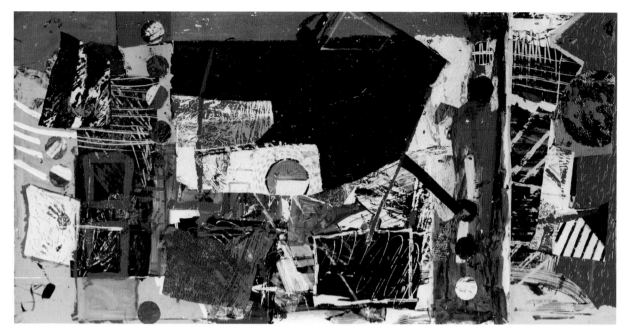

FIGURE 4.1 This 48" x 96" acrylic monographic transfer is titled *Fear Alley.*

It turns out that those imaginings had their roots in an experiment I'd done the month before: painting in reverse on a plastic plate and then pulling it off to reveal the work—layering in reverse. Something clicked that night and it all came together. I returned to my studio, put on the same music I heard that night, and was able to begin the process of creating more than 100 works based on the one experience, many of which are now in private and public collections (**Figure 4.1**).

By mentally storing all kinds of visual imagery, you program your internal computer and intuitive vocabulary with the necessary components for the spark to ignite. Those captured elements can be instantly recalled to consciousness when you're away from the computer and trigger the Aha moment that results in a compelling work. I find that if I rely too much on stored digital photographs, I spend time and energy thinking about where I saw something rather than what I saw. As well, sometimes working with real materials helps me keep the focus on the work—and I'm not alone. I recall John Derry, who was one of the original authors of Fractal Design Painter (now Corel Painter), telling me in 1994 that he would go scrub a piece of chalk on paper to determine how the digital version should work and would then incorporate that visual imagery and feel into the product.

When I taught experimental painting techniques, I would tell my students that it's just fine to paint what you like. Even cliché subjects like daises, mushrooms, dead trees, and Hawaiian sunsets can be made unique and compelling if you can find a creative way to use the subject. One of the masters of looking at ordinary things in new ways is Edward Weston (http://www.edward-weston.com/edward_weston_natural.htm). His images of peppers, toadstools, chard, and

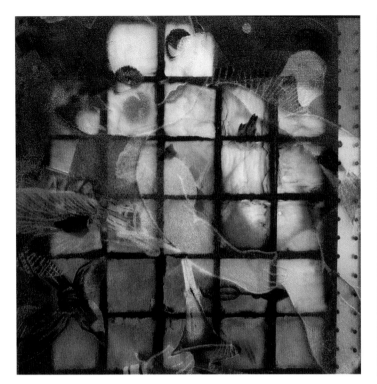

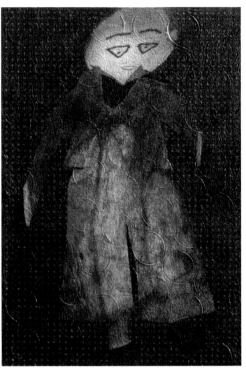

FIGURE 4.2 This 2001 24" x 24" UV pigment on polycarbonate with a mirror is titled *Paper Doll*.

FIGURE 4.3 This 2005 24" x 30" inkjet pigment direct image to sand is titled *Bubble Dance*.

artichokes express beautiful simplicity in a way that reflects his own creative voice. For me, what it comes down to is you must be open to experimentation while drawing on experiences to fuel you. Those experiences you bring are what keep you prepared for the unexpected and new.

Practice

The best way to learn to do art is to *do* art. I read somewhere that it takes 10,000 hours of practice to become an expert in something. Now that doesn't mean that it takes 10,000 hours and then you produce your first good piece of art out of thin air—it's an evolution over time. It does help, though, to have basic techniques mastered first so that your voice comes through. I'm not sure that I'd want to hear

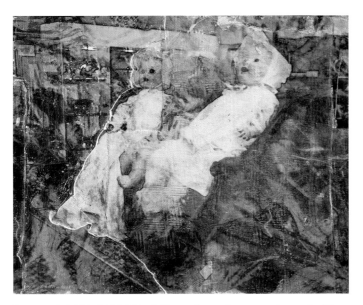

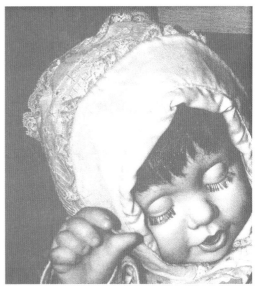

FIGURE 4.4 This 2006 24" x 30" transfer to fresco overlayered with a transfer to an old tablecloth is titled *Tea Time Ladies.*

FIGURE 4.5 This 2012 34" x 48" anthotype/UV pigment on metal is titled *Baby Doll* (detail).

the first time Chip Davis played the drums as a child, but I've no doubt that the genius behind Mannheim Steamroller was there. You just couldn't hear it behind the immature technique!

So where to begin? The mastery of digital tools is an exhausting process, and a never-ending treadmill of change. I've found that it's best to learn things just as I need them to express my vision at that time. As I develop new content and ideas, I learn the computer skills to complete the work. I'm by no means a Photoshop expert, but in those things that I use I'm pretty good. A basic foundation is certainly required, but don't wait until you've finished the last chapter before starting to create; exploit what you know to its fullest, and then add more tools to your pallet as you grow.

Next, think about the statement you're trying to make with your art. You should have a reason for the subject matter and the techniques you use in your work. Remember, you're not going to be around to explain the image—you're a visual artist. While the artist's

statement has become a traditional attachment, the best works stand by themselves, without comment. Just make sure that the statement you're making isn't something like, "I just learned how to use the XXX plugin for Photoshop!" Your techniques may grow over time, and that might be part of the story, but it shouldn't be the whole story.

I have been creating a series of images of dolls over the past several years, adding one or two at a time (**Figures 4.2** through **4.5**). I think you can see the evolution of my voice and vision as well as the techniques and technology as you look across the body of work. You can see the full image of one of the "Girls" in Chapter 11; I'm sure you can see from its character the newness of it, as it uses chlorophyll light-sensitive emulsions that I've never explored before. The process conveys a sense of nostalgia to the image. For me, the materials influence the content and add to the visual feast.

Salvaging Photographs

by Carrie Neher Lhotka
WWW.CARRIELHOTKA.COM

A few years ago I was walking with my sister and my young niece at Chatfield State Park here in Colorado. There wasn't anything special about that day, no birthday or holiday to ensure that I brought a good camera along for the trip—just some time out of the house to walk with my niece and her dog. When my niece started skipping ahead, holding the dog's leash, her smile was so big you could almost see it from behind. The only thing I had to capture the moment was my old Motorola Razr phone camera. Rather than let it pass, I took the picture. When I got home, I realized I'd captured a precious moment: universal childhood joy. The composition was wonderful, yet the technical aspects were pretty poor—it was too small, of low quality, and really good only for a snapshot.

A couple of years later I came across it again, shortly after my mother-in-law, Bonny, invented the SuperSauce stone paper transfer, and it all came together.

I did some basic editing in Lightroom and Photoshop, converted it to black and white, flipped the image horizontal, and printed it out—at 20" x 30". The image on the film looked pretty grainy and I wasn't sure that it would actually work, but I decided to take a chance and transfer it to stone paper (**Figure 4.6**). It turned out wonderfully—Bonny's process let me save a poor photograph and turn it into a work that captured that moment, and allowed me to express my own creative voice.

So the next time you see something that touches you—a moment, a picture, a scene, or a smile—don't just wish you had a better camera. Take the picture with what you have. Then go back to your studio and think outside the box, salvage the picture, and share the moment.

FIGURE 4.6 These processes let you use images that would otherwise just be a file on a computer. This 20" x 30" stone paper transfer is titled *A Day in the Park*.

Carrie Rebora Rhoda '11

Body of Work

Digital photography has given us many wonderful options that we never had before, but some of these options can be a two-edged sword. There is no longer a cost associated with each shutter click, so we tend to capture without thought or purpose. There are uncounted snapshots for each artistic photograph, and if we're not careful we can lose the wheat amongst the chaff in our own digital libraries. Shoot, but shoot with a purpose, and remember, it's always better to get it right (meaning close to your vision) in the camera than to rely on the computer later. There are exceptions, though (as you saw in Carrie's sidebar); it's better to capture a technically poor photograph than to miss a moment completely.

In the end, take your images—either captured on your smartphone on the spur of the moment or with

FIGURE 4.7 This 48" x 48" UV-cured pigment on acrylic is titled *Tree Farm*.

a Nikon DSLR after waiting hours in the rain for the right moment—back to the studio, bring them into your image library, and take a moment to reflect on your whole catalog. Do you have a group of photographs of a single subject like trees, hills, antiquity, ruins, joy, embers, sea walls, nature's fury, illusions, monoliths, snowscapes, relics, textures, solitude, food, sunsets, passages, or time? Does a story emerge? Grab

those images and bring them to a collection. There's a body of work.

Or perhaps it's the reverse. Has something inspired you recently, like a particular sunset, story, sermon, laugh, or vacation? Then go out and take a series of photographs that reflect the idea; I did that in my Illusions series (**Figures 4.7** and **4.8**), which you can also see on my website, www.lhotka.com. All of the

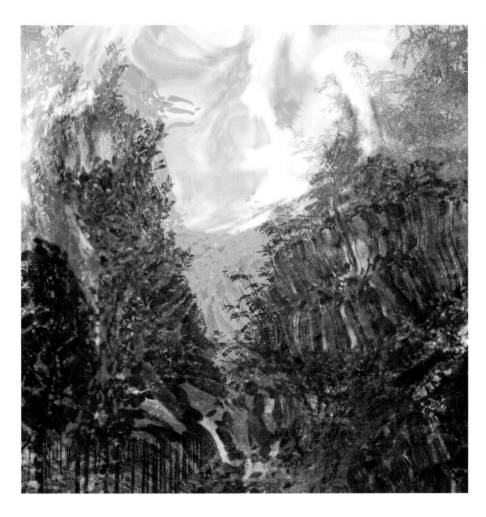

FIGURE 4.8 This 48" x 48" UV-cured pigment on acrylic is titled *Tree Farm Row Two.*

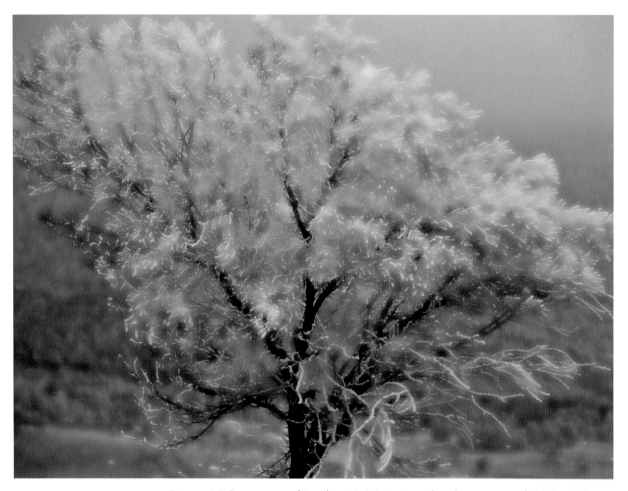

FIGURE 4.9 Processes are driven by artistic intent, not the other way around. A 30" x 40" pearloid image from my Foothills collection.

photographs were taken through distorted methods (wrinkled mirrored Mylar, water, window glass, fountains, or a handmade fluid filter). The distortion brought a commonality to the images that made the series work.

Another of my series is based on one two-hour experience while being caught in an ice and fog storm. Since it was too dangerous to drive, I pulled out my camera and started taking photos of what I thought was nothing but white shadows. Through the magic of digital manipulation I was able to pull images out of the fog, and the crystalline reality drove me to create the pearloid process I share in Section 4 (**Figure 4.9**).

Conclusion

As Garr Reynolds suggests in *Presentation Zen*:

"Being creative does not mean wearing a black turtleneck and hanging out in jazz cafés sipping cappuccinos. It means using your whole mind to find solutions. Creativity means not being paralyzed by your methods and knowledge, but being able to think outside the box (sometimes very quickly) to find solutions to unforeseen problems."

You can become a very fine technical photographer by understanding the rules (exposure, focal length, and so on), but creativity comes in knowing when to break those rules, even if you're not exactly sure why. When your creative voice says, "Wow, that's an amazing waterfall," don't think, "Darn, it's noon and it's harsh, specular light, so there's no point in taking a picture," or, "Oops, I left the better lens back in the car." Instead, listen to that voice. It sees something: something that may be technically wrong but artistically right. What if you take that waterfall and transfer it to mill finish aluminum so that the specular contrasts sparkle? Or an image of a haystack under gray skies then glows warm after you transfer it to canvas? Or a Halloween snapshot of a grandson becomes an affirmation of imagination in black and white when you transfer it to glass as a pearloid?

As my favorite Vulcan often said, "There are always possibilities." Listen to your creative voice and learn to see them.

AGED ALUMINUM PLATES

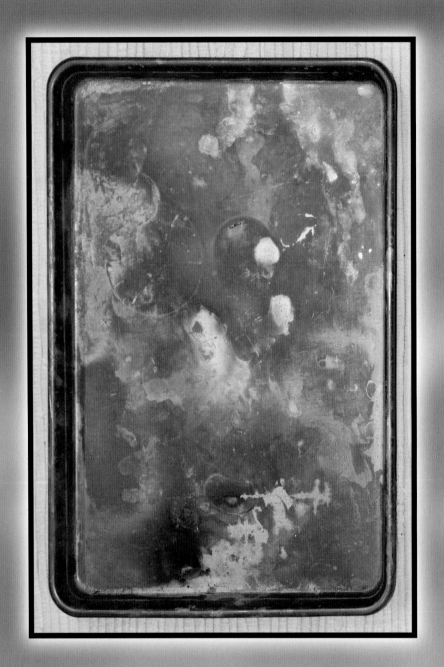

5

INTRODUCTION TO AGED PLATES

I recall looking at old tintypes with my parents, and being fascinated not only by the history captured in the image, but also by the iconic character of the images themselves—we all recognize a tintype as that street-vendor photograph of old. Photographers and artists are always looking for ways to create unique works, where the process takes place not only behind the lens, but also in the studio (and not solely in the digital studio). This section provides a way to merge a classic look with modern technology—minus the hazardous chemicals of the past!

Last year, I tried washing my cookie tray in the dishwasher and discovered that the color had changed. I investigated and learned that the removal of the phosphates and reformulation of the detergent had caused the tray to become rainbow brown in color, as you can see in the image to your left. Holding the now ruined tray in my kitchen, I recalled those old tintypes, and the inspiration for this chapter was born.

FIGURE 5.1 The patterns and colors ranging from black to golden rainbow are easy to achieve.

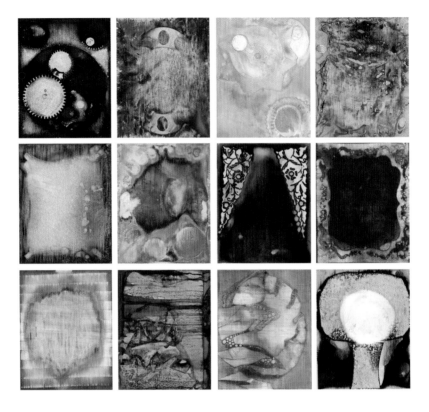

HINT: The brand names in this chapter are important—those are the ones that I've tested and found work the best.

After much experimentation, I discovered some important hints (like setting your dishwasher on a hot pots and pans cycle and using the heat dry cycle) that we'll follow to create a wide variety of plates to use as substrates (**Figure 5.1**). There are three key steps to this process: preparing the plates, stacking the plates, and cooking the plates. The combination will determine what your plates generally look like (a batch can vary considerably). Remember that these plates will continue to oxidize over time, so make sure you use a postcoat from Chapter 20 to protect your final work.

At the end of this chapter I've created a table that shows what combinations of methods from the three steps work best together. I've also included some works in Chapter 8 that serve as examples of tintype results throughout this chapter. For current and updated samples of all the possible tintype results I've created, and for a list of resources, you can check the book's website: www.thelastlayerbook.com.

You can use the aged plates that you'll make here for the transfer process in Chapter 6 and for direct printing in Chapter 7. The transfer process involves using a solution to transfer your film image to the aged plate. Direct printing, conversely, involves printing your image directly to the substrate and requires you to create a template in Photoshop that you'll use for positioning purposes.

Preparing the Plates

While I managed to get surprising results with a cookie tray, I decided that was a bit expensive to use as a substrate. After experimenting, I discovered that it's important to use mill finish aluminum as the material for the plate. Most other sheets, including roofing material, are anodized, a process designed to block the effects we're after. I like to use the 0.025" thick versions since I can both transfer to them and run them through my printer for direct imaging.

The downside is that these sheets have a coating of oil on them that you must remove before you can transfer to them. Ordinary cleanser and soap do not fully remove this oil, and even the protective plastic film sheet on some of them can leave behind its own residue. To make things a bit more challenging, your fingers can also leave behind oil that changes the final result (to better illustrate the steps, I'm not wearing gloves in the photographs, but I always do when doing real work). Follow the instructions in Chapter 2 to clean this residue (**Figure 5.2**).

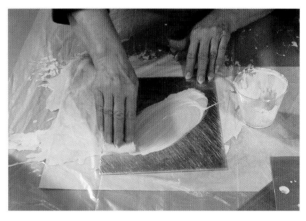

FIGURE 5.2 Once the plate is clean, make sure you don't get the natural oils from your hands onto it.

There are a couple of methods I've come up with to prepare the plates. You can then follow with a selection of stacking and cooking methods.

MATERIALS NEEDED

- 40- and 220-grit sandpaper
- Drywall sanding screen
- Acrylic or other templates
- TransferRite Premium Ultra application tape (Medium Tack 782U)

TOOLS NEEDED

- Safety equipment
- Random orbital sander
- Sanding block
- Rubber roller
- Plastic scraper
- Hobby knife

FIGURE 5.3 Wear appropriate safety equipment when sanding plates.

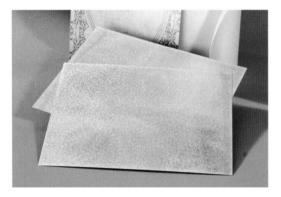

FIGURE 5.4 I like the sparkling surface when combined with black and white images.

FIGURE 5.5 This white, nonreflective surface is great for portraits.

Distressing Plates

After the plate is clean, you may want to add interest by altering the surface. You can do this by sanding a portion or the entire surface with an electric random orbital sander (**Figure 5.3**). Using 40-grit sandpaper gives you a sparkling surface (**Figure 5.4**), while using 220 grit creates a white, nonreflective surface (**Figure 5.5**). I also like to sand with a block wrapped with drywall sanding screen, which leaves a more structured pattern. After the aging processes below, you can always go back and sand the plate again to restore portions of the plate to this more natural state.

> *HINT: Always prepare both sides of your plate. You never know what will happen on the back, and you're going to cook both sides anyway!*

To make acrylic stencil patterns with transfer tape:

To create more complex and interesting patterns on your final aged plate, you'll need a guide for cutting out sections of transfer tape. I find that a template pattern cut out of a 1/8" acrylic plastic sheet is easiest, and can be reused many times as a stencil. Most trophy and sign shops can cut the pattern for you. Talk to them about what you'll need to provide (it may be a drawing or a digital file of the pattern). You can also hand cut a pattern out of other materials such as a polypropylene sheet, but you'll have to be more careful when using it as a stencil (**Figure 5.6**) so you don't accidently cut into it (the acrylic is razor proof).

> *HINT: You can use some of the techniques in the free, downloadable bonus chapter to create your own patterns if you have access to the specific equipment listed in that chapter, or get them cut with a laser at a local awards/sign shop. Register at Peachpit.com/ LastLayer to access the bonus chapter.*

1. Apply TransferRite tape to the surface of a cleaned and lightly sanded plate, and then use a soft rubber roller to smooth the tape down and press it to the surface (**Figure 5.7**).

2. Use a plastic scraper to burnish the tape tightly to the plate. This will keep it from coming off in the hot water (**Figure 5.8**).

3. Place your template over the plate and then cut out the pattern using a hobby knife (**Figure 5.9**). Only the sections without tape will be aged in the process.

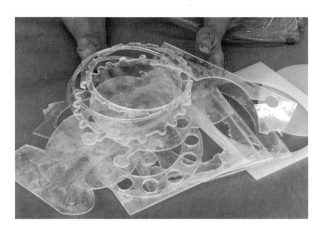

FIGURE 5.6 The number of patterns you can create is unlimited.

FIGURE 5.7 TransferRite brand tape seems to work the best for this process—but watch out, it may stick to gloves.

FIGURE 5.8 Make sure the tape adheres tightly to the plate surface.

FIGURE 5.9 Carefully remove the sections of the tape after you cut them out.

Stacking the Plates

Looking back at traditional tintypes and other wet plate photography, we can see that they clearly have water stains and other irregular surfaces. That randomness can be achieved with our modern techniques; you never quite know what you're going to pull out of the cooker in the end. The stacking methods you'll see below, however, allow for some control over what pattern your final plate will have, and will work with either plain, distressed, or stenciled plates. You'll notice that I place weights on top of many of the finished stacks. This is to keep the stack from moving during the cooking process. You'll read more about that in the cooking section.

Once you've stacked the plates and placed them in the chosen container, you'll be ready to begin the cooking method of choice.

MATERIALS NEEDED

- Aluminum foil
- Steel nail stoppers
- Heavy-duty staples
- Junk
- Large binder clips
- Wool felt (synthetic felt doesn't work)
- Drywall screws

TOOLS NEEDED

- Safety equipment
- Wire basket with handles
- Scissors

To make crushed foil patterns:

One of the basic plate patterns, and the only one that works to cook in a dishwasher, is made using crushed foil between plates (**Figure 5.10**).

1. Place the first plate in the wire tray, and then place a piece of crushed aluminum foil on top.
2. Add another plate and a piece of foil, and then continue this stacking method until you have enough plates to fill the container used for the cooking method you've chosen (**Figure 5.11**).

FIGURE 5.10 This was my original aging method, using crushed foil and cooking the plates in a dishwasher.

FIGURE 5.11 This stack can be cooked with any of the cooking methods, but is the only stacking method that works in the dishwasher.

To make solid color plates with nail stoppers:

Making solid color plates (**Figure 5.12**) is not difficult if the plates are separated with very little touching the surface. As you build this stack, separate the plates with the nail stoppers (**Figure 5.13**) as I show here; place them so the points just touch the plate. You'll find nail stoppers in the electrical section of your home center—they're used to nail over studs to prevent drywall screws from penetrating and cutting into electrical wires.

FIGURES 5.12 You can create solid color plates like this using nail stoppers and the hot roaster oven method.

FIGURE 5.13 Nail stoppers are sold in the electrical section of your local home center.

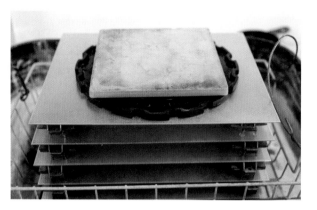

FIGURE 5.14 Use nail stoppers to separate the plates as you build your stack.

1. Place the first plate in the wire tray, and place a nail stopper on each corner. Make sure the points just touch the metal (**Figure 5.14**).

2. Add another nail stopper with the points up, on top of the first set of stoppers, and then add a second plate. Continue this stacking method until you have enough plates to fill the container you've chosen.

To make flow patterns with staples:

For a slight variation, you can use staples instead of the nail stoppers. These keep the plates closer together and create flow patterns across the surface. The farther apart they are, the less of a pattern is created (**Figure 5.15**).

1. Place the first plate in the wire tray, and then place a single heavy-duty staple on each corner of the plate (for a more complex pattern, you can place staples in the middle, too).

2. Add another plate and staple on top of the first one. Continue this stacking method until you have enough plates to fill the container you've chosen (**Figure 5.16**).

FIGURE 5.15 Using staples creates flow patterns when cooked with the hot ice chest method.

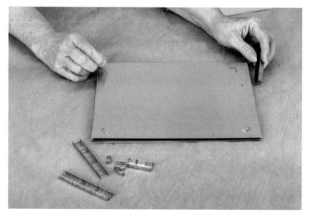

FIGURE 5.16 To create interesting patterns, use staples to separate the plates as you build your stack.

To make mixed junk patterns:

For a more complex appearance, you can use random junk between the plates (**Figure 5.17**). This is always a fun surprise—you never know what you'll pull out of the cooker! I've tried using corrugated cardboard, string, cotton fabrics, coins, washers, gloves, doll clothes, plastic or metal screen, wire mesh, puzzle pieces, watch parts, old gears, saw blades, textured papers or clothes, place mats, bubble wrap, flowers, leaves, and just about anything else you can find in a junk drawer (**Figure 5.18**)!

1. Place the first plate in the wire tray, and then place your junk on the top of the plate. Use a binder clip to attach a second plate to the top (**Figure 5.19**).

2. Add another plate and junk on top of the first one, and clip the second and third plates together. Continue this stacking method until you have enough plates to fill the container you've chosen.

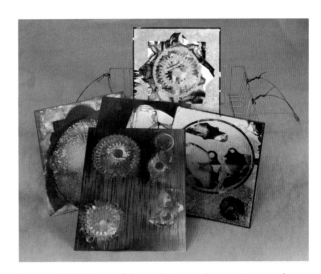

FIGURE 5.17 Some of these plates can have a steampunk look.

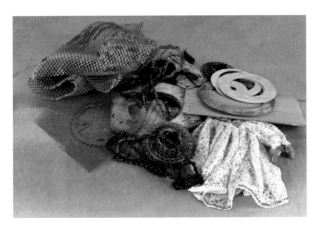

FIGURE 5.18 Most of the junk can be reused, but the paper probably is a one-time thing.

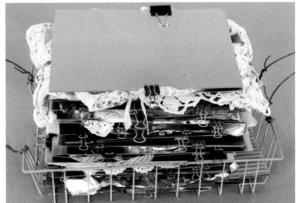

FIGURE 5.19 Use clips to hold the junk in place while cooking.

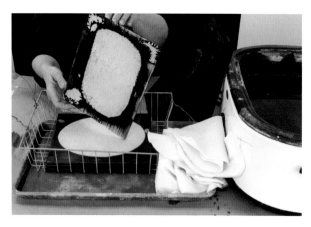

FIGURE 5.20 One way to make a frame plate is to cook a stack with wool felt ovals.

To make mattes and ovals with felt and screws:

You may prefer a plate with a large central area for the majority of your image, almost like a frame (**Figure 5.20**). Cut ovals or other shapes out of wool felt (**Figure 5.21**) to make plates with a central large texture and flowing patterns around the edges.

1. Place the first plate in the wire tray, and then place a felt oval on top of it. Use a drywall screw to keep about ¼-inch spacing between each plate. You won't see marks from the screws on the finished plate—it's the space between the plates that causes the patterns as the water moves across them.

2. Add another plate, a piece of felt, and a drywall screw on top of the first one. Continue this stacking method until you have enough plates to fill the container you've chosen (**Figure 5.22**).

FIGURE 5.21 Cut out ovals or other patterns from wool felt.

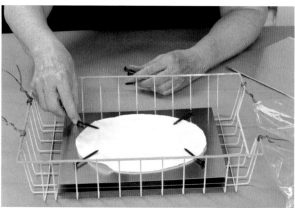

FIGURE 5.22 Felt helps simulate tintype oval portraits.

Cooking the Plates

The cooking method you choose (which is a combination of container, temperature, and cleaning agents) will determine what color or colors your final plates will include, along with how quickly they will be ready.

You can use any of the stacking methods with any of the cooking methods I outline here, with the exception of the dishwasher method that should be done only using foil (refer to the table at the end of the chapter for optimum combinations).

All of these methods are pretty messy, so I like to do them outside or in a garage, where spills can be hosed down.

IMPORTANT: The detergent solutions you're going to mix are very concentrated, and while these are household products, you should treat them like any other art material; that means wearing appropriate safety equipment (eye protection, gloves, and so on). Read the warning labels on the products and follow all of their restrictions. Do not experiment with other detergent or cleaning products, as they may create unsafe or dangerous reactions.

MATERIALS NEEDED

- Cascade Complete powdered dishwasher detergent
- TSP (tri-sodium phosphate), available at home centers
- OxiClean laundry additive (the kind with the chlorine)
- Tap water
- Stack of prepared plates
- Bricks, barbeque grill press, piece of iron, or other heavy weights

TOOLS NEEDED

- Plastic-covered work surface
- Thermometer (infrared works best)
- Stirring utensils
- Long cooking tongs
- Safety equipment
- Dishwasher
- Ice cooler
- Roaster oven
- Waterproof gloves
- Dish rack for drying plates

HINT: While you can use a Styrofoam cooler with a heavy plastic bag as a liner, if there are any holes in the bag at all, the solution will probably melt through into the cooler overnight and you'll have a huge mess. It's worth buying a real cooler with a drain for your artwork (but not to be reused for food!).

Factors That Alter the Final Look

Many factors affect the final colors of your plates, and experimenting to see the various effects can be fun. The hardness of your water can affect your final results after cooking, with the harder the water, often the better the results; a water softener or filter is more likely to mute the colors. That's why using distilled water is actually the worst; the cooking methods I show using cold water and OxiClean don't work at all with distilled water! Also, if you use a piece of iron to weigh down your plates, it will affect the color of the entire plate stack, and may leave a pattern directly on the top one; you can experiment with this effect. Use a brick if you want to maintain the basic color. Finally, the length of time you cook the plates will create variations in color and intensity. Again, you can experiment with this as you go along. Simply check the progress over the recommended time period and adjust to your taste, either cooking the plates longer or taking them out of the container sooner than suggested.

FIGURE 5.23 This is an easy way to make plates.

NOTE: After cooking your plates in the dishwasher, always run another cycle with it empty afterwards to clean away the residue! Unlike all other activities that require you to use separate equipment for your art, since you used only soap here, it's safe to use your household dishwasher for this method.

To cook plates in a dishwasher:

This is the original cooking process, and can be used safely only with the aluminum foil stacking method. It produces dripping water patterns in gold, brown, and rainbow colors (**Figure 5.23**). To make this work, you'll have to have a dishwasher that gets very hot—many of the newer energy efficient models don't work (I use a Bosch dishwasher to make these, and have to run my tap to get the water hot before I start the cycle).

1. Rather than putting the plates in the wire basket, just stack them into the dishwasher racks with the foil in between following the crushed foil pattern procedure above (**Figure 5.24**).

2. Fill the detergent cup almost full with Cascade Complete, and then add 1 teaspoon of TSP.

FIGURE 5.24 A dishwasher can hold several dozen plates at a time.

FIGURE 5.25 Unwrap the plates and allow them to dry.

3. Start the dishwasher and run it on the heaviest cycle, along with the heat dry cycle (if you have one).

4. When it's finished, leave the door closed and allow it to cool and dry overnight. Don't peek! If you do you may not get the richest possible color.

5. Remove the plates from the dishwasher and if necessary air dry them completely before use (**Figure 5.25**).

To cook plates in a cool-water ice chest or plastic box:

This cold-water bath process will create plates that have gray and silver tones with swirling water patterns (**Figure 5.26**). OxiClean produces the swirls because of the blue granules and the release of peroxide as the powder dissolves in the water. If you use a plastic box, make sure it's watertight!

1. Place the basket of plates in the ice chest or box, and put a heavy weight on top to keep them from moving around.

FIGURE 5.26 The bubbles rising through the water make interesting patterns.

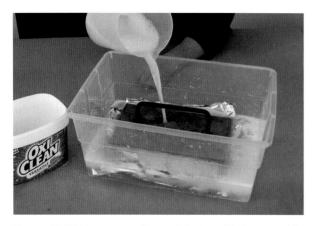

FIGURE 5.27 If you use an iron weight, its oxidation can add color to the water and some of the plates.

2. Add ½ cup of OxiClean to a container and fill it with ½ gallon of water. Pour this over the top of the stack of plates. Continue adding batches of the same proportion of OxiClean and water until the top plate is just covered (**Figure 5.27**).

3. Close the cooler or box and leave it overnight or for several days (**Figure 5.28**).

4. Drain the solution out of the cooler and dispose of it properly. Remove the basket of plates and rinse them off. If the OxiClean is caked on the plate, you can use an old credit card to scrape it off.

> *HINT:* Do not let powdered OxiClean lay directly on the metal; otherwise it will form a very hard crust that is difficult to remove.

5. Put the plates in the drying rack and allow them to air dry completely before use (**Figure 5.29**).

FIGURE 5.28 Place the lid on the container and leave it to "cook."

FIGURE 5.29 Allow the plates to air dry.

To cook plates in a hot-water ice chest:

This process will create plates that have sepia and black patterns (**Figure 5.30**), and after only four hours.

1. Place the basket of plates in the ice chest, and put a heavy weight on top to keep them from moving around (**Figure 5.31**).

2. Pour water that's at least 150 degrees (hotter won't change the effect, but just make sure it's not boiling) over the stack until it's just covered (**Figure 5.32**). Add ½ cup of Cascade Complete and ¼ cup of TSP into a large container and add enough hot water to dissolve completely. Pour this over the top of the stack.

3. Close the cooler and leave it for about four hours. Start checking the color shift after about two hours, and when it reaches the color you want, move on to the next step.

FIGURE 5.30 This method is faster than the cool cooking process, but produces different colors.

FIGURE 5.31 Use a cooler just big enough to hold the plates.

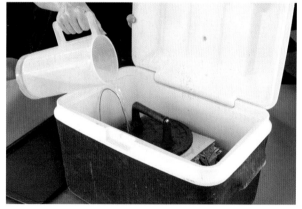

FIGURE 5.32 Make sure you don't splash hot water when pouring!

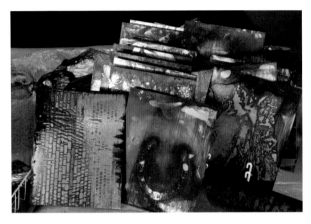

FIGURE 5.33 You can cook plates pretty quickly with this method.

4. Drain the solution out of the cooler and dispose of it properly. Remove the basket of plates and rinse them off.

5. Put the plates in the drying rack and allow them to air dry completely before use (**Figure 5.33**).

> *HINT: Do not let powdered detergent lay directly on the metal; otherwise it will form a very hard crust that is difficult to remove.*

To cook plates in a hot-water roaster oven:

This is the fastest method to cook plates, and produces colors ranging from golden brown after 90 minutes to blue-black after four hours (**Figure 5.34**).

1. Place the basket of plates in the roaster oven, and put a heavy weight on top to keep them from moving around (**Figure 5.35**).

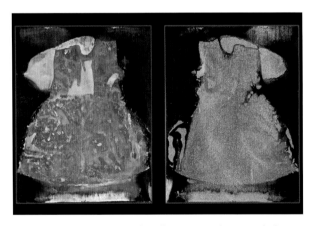

FIGURE 5.34 As I suggest for all art materials, use a dedicated roaster for making plates like this.

FIGURE 5.35 Use a brick for the basic colors, or use a heavy iron weight for a different option.

2. Pour water over the stack until it's just covered. Bring the water to 150 degrees before adding the detergent. Depending on the particular colors you want, add either ½ cup of Cascade Complete and ¼ cup of TSP *or* ½ cup OxiClean by itself into a large container, fill the container with enough hot water to dissolve completely, and then add the mixture to the roaster (**Figure 5.36**).

3. Close the roaster and raise the temperature to 180 degrees, and allow it to simmer. Keep a close eye on how the color is changing, especially between the three- and four-hour period, when it can turn black pretty quickly. When the plates reach your desired color, remove the basket of plates and then rinse them off (**Figure 5.37**).

4. Put the plates in the drying rack and allow them to air dry completely before use. For best results, do not use a fan.

> *HINT:* Do not let powdered detergent lay directly on the metal; otherwise it will form a very hard crust that is difficult to remove.

FIGURE 5.36 Make sure to use enough water to account for evaporation during the cooking process.

FIGURE 5.37 Remove the plates from the cooker, and then pull off any materials you used during stacking.

Combining the Preparing, Stacking, and Cooking Methods

The following table shows the combinations of methods from the three steps—preparing, stacking, and cooking your plates—that work best together. The expected outcomes of color and pattern variation are based on materials used, chemicals added, time, and temperatures (**Table 5.1**).

TABLE 5.1 Outcome of Combined Methods and Materials

	DISHWASHER	COOL ICE CHEST	HOT ICE CHEST	HOT ROASTER
Crushed Foil	Rainbow colors and gold water patterns	Gray and silver water marks	Gold crushed patterns	Dark black-brown crushed patterns
Nail Stoppers	Does not work	Pale, nearly solid gray, minimal patterns	Solid charcoal gray, minimal patterns	Blue-black near solid plates
Staples	Does not work	Light gray, flowing patterns with speckles	Gold and sepia, flowing patterns	Dark gold, brown, and black, flowing patterns
Junk	Does not work	Gray, brown, white patterns from junk	Golden brown, strong patterns from junk	Very deep, dark blue-black-brown patterns from junk
Mattes & Ovals	Does not work	Gray patterns forming a frame	Golden brown, tintype-esque frame	Dark blue-black frame pattern

Conclusion

From that original cookie sheet (and then some oddly colored pots and pans), a whole new way of creating unique surfaces for art emerged (**Figure 5.38**). I keep a large variety and selection of pre-made plates in my studio. I tend to make them in batches—it's just as easy to make twenty plates as it is to make two. That way, as I'm creating works I can try to match the plate and the image. Sometimes, if I have a particular image that I want to transfer, I'll try to create a special plate for it, but more often than not one of the random ones works better!

Now you're ready to add an image to your new aged plate.

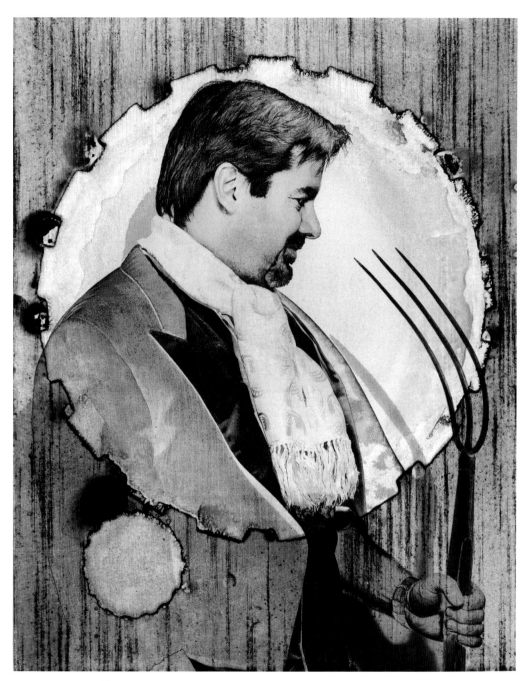

FIGURE 5.38 An old gear gave me a surprise pattern that may never be repeated. This 8" x 10" transfer on aged metal is titled *What's the Point?*

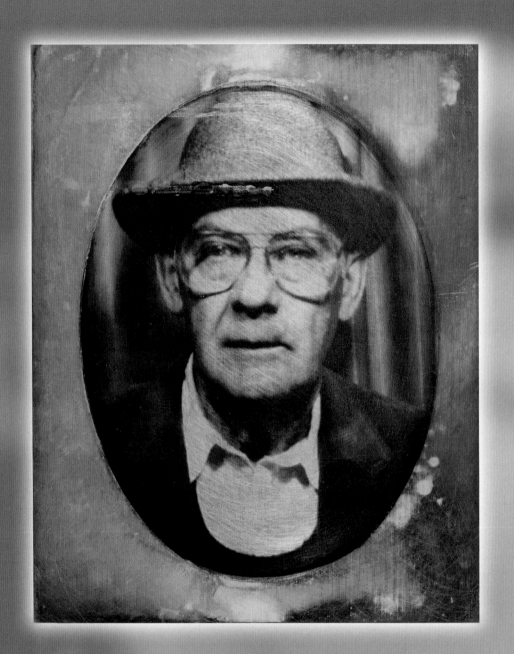

6

VINTAGE TINTYPES TRANSFER

The reaction I've been seeing to this process is amazing. When I was at the latest EG Conference, we had an assembly line set up to do portraits and transfers for the attendees. The smiles and laughter as folks dressed up for their portraits was matched only by the delight as they saw their final works (see the display of images just after the Table of Contents). This is an ideal process for images that might have imperfections, as those imperfections tend to disappear into the substrate. The image I'm using in this section is one of my dad from the 1950s taken in a photo booth—it has perfect tonality for the plate colors.

I've found that the real key is to have a good selection of aged plate backgrounds so that it's easy to match the image with the substrate. To do this match, I just lay the printed film (upside down so the image is right side up) on a variety of plates until something clicks for me—then it's off to go transfer!

For a current and updated list of products and resources (since products may change from time to time), you can check the book's website: www.thelastlayerbook.com.

About the Transfer to Aged Plates Process

HINT: While the traditional tintype images have been portraits and a few landscapes (as are most of the examples in the book), don't let yourself be limited by the past. Find what works best for your creative voice.

The transfer process itself involves using a solution to transfer an image to a substrate, and in this case, the substrate is an aged metal plate. Because of the nature of this process, the emulsion is held on the surface of the nonporous substrate suspended in the dried solution, rather than an image on porous paper that becomes part of the paper itself.

Aside from avoiding all the health risks associated with traditional tintypes, the part of this process I like the best is that I can merge modern imagery with a classic appearance and feel free to create works that span time. By using Photoshop to tint, colorize, or manipulate my digital images, I can achieve looks (including full color tintypes) that were never before possible.

I also really like the hands-on time I get with my work, both with the camera as well as with the transfer. I enjoy getting folks to wear hats, glasses, or costumes (like Russell Preston Brown on the cover), and then producing crazy and fun portraits (**Figure 6.1**). But if you do that, it's important to take the photograph against a white or light-colored background so that the substrate—the last layer—shows through.

As always, be sure you read through all the instructions before beginning the procedures in this chapter—not only will you need to have everything ready in advance for the time-sensitive steps, but you'll also find that some of the steps assume you have items already prepared (including materials and tools) using knowledge or procedures from Chapters 2, 3, and 5.

FIGURE 6.1 I finally found a use for all those old costumes I bought while rummaging through thrift stores.

MATERIALS NEEDED

- Aged plate
- Printed transfer film
- SuperSauce Gloss Solution
- Cover stock or newsprint paper
- Oil paints or Marshall's Photo Oils (optional)

TOOLS NEEDED

- Safety equipment
- Steel wool pads
- Non-absorbent work surface
- Sandpaper
- Hair dryer (optional)
- Blue painter's tape
- Rocket Blaster or canned air
- Sponge brush
- Paint roller
- Cotton swabs

HINT: If you want the whites to have the creamy color of a traditional tintype, in Photoshop apply a color tint using an adjustment layer.

To create an image using the transfer to aged plates process:

Because the substrate is so thin, we'll use a modified version of the alignment board procedure from Chapter 3 to complete this transfer.

1. Select a plate appropriate for your image (**Figure 6.2**). In this case, since it's for a portrait, I chose one with an oval shape that I'd prepared using a stencil with the mattes and ovals stacking procedure and the hot ice chest cooking procedure from Chapter 5 (**Figure 6.3**).

FIGURE 6.2 Hold the printed film over the plates to see which one matches best.

FIGURE 6.3 Oval plates replicate the traditional tintype image.

FIGURE 6.4 Clean off any parts of the plate where you want the image to show clearly.

FIGURE 6.5 Make sure the plate is completely dry or your transfer will fail.

2. If there's too much texture where the face will go, use a soaped steel wool pad to clean the metal and bring back the shine. If you prepared your plate using an acrylic pattern stencil, you can use the same template to control the scrubbing as you did when you originally made the plate (**Figure 6.4**). For this image I wanted a slightly abraded surface, so I used a fine grit sandpaper to create light scratches in the surface.

3. Wearing your gloves, hand wash the plate with dishwashing detergent. Rinse and dry the plate completely (**Figure 6.5**). If you're going to transfer it right away, use a hair dryer to speed the drying. Remember, water marks allowed to dry on the plate will show through the final image.

4. Tape a sheet of cover stock or newsprint paper to the work surface to absorb excess solution and to keep a neat work area (**Figure 6.6**). Use a rolled piece of tape to tape the plate down to the paper. Use a Rocket Blaster or canned air to remove any dust or lint from the plate surface (**Figure 6.7**).

FIGURE 6.6 Make cleanup easy on yourself by placing a sheet of disposable paper on your work surface.

FIGURE 6.7 Dust the plate, and then use a piece of rolled tape to secure it to the work surface.

5. Because the substrate is so thin, you don't need the second piece of metal for alignment that I suggest in Step 2 of the alignment board procedure from Chapter 3; just tape the film directly to the paper (**Figure 6.8**).

6. Using a sponge brush, apply a layer of the Super-Sauce Gloss Solution to the surface of the plate (**Figure 6.9**). Crisscross the plate several times until you have a thin, glossy smooth layer (avoid any puddles). Brush off any excess solution, and then check for any bits of dust and pick them off.

7. Using the alignment board procedure in Chapter 3, roll your print down onto the plate.

8. Use a soft, dry paint roller and lightly press the film down to the plate. Leave it in contact with the plate for at least three minutes (**Figure 6.10**).

FIGURE 6.8 Use the modified alignment board technique to prepare for the transfer.

FIGURE 6.9 Make sure you don't have any missed spots or puddles on your plate.

FIGURE 6.10 Lightly smooth down the film with your dry paint roller.

FIGURE 6.11 Carefully break the emulsion at the edge.

FIGURE 6.12 Slowly remove the film to transfer the image to the plate.

FIGURE 6.13 You can modify your image by wiping some ink off the transfer film.

9. After the three minutes, run a finger along each edge to break the emulsion at the edge (**Figure 6.11**), and then carefully lift one corner of the film and remove it in one continuous motion (**Figure 6.12**).

10. Set the plate aside and let it dry overnight.

11. See Section 5 for instructions on postcoats and finishing your plates to prevent continued corrosion.

> *HINT:* This is a good example of how both technology and the hand can come together in a unique way. There was a velvet curtain behind my dad in the photo booth, and I deleted most of it in Photoshop before printing the film. Then I used a wet paper towel to wipe the inkjet coating on the film (**Figure 6.13**), which smears the ink and gives a soft look that's easier to achieve by hand (and more fun!). Allow the film to dry completely if you do this (do not use a hair dryer on it).

> *HINT:* In the transfer to metal process in Digital Alchemy, we used a thin base layer of SuperSauce Concentrate to get good adhesion to the surface. The aged plates don't require this step for SuperSauce Gloss because you've already prepared the surface in the aging process. If you want the final work to be matte instead of gloss, you can use SuperSauce Matte for the transfer, but you'll need a thin primer coat of SuperSauce Gloss Concentrate (allowed to dry)—and that could mean your substrate may not show through as well. Otherwise, see the first option below.

Creative Options

There are some options to this process that will add variety to the final images.

To create a more matte surface:

The final image has a glossy surface because the inkjet emulsion is embedded into the SuperSauce Solution. That solution is somewhat waterproof, so the water-soluble emulsion is floating on top. At our EG workshop, fellow printmaker and artist Jack Duganne discovered that this emulsion layer could be rinsed off of a completely dry plate without affecting the underlying image, resulting in a more matte or satin final image.

To create a more matte surface, just put the plate under a stream of water for a couple of minutes (**Figure 6.14**). Soon you'll see a clear, slimy layer start to swell and rinse off. Continue rinsing until the layer is gone, but be careful you don't touch the image. Set the plate aside to dry. You can speed up the drying time with a hair dryer, but never touch the surface with a towel as it will damage the image. Once it's dry, the pigment ink will look like it's part of the metal surface with more of the substrate showing through.

FIGURE 6.14 Be careful not to touch the image while you're rinsing off the emulsion.

FIGURE 6.15 Hand coloring is a classic technique.

To create a hand-colored image:

After you've rinsed off the emulsion and created a more matte surface, you can hand color the image using Marshall's Photo Oils. I remember my aunt doing this in the early 1950s as part of her job creating color photographic portraits, and it's a traditional technique on classic tintypes (**Figure 6.15**). I like to use a cotton swab with light strokes to apply the color, and then use a second one to blend out the edge (**Figure 6.16**).

Conclusion

All of this may seem like a lot of work, but if you want truly one-of-a-kind original works, it's well worth it. And working through the process itself is satisfying.

If you have a lot of images to produce, you can optionally create one batch of plates, scan them, and then use those as different background layers in Photoshop. They won't have the same look and feel as an original, but it's still a cool look.

With transfers to aged plates, the actual images have an allure that draws viewers in, capturing their attention rather than only their passing glance. Beyond simply printing on metal, the complexity of the last layer as you've consciously designed it becomes part of the final work itself (**Figure 6.17**).

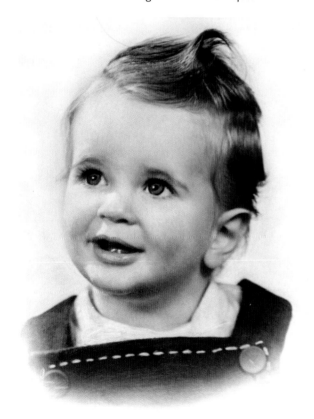

FIGURE 6.16 This is an old hand-colored photo created in 1947.

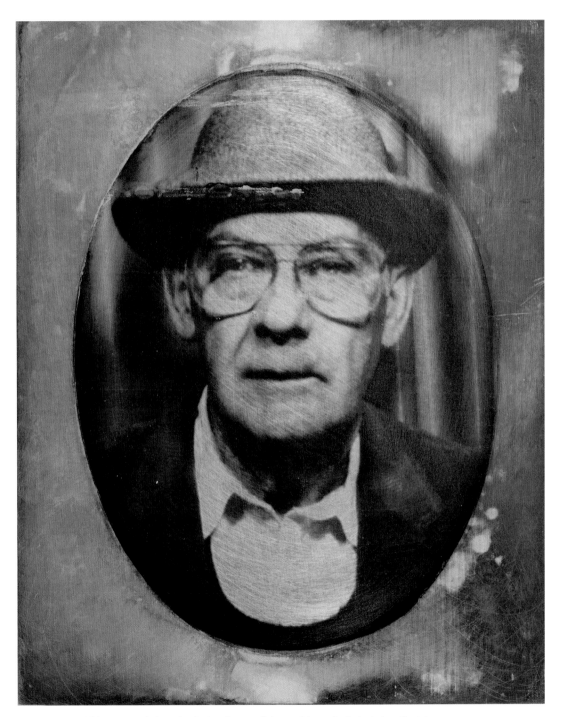

FIGURE 6.17 This process brings back the charm of those old carnival photo booth pictures.

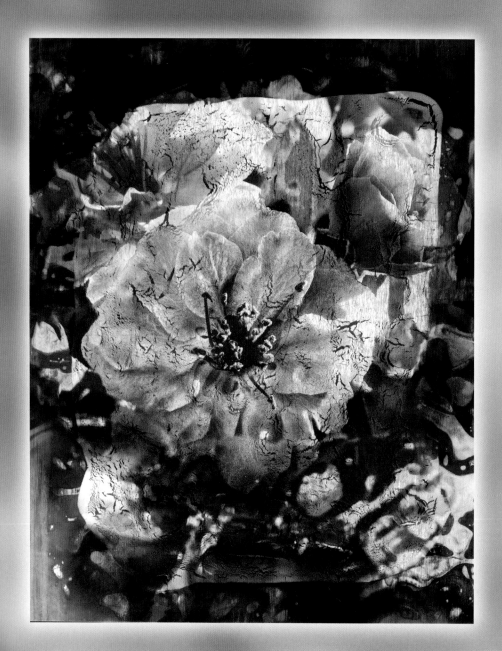

7

DIRECT IMAGING TO AGED PLATES

Real personalization of your digital file comes when you combine your image on the unique plates—adding that last layer. Watching a plate emerge from the printer is captivating as the new creation is revealed. It's the culmination of the creative process (well, except for finishing and mounting), and almost always surprises me.

While the previous chapter covered the transfer process, here we'll be doing a direct print to your plate. With this project we'll work with some of the new desktop printers. For my examples I use Epson models, but there may be others on the market that will work as well, as long as they use pigment inks. Since direct imaging on these types of substrates has the potential to damage your printers, make sure you read the printer manual, and stop if you feel uncomfortable with the process. Follow the information regarding platen gaps and testing, and make sure you understand your printer's limitations and capabilities. If in doubt, don't risk your hardware.

Please read through all the instructions before beginning the procedures below so that you have the items you need already prepared.

For a current and updated list of products and resources (since products may change from time to time), you can check the book's website: www.thelastlayerbook.com.

About Direct Imaging to Aged Plates

HINT: I use the Epson 3880 printer in this chapter because the front-loading feature makes it much easier to work with. In that mode, the front pizza wheels are raised and nothing touches the image after it's printed. Check the Epson website for other models that have this feature.

Direct imaging on metal, rather than transferring from printed film, is something that a lot of photographers and artists are doing, and most are going out to a service outlet. That can be expensive—and you may learn part of the reason as you try this process. I have stretches where everything just works, and others where I end up washing the images off the plates and starting over. Experiencing these mistakes on your own printer rather than at the service outlet can save you money. Take your time and go slowly—practice on some basic plates first before using your favorite ones, just in case something goes wrong. Of course, there are always those mistakes that turn out to be wonderful works of art!

Now is a really good time to get out that printer manual you've never read. With Epson printers, there are a couple of tricks to get the printer to properly read the dark plates (I'll give you the steps), but it's up to you to make sure your printer can handle the plates without a head strike (that's a very bad thing!).

Direct printing to a substrate requires that you first apply a precoat to the substrate so that the ink does not soak into or, in this case, run off the surface. You add the precoat with a coating rod, bar, or sponge brush depending on the substrate and the effect you want.

MATERIALS NEEDED

- Aged plates no thicker than 0.03"
- Inkjet precoat that dries clear (I use DASS Universal Precoat II in this example) and that adheres to metal
- Paper cups
- Cleaning paste (see Chapter 2)
- Viva paper towels
- Precipitated chalk or precipitated calcium carbonate
- Four-ply white mat board for most desktop printers

TOOLS NEEDED

- Safety equipment
- Protective gloves
- Chopping mat
- Blue painter's tape
- #50 Mayer coating rod
- Plastic squeeze bottle (optional)
- Clean foam brush (optional)
- Mat knife or single-edged razor
- Canned air or Rocket Blaster

SPECIAL CAUTION: PRECOATS AND YOUR SUBSTRATE

If you apply any precoat to an un-sanded, shiny, or smooth metal surface, you run the risk of having the precoat come off the substrate to remain in your printer and damage it. While the aged plates do provide a good surface for adhesion, this can still happen with some precoat products; be very careful when choosing a precoat. Always test them at small scale on an inexpensive printer before trying a large print or using your precious large-format machine. Test your precoat by letting it dry on the substrate for at least 24 hours. Some precoats detach very easily or even lift off on their own when completely dry. To test if it's working, press clear packaging tape to the center of the dry, coated plate. If the tape doesn't cause the precoat to pull off, then it should be properly attached.

I specifically developed the DASS Universal Precoat II to reduce the risk of detaching, and it's what I use for all the processes in this book (even on un-aged mill finish aluminum that I've cleaned with the paste). I highly recommend that you take special care with these processes regardless of what precoat you use, and even additional care if you use a different precoat than those I cover in this book. I've tested many of them, and haven't found another that is as "Universal" as the one I developed.

To prepare the plate with a precoat:

Make sure the plate you select has been washed and is completely dry before proceeding. If you've touched the plate with your bare hands, do a single cleaning with the paste described in Chapter 2.

1. Place the plate on a clean, smooth, non-absorbent surface. A chopping mat or other polypropylene sheet works well. If the mat moves easily, tape it to your work surface, and then use a double loop of tape to secure the plate to the mat (**Figure 7.1**).

FIGURE 7.1 Secure the plate to the work surface—make sure you don't touch it with your bare hands!

FIGURE 7.2 Make sure you don't have gaps in the strip of precoat.

FIGURE 7.3 Use a single smooth, even motion to coat the plate.

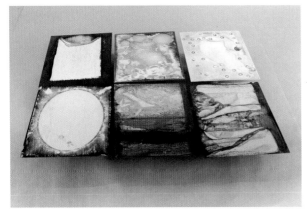

FIGURE 7.4 Don't use a fan to dry the plate faster—you'll get lint in the precoat.

2. Pour a long, thin strip of your clear precoat at the far edge of your plate (**Figure 7.2**).

3. Use a #50 Mayer coating rod to pull the liquid across the metal in a single pass (**Figure 7.3**). This is a pulling motion—you're not rolling the rod. The uniform wires on the rod ensure a uniform coating. Make sure you wash the rod with soap and water before the precoat on the rod dries.

4. Lift the plate and place it on a paper cup to dry; doing so helps keep the precoat from sticking to the table and getting too thick on the edges where it meets the table (**Figure 7.4**). Allow to dry for 24 hours.

White Crackle Plate

At this point you're ready to direct image to your plate, but if you want a different look, you can try this White Crackle Plate variation.

CAUTION: This variation may change the properties of your precoat—make sure you test the surface and that it won't come off in your printer. It may also make your plate slightly thicker, so check that it will still pass safely through the platen gap by measuring it with a digital caliper.

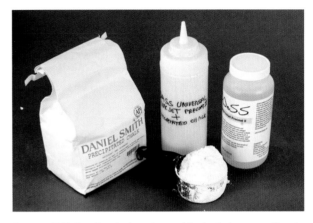

FIGURE 7.5 Gently stir the mixture (don't shake or you'll get bubbles) before applying it, as the chalk will settle.

1. Using the steps above, apply a base coat of the clear precoat to your plate and allow it to dry overnight.

2. Pour 1 cup of your precoat into a plastic squeeze bottle and add ¾ cup of precipitated chalk or precipitated calcium carbonate (available from Daniel Smith). Mix thoroughly and let it rest for about two hours. It will become a thick, creamy syrup (**Figure 7.5**).

3. Pour a puddle of this mixture on the dry plate. Spread it gently around with a clean foam brush, but be careful not to work it into the dry layer of precoat already on the plate by pressing too hard or making too many passes over the surface (**Figure 7.6**). You can coat the entire plate, or just portions of it.

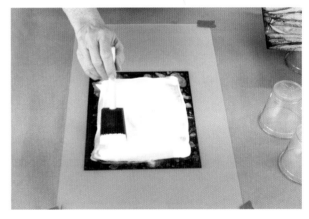

FIGURE 7.6 The coating should be fairly thick to get the look we're after.

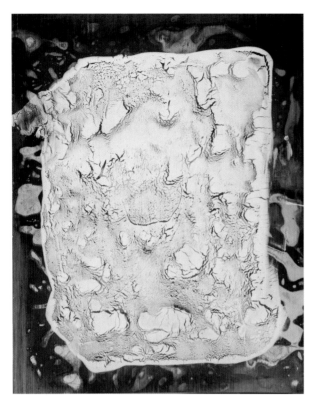

FIGURE 7.7 The white cracked surface after using chalk or calcium carbonate.

4. Set the plate back on the paper cup and allow to dry for 24 hours—do not use a fan. In the morning you'll have a white cracked inkjet-receptive surface (**Figure 7.7**).

> **TIP:** *The cracks allow the image to sparkle underneath; however, I suggest using this variation on only portions of your aged plate. If you're coating the entire plate, you may instead want to use a clean, sanded sheet rather than an aged plate since you will no longer be able to see the aged plate beneath the white cracked surface.*

> **HINT:** *As an alternative to the chalk, you can use marble dust (I like Fredrix), and the surface will appear like smooth sandpaper rather than cracked.*

To create a template and print directly to the plate:

> **CAUTION:** *Before you begin, make sure your printer will take material this thick—read your manual, measure the materials, and check everything twice. Head strikes are bad! When in doubt, don't print. Use a caliper to measure the thickness of the coated plate.*

Now that we've talked about printers, there's some special techniques you'll need to know when printing directly to a substrate (rather than transferring to it). Most printers need a white surface to begin feeding a substrate. Also, they cannot properly print full bleed directly on custom substrates. To address both issues, we'll create a template to use around our panels. You'll be able to reuse this template for many prints, so long as it's in good condition.

1. Adjust your digital image so that it's ¼" larger than your plate (8¼" x 10¼" for an 8" x 10" plate).

2. For this example, I'm using an Epson 3880 printer and want a full-bleed print. We'll need to create a template out of mat board, but first we need to do a test run of the image placement. Cut a sheet of 4-ply white mat board to be the full width of the printer and several inches longer (I use 16" x 20" for my 8" x 10" panel).

3. Pull out the front-loading tray from the printer (**Figure 7.8**). This will raise the front pizza wheels.

4. On the printer itself (for the Epson 3880), set the platen gap to its widest setting.

> *CAUTION: Some print drivers reset the platen gap after every print, and there's no way to stop it. So make sure you check that setting every time before you print. You may damage your printer if you forget to do this! Make sure you read your manual and follow all instructions included.*

5. Place a support at the front and back of the printer the same height as the media loading slot, and then feed the board into the front slot, passing it past the white line on the front load tray. Grab the back edge of the template and align the front edge to the white line on the extended tray (**Figure 7.9**). Press the load button and the printer will measure the mat board.

> *HINT: If the rubber grippers or rollers are preventing you from pushing the template through the front, press the load button to release them.*

6. Make a copy of your image, and then either delete the center of it, or set it to be very faded (to save ink).

7. In the Photoshop Print Settings dialog box, first choose Photoshop Manages Color. Select your printer profile—I like the Premium Luster Photo Paper profile to get rich Photo Black ink (**Figure 7.10**).

FIGURE 7.8 Pull out the front-loading tray so we can load media.

FIGURE 7.9 Raise the top lid so you can see the paper path while loading the template.

FIGURE 7.10 You can try different profiles to get the look you're after.

8. Click the Print Settings button. In the new window, create and select a custom paper size the same as your mat board (not your substrate), with margins of zero. Set the Page Setup to Manual – Front and your Media Type to Ultra Premium Photo Paper Luster. Under Advanced Media Control, set the drying time to 50. Set the Output Resolution to SuperFine – 1440 dpi printing, and the Color Mode to Off (No Color Management) (**Figure 7.11**).

FIGURE 7.11 The Print options dialog box settings for my Epson 3880.

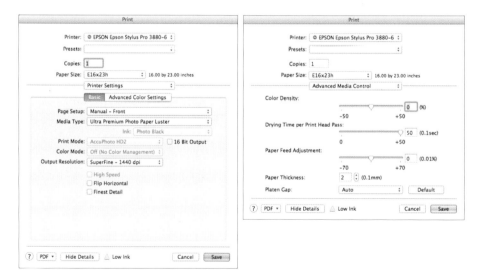

9. Back in the Photoshop Print Settings dialog box, center the image on the page, and then unselect the Position Center option. Change the Position Top to be 3 inches, select Perceptual as the Rendering Intent, and check Black Point Compensation (**Figure 7.12**).

FIGURE 7.12 The Print Settings dialog box settings in Photoshop CS6.

10. Print the entire image on the board. You can then delete the copy of your image so you don't accidently print it on the plate instead of the real one! Eject the mat board and allow it to dry.

11. In these next few steps, avoid touching the front of the plate with your bare hands to prevent the oils from affecting the final print. Lay the plate in the center of the printed image on the board, and cut around it (**Figure 7.13**).

FIGURE 7.13 Try to keep the plate centered and straight while cutting around it.

FIGURE 7.14 Press the tape firmly so that it doesn't catch in the printer.

FIGURE 7.15 Remember to set the platen gap on the printer!

FIGURE 7.16 You must fool the printer into measuring the entire width of the template.

12. Place the metal panel face down in the opening you cut in the mat board, and then tape around the edges to hold it in place (**Figure 7.14**). Tape a second layer to give added support. Turn the board over and brush off any lint or dust with a soft brush, canned air, or Rocket Blaster—don't use your hand!

13. Use your canned air or Rocket Blaster to do one last dusting on the surface, and then feed the combined metal and template into the printer the same way you did with the original template. This won't engage the grippers just yet (**Figure 7.15**).

14. To ensure that the printer measures the width properly, you *must* do this step. After feeding in the template and metal, slide a piece of white paper over the plate itself, and look in the top to make sure that the plate is completely covered. I find it's much easier to do this after the template is already in the printer. Now press the load button; the grippers will engage and the print head will measure the paper. When that's done, you can pull out the blank sheet (**Figure 7.16**). This is why we need three inches in the front of the metal—otherwise the grippers would hold the paper on top of the printer.

15. Print your image the same as you did for the earlier test. When it's out, set it aside to dry for an hour or two.

16. Remove the plate from the template and let it dry for 24 hours (longer in humid climates). See Section 5 for instructions on postcoats and finishing the plates (**Figure 7.17**).

FIGURE 7.17 Allow plenty of time for the plate to dry completely.

DIRECT IMAGING ON GLASS

The main process we just covered also works for direct imaging on glass. Check the book's website for a list of sources on where to buy precut soda lime 1.2 mm glass slides that work for this process. This glass isn't tempered, so wear gloves and eye protection, and be very careful with it. Clean the glass thoroughly with the high-quality cleaning paste in Chapter 2, and coat with DASS Universal Precoat II. Other precoats likely will not stick to glass and will come off in your printer, so be cautious. Allow the precoat to dry completely (and test it to make sure it's bonded properly), then proceed as in the main process. You can back the final piece with gold foil bonded to the glass using Rhoplex N580. Apply the Rhoplex to the foil, let it dry until it's tacky, and then apply the foil to the glass.

Conclusion

The techniques in this chapter allow you to produce cost-effective direct prints on aged metal for a fraction of the cost of using a UV printer at a print shop, without having the accidental defects that are part of the transfer process (**Figure 7.18**).

Speaking of accidents and defects, the white crackle surface was another chance discovery. I was walking through my mental library of ideas one night when I woke up and wondered if it would work to add chalk or calcium carbonate to my substrate. Sure enough, when I tried it the next morning, it worked—I love discovering things by making random connections. I love it even more when they produce really cool art!

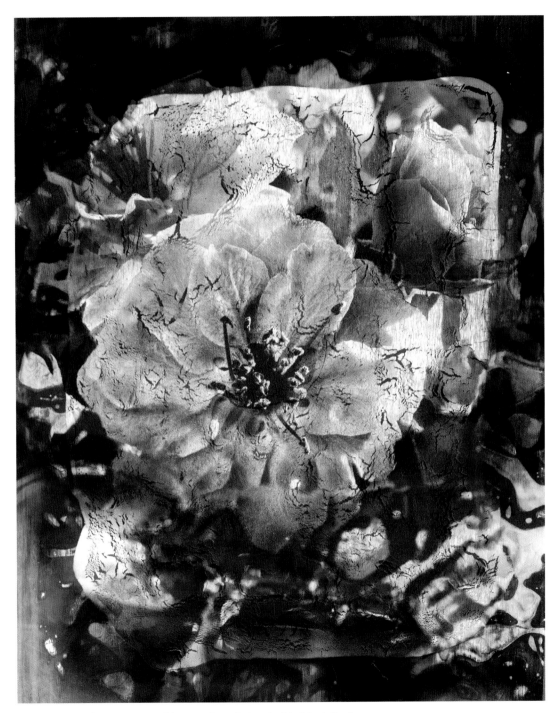

FIGURE 7.18 This 8" x 10" crackle coated aged plate is titled *Rock Garden*.

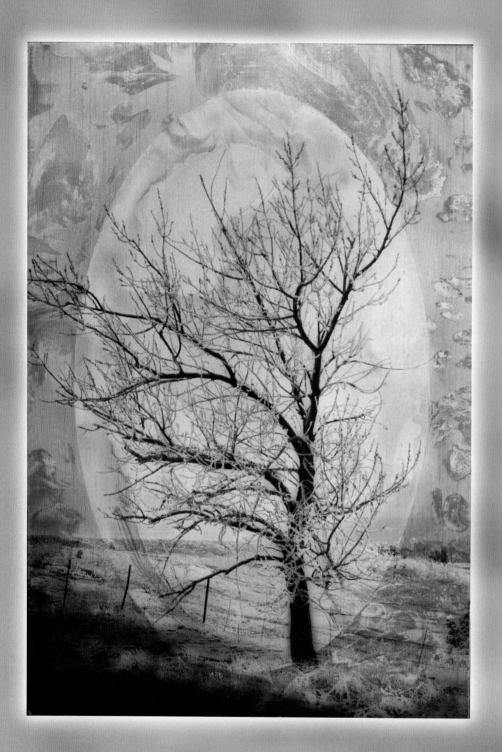

Gallery of Work: Aged Plates

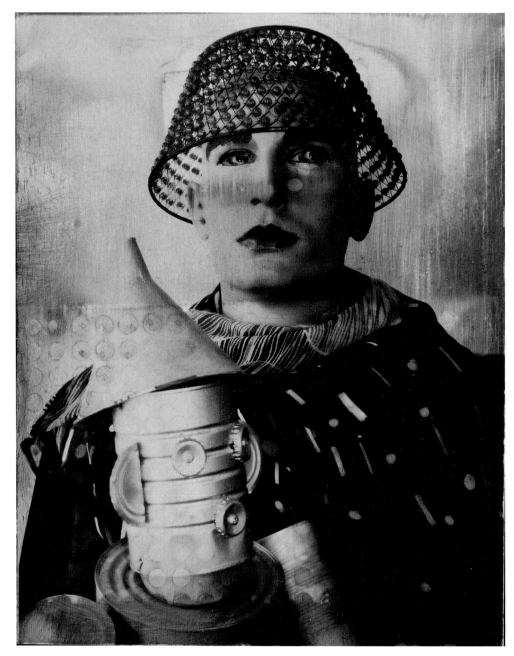

Tin Man

8" x 10". Pigment Transfer on Aged Aluminum. Bob lives in my studio and appears occasionally in my art. I hand colored the image after the transfer was washed and dried.

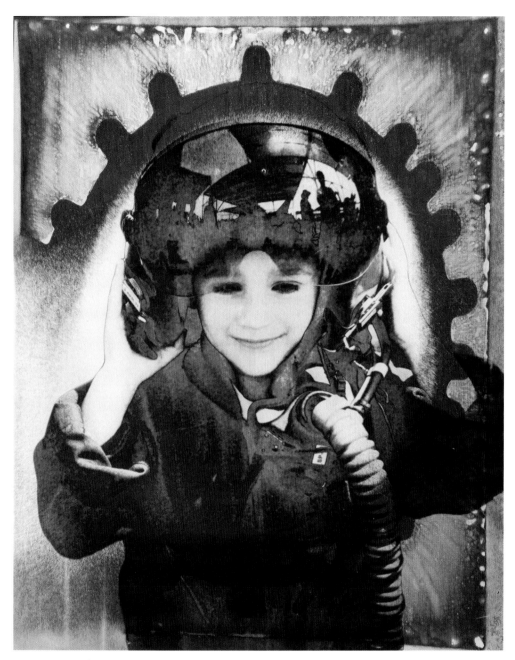

Escape Hatch

8" x 10". Pigment Transfer to Aged Aluminum. I used a plastic template to create a scalloped pattern, and then aged the plates using the hot ice chest method.

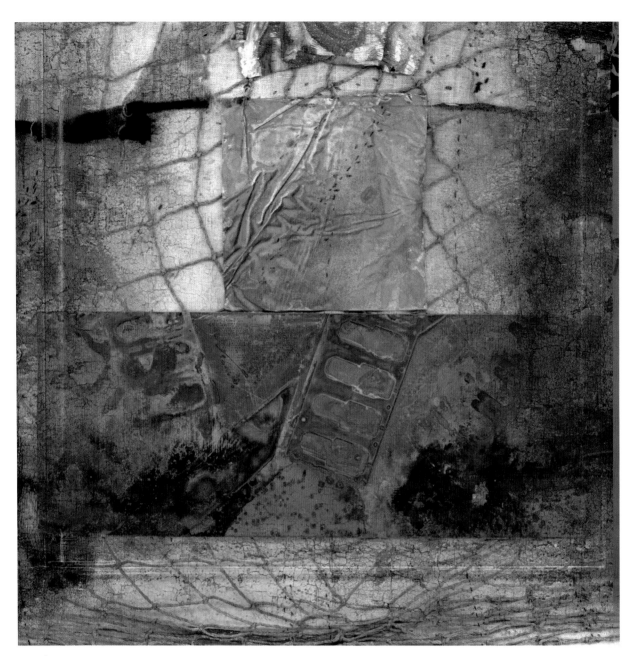

Yard Scraps

36" x 36". Pigment Transfer to Aged Econolite. To give a different result, I used a large Econolite panel for this transfer rather than mill finish aluminum, and aged it in a big tub in my back yard. The image is composed of scans of junk and a landscape photograph.

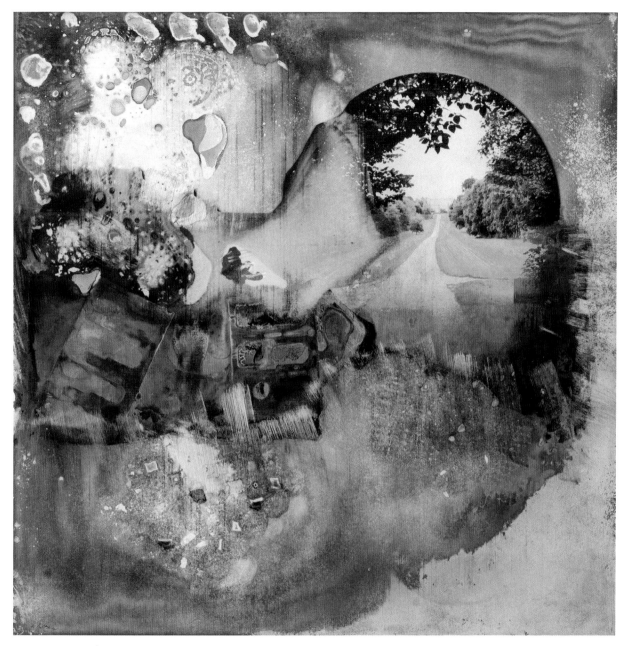

Country Road

36" x 36". Pigment Transfer to Aged Econolite. This large panel was also aged in a big tub outside, and has such an interesting surface that I kept a large portion of it in the final image.

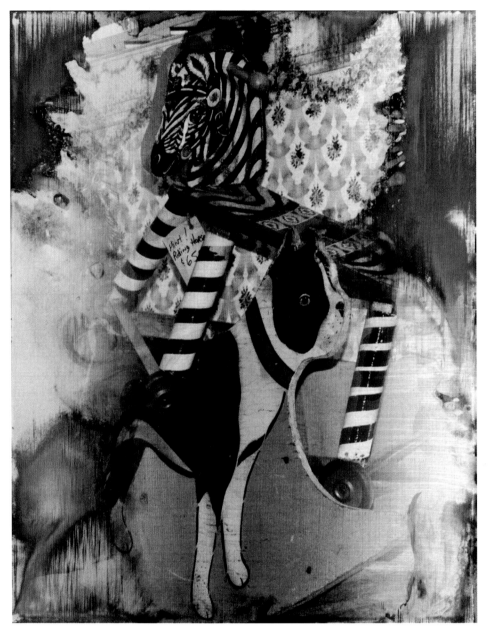

Rocking Horse

36" x 36". Direct Pigment Print on Aged Aluminum. After I completed a photo collage in Photoshop, I scanned the plate and merged the two as separate layers. I then erased part of the original collage so that the plate merges with the objects.

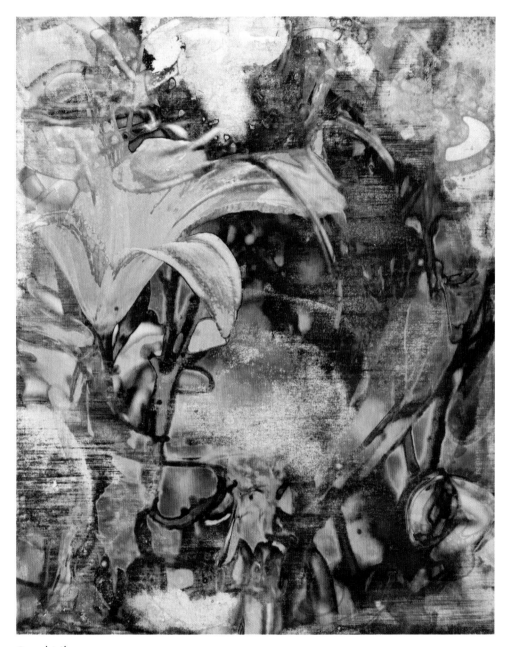

Pond Lily

8" x 10". Direct Pigment Print on Aged Aluminum. After the photo collage was completed in Photoshop, I printed it directly to an aged plate coated with precoat.

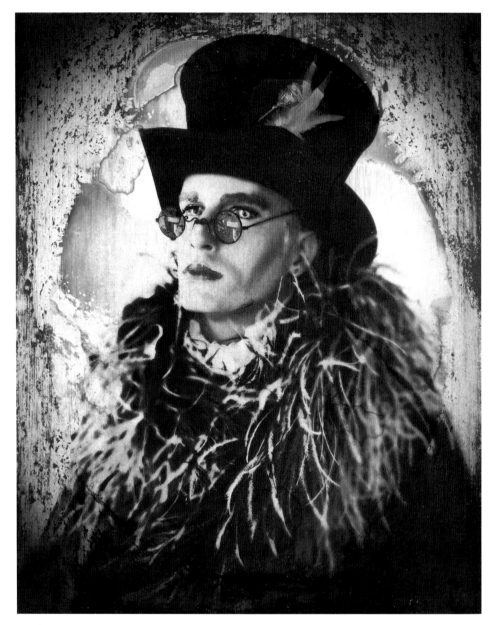

Night Out

8" x 10". Pigment Transfer to Aged Aluminum. This aged plate came out of a surprise batch that I probably couldn't duplicate if I tried—at times, odd patterns emerge, and this is one I particularly loved. I used another plate from the same batch for this book's cover photograph.

The Capitol

8" x 10". Direct Print to Aged Aluminum. This is one of the times when the pattern on the plate led me to my archives to find this particular photograph—the match is perfect!

Kitchen Sink

8" x 10". Pigment Transfer to Aged Aluminum. I used a sheet of metal covered with transfer tape, and engraved a fine line design over the entire plate. I then soaked it in OxiClean for four days, and then created the light leak illusion in Photoshop. After drying it overnight, I washed off the emulsion to create a softer final look where the pigment blends into the metal.

Winter Ice

13" x 19". Pigment Transfer to Aged Aluminum. I took this image after an ice storm that kept me stuck at home. Soaking the plate in cold water with OxiClean for three days with an oval template created a cool, portal-like effect.

Back Yard Cow

8" x 10". Pigment Transfer to Aged Aluminum. This is one of the friends who lives in the field behind my house. I sanded the center oval with 220-grit sandpaper to make the snow field appear white. I also sanded patches in the outer frame to create a more interesting aged surface.

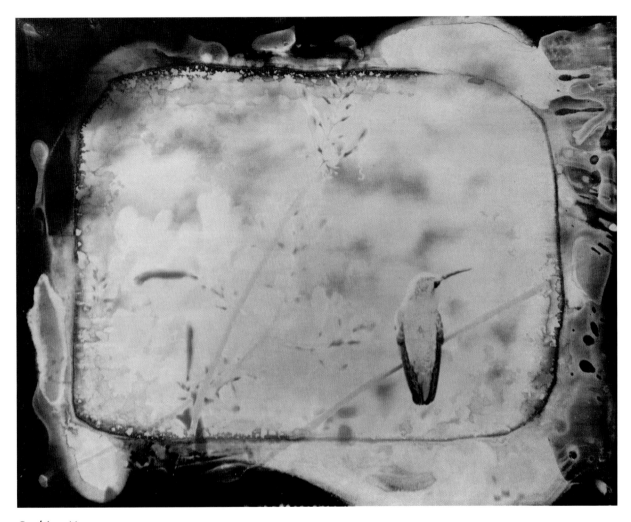

Seeking Nectar

11" x 14". Pigment Transfer to Aged Aluminum by Carrie Neher Lhotka. Carrie used the wool felt method to make the plate. The image is another old cell phone image that works wonderfully with the process.

SECTION III

TRANSFORMED BY LIGHT

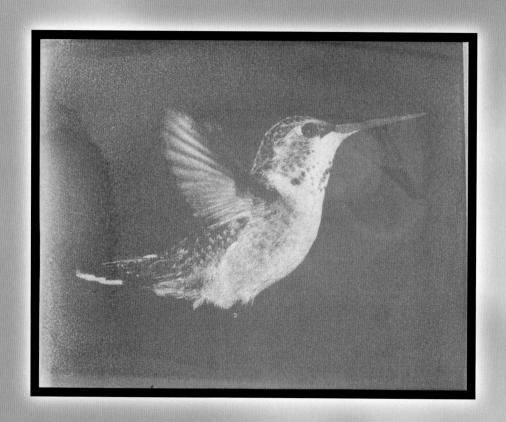

9

INTRODUCTION TO PHOTOSENSITIVE PROCESSES

Every time we have a blizzard here in Colorado with the national news giving the impression we live in igloos, I have to smile. Our hidden secret is that we enjoy 300 days of sunshine every year—on Thanksgiving, there's more golf than sledding! With all the glowing sunsets, I became interested in somehow using that great natural resource, sunshine, in my artwork. The techniques in this chapter are the result of that interest, and have allowed me to produce some of the most creative and fun work I've ever done—and some of it won't even last!

That last part may sound strange, but it's true. Several of these processes won't measure up to the longevity of pigment inks that are meant to last more than a lifetime.

The temporal nature of my photosensitive processes speaks to the creative journey more than the final result; to capture that end we'll use the photosensitive print as a plate to create an edition of permanent prints.

For a current and updated list of products and resources (since products may change from time to time), you can check the book's website: www.thelastlayerbook.com.

Overview

NOTE: *At the start of some of these steps, you'll notice what I call a light-sensitive icon (☽). This is a reminder that when you see that icon, you must work in a darkroom, in a dark bag, or under very dim lighting or a safe light.*

In this section, we'll blend traditional printmaking techniques with digital imaging. After a discussion of the tools and techniques specific to these processes, we'll begin by generating a digital negative. We'll then create a substrate with a photosensitive coating on it. Next, we'll place the negative on the substrate and expose it to light (using either the sun or a UV light box). That will turn the substrate into a *plate* from which we can make a limited edition of prints. In these processes, the hands-on quality comes both from the exposure of the plate as well as from creating the final prints themselves.

So why not just use those traditional printmaking techniques? Many of them involve harsh or hazardous chemicals. In addition, most of those techniques cannot easily leverage the digital tools in a typical modern studio. I spent many years making collagraph prints, with hours building the plates by hand. Now, by working in Photoshop I can build a digital file and make my digital negative in minutes, and *then* apply it to the substrate and expose it, in this way adding the hands-on creativity. Plus, now I can leverage the incredible detail captured by modern cameras in a direct way never before available to the printmaker.

Please read through all the instructions before beginning the procedures below so that you have the items you need already prepared.

Light

In the processes of this section, we'll be using light to expose the negative or positive that sits on the substrate. But first there are a few pieces of useful information regarding the use of light and other materials to understand.

Glass

We've all been wearing sunblock to filter out UV light that causes sunburn. But ever notice that you don't burn as badly when you're indoors in front of a window? That's because most glass contains naturally occurring iron oxides, which block a percentage of both UV and visible light. For the processes in this section, we want

the UV to shine through, so I recommend low-iron glass. This glass has as little as 10 percent of the iron content as regular glass, which allows it to transmit 91 percent of the UV light (versus 83 percent for standard glass). If you do use regular glass, you'll need to extend your exposure times.

These low-iron glass panels are available from any good glass supplier. I *strongly* recommend that you have the glass tempered. It may cost a few dollars extra, but we're going to be moving this glass around a lot, and tempering is much cheaper than a trip to the emergency room for stitches! Though tempered glass breaks into pellets instead of shards, you should still always wear gloves and safety glasses when handling glass.

Light Sources

For those who live in the tropics, you'll likely be able to use the natural sun for most of the processes. For those of you up north, especially in the winter months, you're going to need a little help. I've found that a bank of 350BL black light fluorescent bulbs in a wood box works really well. While it may take a bit more time exposing than it would in the summertime noon sun in Colorado, the end result is the same.

There are two kinds of exposure units you can use. The first is a light box that provides predictable, reliable light. The second is a technique that uses solar light and is suitable for most climates.

CAUTION: UV light can be dangerous to your eyes. Always wear 100% UV-protective safety glasses and avoid skin exposure whenever you work near it.

MATERIALS NEEDED

- Twelve T8 or T12 36" 350BL fluorescent light bulbs
- Six 36" strip light fixtures with added power cords
- One 6-outlet power strip (either a GFI strip, or use in a GFI outlet)
- 31.5" x 37.5" Starphire or other low-iron ¼" plate tempered glass with polished edges

- White glossy exterior grade paint
- 1" and 2" wood zip screws
- Self-adhesive cork discs
- Four 1" x 2" x 31.5" lumber
- Five 2" x 2" x 31.5" lumber
- Two 1" x 10" x 36" lumber

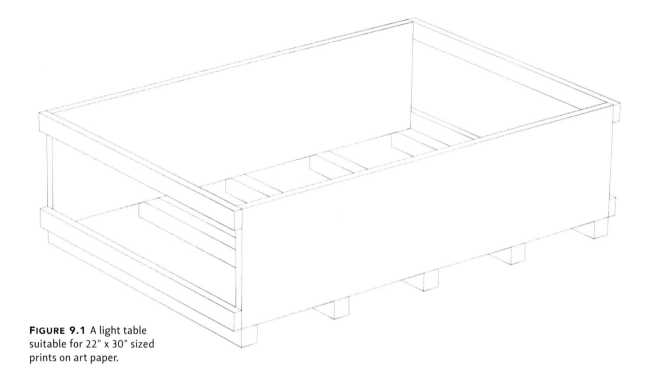

FIGURE 9.1 A light table suitable for 22" x 30" sized prints on art paper.

To build a light box exposure unit:

Karsten Balsley Woodworking of Boulder kindly shared a diagram for making a really nice light table box (**Figure 9.1**).

1. Follow the diagram to build a light table suitable for 22" x 30" prints on art paper.

2. After you assemble the box, paint the entire inside with the white paint. The box will have extended exposures of UV light, so make sure you use a high-grade exterior paint that has a UV-protectant rating; otherwise it'll turn yellow pretty fast.

3. You'll want heat to escape from around the glass, so before laying the glass into the frame, place the cork discs around the edges (**Figure 9.2**). You can also set a fan at one end to blow the air through if it gets too warm inside. It's best to place the light box on a heat-proof white surface to reflect light upwards as well.

4. Place the sheet of glass on top of the frame and the cork discs. Its weight will hold it in place.

5. After the frame is assembled, slide in the 36" bulb units. Attach the power strip to the side of the frame and plug in the lights. Always turn off the light box when not in use.

To build a glass sandwich exposure unit:

This is a simple sandwich made from a sheet of ¼"-thick tempered glass and a sheet of wood, Masonite, or fiberboard to use as backing. I can't emphasize enough that you don't skimp on the tempering here; it's not worth the risk of injury if something breaks. The materials list and photographs are for a small 8" x 10" sandwich, but the technique works just fine for larger sizes.

FIGURE 9.2 A larger version of the same design for exposing 36" x 48" images.

MATERIALS NEEDED

- One piece 8" x 10" Starphire or other low-iron ¼" plate tempered glass with polished edges
- One 8" x 10" sheet of wood, Masonite, fiberboard, or similar material for backing

- Four to six clips or clamps with rubber tips
- ¼"-thick black foam craft sheets or black cloth, 8" x 10"

1. While protected from light, place the backing board on a table, and lay a black sheet of foam on top of it.

2. Place the substrate on the foam with the emulsion side facing up (you'll learn more about emulsions in the other chapters in this section).

3. Add the digital negative on top of the paper and finally add the low-iron glass sheet to the top.

4. Clip the sandwich together (**Figure 9.3**), and then place it facing the sun for the exposure (**Figure 9.4**).

> *HINT:* *You can use a light box with black light bulbs or the sun to expose your prints. If you use the sun, exposure times can vary due to seasons, latitude, altitude, and cloud cover. A light box is more predictable.*

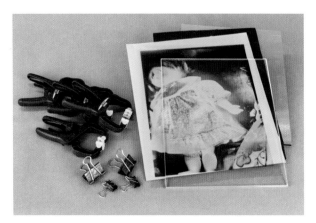

FIGURE 9.3 Use clips to hold the stack together.

FIGURE 9.4 Exposure times can be as short as two minutes or as long as two hours, depending on what light-sensitive material in your substrate you're exposing.

Digital Negative or Positive

Making a digital negative or positive seems like it should be a simple process, but there's far more nuance than first appears—whole books have been written on the subject. I'll share some simplified methods on how to make digital negatives and positives for contact prints with various light-sensitive emulsions. And because some processes actually use a film positive, I'll show you those methods as well. In each chapter of this section, I'll tell you which one of these methods to use.

Later in this chapter, my friend David Saffir shares his thoughts on how to create digital negatives for those who still work in a traditional photographic darkroom.

You'll be printing these images on clear film. While we won't actually be transferring the prints in this section, if you've already set up your printer for transfer film, I recommend using the same transfer film here; it minimizes the fiddling you'll have to do with profiles. It's important, though, that you use a profile that uses Matte Black rather than Photo Black ink, and let the prints dry for 24 hours before using them.

To make a digital positive using a curve adjustment and bitmap screens:

You can use this method for direct imaging on a photopolymer plate for contact exposure (**Figure 9.5**).

1. Create a black and white digital image, adjusting it to your liking by using the Image > Adjust > Black and White menu, but leave the image in an RGB color space (Adobe RGB 1998, ProPhoto RGB, or the like), and do not invert it (we're making a positive).

> *IMPORTANT: Some of the processes in this section use positives, some use negatives, some need the image reversed horizontally and others do not. Read the instructions carefully and make sure you create the right type of image. And always remember that if your substrate is wet, the film side goes towards it; if it's dry, then the ink side of the film goes towards it. You'll get the sharpest images by using dry substrates with the ink side down.*

FIGURE 9.5 The continuous tones provide a richness and depth unique to digital work.

2. In Photoshop, open the Curves dialog box and set the Output to 25 (**Figure 9.6**).

3. Resample the image to match the dpi of your printer. That should be 720 for most Epson printers and 300 or 600 for most HP printers (300 or 360 dpi will have more grain in a bitmap image) (**Figure 9.7**).

> *HINT: On some printers, strange moiré patterns randomly appear in the print if you use other settings (though if you use a professional rip printer driver, you may not see this). On Epson printers I have the best luck keeping the file at 720 dpi and the print resolution at 1440.*

FIGURE 9.6 You can experiment with other settings, but try this one first.

FIGURE 9.7 It's important to resample the image to match the actual dpi of your printer.

4. In Photoshop, convert the image to grayscale, and then convert it to bitmap using Image > Mode > Bitmap. Make sure you set the size to match the dpi of your file from Step 3. When asked, select Diffusion Dither (**Figure 9.8**).

5. Convert the image back to grayscale, setting a Size Ratio of 1 (**Figure 9.9**).

6. Print this image on clear film. Make sure you use a profile that uses Matte Black ink (not Photo Black), and does not use gloss enhance (**Figure 9.10**).

> **NOTE:** *The dot pattern we're creating here prints only black and white instead of grayscale. This makes doing exposures, particularly for Solarplates (see Chapter 10), much more predictable (Figure 9.10).*

FIGURE 9.8 Make sure the dpi in this step matches the dpi in the previous step.

FIGURE 9.9 Once set, never change the dpi or size of a bitmap image, as it will degrade significantly.

FIGURE 9.10 Exposures work better when using a black and white dot pattern as shown in this detail.

To make a digital positive using bitmap screens:

I use this method for the chlorophyll emulsion process. When working with that process, the highlight detail is lost very quickly, long before the darks begin to develop.

For this method, we'll follow the same steps as above, but we'll apply a different curves adjustment as shown in **Figure 9.11**.

FIGURE 9.11 You may have to experiment with adjustment curves to get the exposure that you're looking for.

To make a digital negative using Blending mode:

I developed this method for making a digital negative especially for use with the flow blue fabric process using Inkodye (Chapter 12). This method requires a 10- to 30-minute exposure, and the black inks must be very dense to block the light and keep the whites from being overexposed.

1. Create a digital image, adjusting it to your liking. Convert it to black and white using Image > Adjust > Black and White, but leave the image in an RGB color space (Adobe RGB 1998, ProPhoto RGB, or the like), and then invert it (**Figure 9.12**).

2. Duplicate the layer, and then set the Blending mode to Multiply (**Figure 9.13**).

3. Flatten, convert to grayscale, and then save the image.

You can also use two negatives stacked together to get a richer result (sort of a manual multiply method). To do this, print the original twice, but before printing the second one, flip the image so that it's reversed. After allowing the prints to dry completely, stack them ink-sides together. It's important to make sure that the prints are perfectly aligned to avoid fuzzy edges.

FIGURE 9.12 We need an image with rich darks to get proper exposure with this method.

FIGURE 9.13 Try this multiply method first, and adjust the opacity of the layer to 50% if too much light is blocked.

Negatives for Silver Halide

By David Saffir

WWW.DAVIDSAFFIR.COM

Digital and the Darkroom—The Best of Both Worlds

In the days when film dominated the landscape of photography, many people were deeply involved in creating their own prints in the darkroom. This required patience, hard work, and a climb up the learning curve. Enlargers, chemistry, print washing all were topics for long, technical discussions—and days in the darkroom could be long, indeed.

For many, fiber-based black and white prints (**Figure 9.14**) were unequaled for quality, dimensionality, luminance, and other attributes. These photographers felt it was worth the effort required to produce archival prints of highest quality.

FIGURE 9.14 Traditional fiber-based black and white prints have been the standard for archival photography.

Having said this, the black and white darkroom had its limitations, limited print size and fragility of negatives among them.

The world of digital photography gives photographers opportunities to create images outside the darkroom. The range of media types available have long eclipsed what used to be available for darkroom use—with some notable exceptions, including fiber-based silver-gelatin papers.

Now, we can create what I call *hybrid* prints—prints that merge the versatility of digital capture and editing for the creation of a *digital negative*, while adding the elements of darkroom printing. The results are amazing! We then use the digital negative, printed using an inkjet printer and transparent or translucent film, to make a contact print—specifically, a silver halide black and white print.

MATERIALS LIST

- Transparent/translucent film
- Contact printing frame
- Photographic paper
- Darkroom chemistry and equipment

WORKFLOW

- Create the source digital file via camera capture or film scan and edit the image using Photoshop, Lightroom, Aperture, or the like
- Adjust the image—prep for printing a digital negative
- Print the digital negative on transparent or translucent inkjet film
- Make a contact-style print, using almost any light
- Develop the print, typically in a regular darkroom, with your preferred darkroom chemistry

Creating and Editing the Source Digital File

Your first step is to create and edit the source digital file that you'll use in the process of creating the digital negative. This means making adjustments to highlights, shadows, and midtones.

Digital camera, scanned film—almost any source will do provided it allows you to meet your needs as a photographer. The criteria you use for image quality and

printability for hybrid prints are in many cases the same as any inkjet print: You'll want to protect highlight and shadow detail, and bring out the subtleties of the midtones and midtone transitions.

One advantage of this hybrid technique is that digital editing provides equivalents for darkroom tools—most notably burning and dodging—that are quicker and easier to use. Tone adjustments, retouching, and the like are also more accessible and efficient.

Since we'll make a contact print later on, the negative should be the same size as the print. For a 12" x 18" print, you'll want pixel dimensions equivalent to that size at 300 or 360 dpi, depending on the printer you'll be using.

Adjusting for Inkjet Printing

Once you edit your image to your satisfaction, you'll want to prepare the image for printing on film; this will become your digital negative. Experience plays an important role in success at this stage. You can use a series of trial-and-error adjustments (these are, for the most part, adjustments in overall density while also protecting highlight and shadow detail, and can work quite well). You can also use a prepackaged tool, such as HP's Large Format Photo Negatives solution for the Z3200 printer.

FIGURE 9.15 Use a gray step-wedge chart for testing and monitoring.

FIGURE 9.16 A more complex chart gives you a wider range of results to evaluate. Following the instructions provided by HP, you can use this patch chart to make a test print.

What you select as your final print media is an important variable, as your adjustments will vary with your choice of media. For example, you can use standard fiber-based darkroom paper, or self-manufactured media. I suggest that you try one or two tests on each media type to get started.

One of these tests can involve printing a gray step-wedge chart such as that shown in **Figure 9.15**. Use the chart to monitor your printer's highlight and shadow tone, and to determine if it needs calibration.

Figure 9.16 shows a more complex chart for providing more information. It's made by HP for the Photo Negative driver used with the Z3200 printer.

To prepare to print on film:

The first step to prepare your image for printing on film is to flip and invert the image on screen, followed by steps to adjust for tonal range and balance.

1. In Photoshop, select Image > Adjustments > Invert to invert the image, and then select Image > Image Rotation > Flip Horizontal to flip it for printing (**Figure 9.17**).

FIGURE 9.17 Invert the image on screen before you begin adjusting it.

2. Generally, transparent film used for making digital negatives has a different, sometimes more constrained dynamic range than "standard" inkjet media. Make adjustments to help achieve balance between highlight, shadows, and midtones. This will help ensure that the print you make using this negative is pleasing throughout, including in the details.

 The method I describe here is a simplified version of one developed through HP's Photo Negative program. There are a number of other methods, two good sources being Dan Burkholder's book—*Making Digital Negatives for Contact Printing*— and his website, both of which contain versatile though sometimes complex methodologies.

3. In Photoshop's Channels panel, select the Red channel. From the menu bar, select Edit > Select All > Fill > Black (**Figure 9.18**).

4. Click the Channels panel once, and then return to the RGB bar. Create a Curves Adjustment Layer by selecting Layer > New Adjustment Layer > Curves.

5. In the Curves dialog box of the Adjustments panel, left-click and then hold and drag the lower-left point (the black point) upward until it shows an Output value of approximately 200. The on-screen image will look something like **Figure 9.19**.

FIGURE 9.18 Convert the red channel to all black.

FIGURE 9.19 Use an Output of 200 as a starting point until you achieve the result you desire.

Keep in mind that this is just a starting point. The Curves adjustment technique can use the RGB channel in Curves or a single channel to control density of the digital negative. I've used adjustments in the Red channel ranging from 175 to 215; the range of tones in your base image file will drive your adjustment decisions. In my view, this is usually a trial-and-error process—you can print test charts all day, but I've found that creating a series of variations and then test-printing them in the darkroom gives a better result.

Printing the Negative on Film

There are several transparent/translucent films you can use, including DASS Premium Transfer Film, Pictorico OHP, and HP Backlit Film.

To print the film:

You'll first need to prepare your printer settings. If you're using an HP printer, you can use the HP driver for Photoshop or the HP Embedded Web Server utility. (This is available only on Postscript-enabled HP printers. If you're using another printer, use the normal printer driver.)

1. When printing with Photoshop, select Application Managed Color and the Photo Negative media profile, available on the HP website.

2. Load the roll of inkjet film as normal. For the Z3100, set the pizza wheels in the Up position. On the Z3200, set Wheels Up in the HP Utility for the profile you use. Always wear lint-free protective gloves, as any oils from your hands will affect the outcome. The film is relatively fragile; avoid contact with hard surfaces.

3. Print the film (**Figure 9.20**), and then protect the negative in a folder with interleaving paper—do not stack negatives without this protection.

FIGURE 9.20 Allow prints to dry completely before stacking. Note that I placed a piece of paper underneath the digital negative to improve visibility in this photo.

Making the Final Print

At this point, you'll make the contact print. You can use a standard contact printing frame, or you can make one from an old picture frame that has good glass. Mid-grade or multi-grade glossy paper will work well. Of course, you'll want to load the paper in a darkroom, in a dark bag, or in a room with a safe light. Keep in mind that any light other than a safe light will fog the paper. If you use a safe light, pick the lowest intensity you can get away with. A bright light can fog the paper.

To make a contact print:

1. ☽ While protected from light, stack the contact frame from top to bottom and front to back, starting with glass, then photo paper, and finally the backing board.

2. ☽ Use clips or tape to hold the stack together. Keep the stack tight—movement or play between sheets will affect image quality.

3. Expose the frame using any light source such as sunlight or artificial light, including an enlarger. Timing the exposure can be a bit of a headache; at minimum, you'll find some trial and error work necessary.

> *TIP: Enlargers can be expensive, but if you hunt around a bit you can find a decent one with a lens at a very modest cost. One limitation of enlargers is that the columns and easels usually permit printing no larger than 20" x 24", and in many cases only 16" x 20" or even 8" x 10".*

Developing the Print

Normal darkroom chemistry will work fine for developing a print, unless you're using materials that require special treatment. Here are a few tips to make this last step run smoothly.

⚠ The darkroom part of this process does not have to be expensive. You can find used, clean trays fairly easily. Try to find sizes larger than you think you'll need; that way you'll have only one set to contend with. A set of four is best. If used, scrub them down to prevent contamination.

⚠ Use fresh chemistry. It's all too easy to contaminate a step and ruin your print. Store chemicals as directed on the label.

- The contrast curve of these prints tends to be pretty steep; small changes in development technique can easily affect the details, particularly in the highlights and shadows. Watch your prints carefully as they develop so that you can monitor developing time versus results. Remember that you'll need to do some trial and error work to get desired outcome.

- Use a hypo cleaning step and an archival-level wash. Consider toning your image; I've used selenium toning to good effect, and of course other toning methods will work, depending on your image and artistic goals.

I hope this summary helps you understand the workflow for creating a hybrid print. If you have just a passing familiarity with darkroom work, you'll find this process relatively easy to master, and certainly budget-friendly. The results can be gratifying, and the method certainly offers the potential for you to expand your portfolio into new areas (**Figure 9.21**).

FIGURE 9.21 You don't really discover the final result until the print comes out and is in your hands.

Conclusion

I've tried to keep the process of creating digital negatives (or positives) as simple as I can. There's a lot of room to experiment here, and you can get excellent results doing so (**Figure 9.22**). I've found that each image requires some tweaking to get it *just right*; as much as I'd like otherwise, there's no real cookbook method for producing these images. Then again, maybe perfection isn't required because you can make your adjustments at so many points in the process—for example, if you're looking for a dark, moody scene, then it's better to underexpose rather than overexpose.

And after all, we have Photoshop to touch up our final file (scanned from the photo exposed plates) after we discover that a bug got squashed between the two sheets of glass! I'll share more tips as we move into the processes in this section.

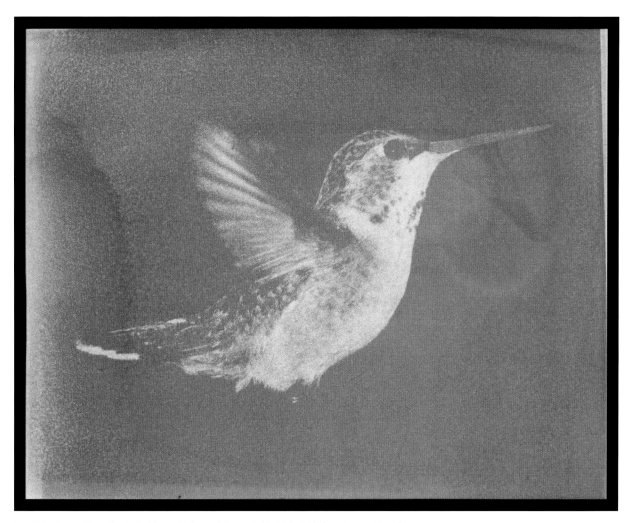

FIGURE 9.22 This 8" x 10" chlorophyll emulsion print is titled *Flight*. The positive film was exposed on Rives BFK printmaking paper coated with linden leaf chlorophyll emulsion.

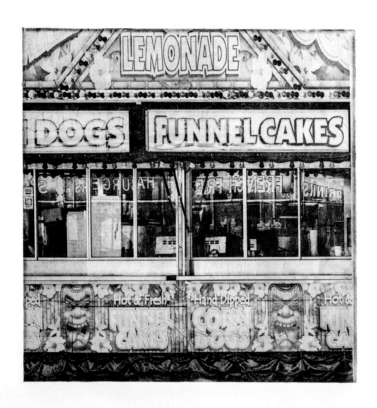

10

PHOTOPOLYMER PLATE PROCESS

n some ways, this chapter is like coming home again. My beautiful Griffin etching press had sat largely unused since I started working with digital and inkjet technologies in the 1990s. Now, thanks to this photopolymer plate process, I've dusted it off and again get to enjoy the traditional printmaking.

Decades ago, Dan Welden developed his Solarplate™ for use in the photopolymer etching process, which exposes the photosensitive polymer plate underneath a photographic transparency (usually a positive) to the sun. After washing off the unexposed polymer from the plate under running water and hardening the emulsion in the sun again, the plate is then printed on a traditional etching press. While there are other polymer plates available, the beauty of the Solarplate is that it's developed in tap water as part of a non-toxic process.

Recently, photographers have started to use digital positive prints on transparent film for the contact exposures, but it wasn't until Epson delivered a printer with a front load feed that keeps the pizza wheels up that we were able to print the positive directly to the Solarplate itself and eliminate the need for the transparent film.

About the Solarplate Process

HINT: *The direct imaging process in this chapter is similar to the direct imaging to aged plate process in Chapter 7, but there are key and important differences. Please make sure you follow the special instructions here when working with Solarplates.*

For the basic process in this chapter, you'll prepare a digital file of your image, print that image to a Solarplate, expose and finish the plate, and then print your final prints using an etching press, all mimicking the traditional process (**Figure 10.1**). What I like about this process is it lets you have full access to traditional printmaking inks and papers. The best part is that you don't need an inkjet precoat on the plate (as I was pleasantly surprised to find out when I stuck a plate in my printer one day—yes, I do strange things with my equipment!).

The Solarplates (**Figure 10.2**) I use in this chapter are available from Dan Welden (www.solarplate.com). While there are other plates on the market, I've found that Dan's work really well for direct printing digital positives. Each brand of plate will require slightly different steps, so if you want to try a different one, you'll need to experiment and tweak things accordingly.

There are some points to remember about this process to make your work successful. I'm a bit fearless about trying new things (and have heard scary noises come from my printers during the experiments) but those mistakes and discoveries are part of my experimental method. But no matter how fearless you are, please read about printers and platen gaps in Chapter 3 and in your printer manual before attempting to direct image to a substrate. The plates have a polymer coating on one side of a thin steel sheet. This coating is very soft, which means that either

FIGURE 10.1 The detail you can achieve through this process rivals traditional etching and collagraph printmaking.

FIGURE 10.2 For more images created with these Solarplates, see www.danwelden.com.

gripper rollers or pizza wheels can easily damage it (depending on which your printer has). To protect against the gripper rollers, we'll use a thick template to hold them up off the plate, and to guard against the pizza wheels you'll need to raise them (either from the printer controls, or manually on the printer itself). In the example here, I'm using an Epson 3880, which raises the wheels when the front feed slot is raised (**Figure 10.3**).

Please read through all the instructions before beginning the procedures below so that you have the items you need already prepared.

> *NOTE: Remember, when you see the light-sensitive icon (☽), you must do that step in a darkroom, in a dark bag, or under very dim lighting or a safe light.*

For a current and updated list of products and resources (since products may change from time to time), you can check the book's website: www.thelastlayerbook.com.

> *NOTE: Many wide-format printers have a vacuum that holds the media away from the print head. This eliminates the need for the exit pizza wheels. But these printers still have gripper rollers that press tightly against the surface. Both pizza wheels and rollers will cause indentations in the Solarplate, which will then show up in the final print.*

Digital and Traditional Combined

When printing on an etching press, large blank areas (which are intended to be a solid color) can be over-wiped in the inking step—removing too much ink from the plate because the surface is so smooth and has little or no texture, or bite (**Figure 10.4**). Called *open bite*, it causes large solid areas to be over or underexposed. On the final plate, those areas will not be able to hold the etching inks—the dark areas will wipe clean instead of holding a solid coating of ink. To avoid open bite, the traditional method is to make two exposures of the plate using a special film screen,

FIGURE 10.3 Unexposed Solarplates are delicate, so any marks on the surface will end up on the final print.

FIGURE 10.4 Large areas of a solid color require special treatment when preparing the digital file.

and then a film positive of your image. First, expose the plate using a commercially prepared aquatint screen for a minute or two, and then follow it with a second and the normal exposure of a film positive of the actual image. The first exposure creates a subtle, rough pattern on the plate that underlies the large blank areas that will appear in the second exposure.

I tried this two-exposure process, but have come up with a simpler approach done digitally. When I held up the aquatint screen to the light, I noticed that it looked a lot like areas in my files where I'd applied a bitmap diffusion pattern in Photoshop before printing. I guessed that if I applied that pattern to the entire image, I could skip the pre-exposure step and just print a modified image directly on the plate. When I tried it, it worked wonderfully, so the steps below are based on this digital version of a traditional printmaking technique.

MATERIALS NEEDED

⚠ Mat board

⚠ Unexposed Solarplates

⚠ Water

⚠ Clean newsprint

⚠ Printmaking paper (I use Copperplate and Rives BFK)

⚠ Etching inks

⚠ Easy Wipe compound

⚠ Mineral oil or vegetable oil

⚠ Liquid dishwashing detergent

TOOLS NEEDED

⚠ Safety equipment

⚠ Mat knife

⚠ Ruler used for a cutting edge

⚠ Masking tape

⚠ UV light source (or the sun)

⚠ Accurate timer

⚠ Soft brush

⚠ Large plastic bag

⚠ Glass for mixing ink

⚠ Plastic scraper

⚠ Magnetic sheets

⚠ Rubber squeegee

⚠ Soft tarlatan cloth

⚠ Chalkboard eraser

⚠ Rags

⚠ Etching press

To prepare the digital file:

You need to make a decision as to whether you want to flip your image in the print driver or in the source file. I generally like working with images right side up, and flip them horizontal only when I print; the danger is that you may forget and end up printing un-flipped!

1. Decide whether to flip your image in the print driver or in the source file. If you're going to flip your image while working on it, go ahead and do it now.

2. Crop the image to a square that is ¼" larger in each dimension than your Solarplate—for a 12" x 12" plate, the image should be 12¼" x 12¼"—and change it to 720 dpi, using the Best for Enlargement setting (**Figure 10.6**).

3. Adjust the RGB image to grayscale using the black and white settings. By doing this instead of an initial grayscale conversion, you'll be able to change the value of the colors to get sharper detail and better contrast (**Figure 10.7**).

FIGURE 10.6 If your image is a higher dpi than 720 at the required size, you may need to do Best for Reduction instead.

*HINT: I used a Nikon D300 converted to an infrared camera by LifePixel to take the image I'm using in this process (**Figure 10.5**). Infrared photographs like this make wonderfully rich source material for making Solarplate etchings.*

FIGURE 10.5 The original image that we'll modify to create our digital negative.

FIGURE 10.7 Use Photoshop adjustments to get the level of detail and contrast you desire.

FIGURE 10.8 Remember, we're creating a digital positive, so dark areas in the image will ink dark in the final etching.

4. Once you've adjusted the image to your desired result, convert it to grayscale (**Figure 10.8**).

5. Apply a linear adjustment curve, setting the Output to 25. This opens up the darkest areas so that the bitmap screen we'll apply in the next step will show the bitmap diffusion dither pattern that holds the inks to retain the darkest parts of the image. You may need to adjust the setting up and down to get the best results (**Figure 10.9**).

6. Convert the image to bitmap using Diffusion Dither at 720 dpi (**Figure 10.10**). **Figure 10.11** shows the bitmap diffusion dither pattern.

7. Convert the image back to grayscale using a Size Ratio of 1 (**Figure 10.12**). If you decided to wait to flip the image until in the source file, do so now in the Print dialog box.

FIGURE 10.9 By saving a version of the image now, you can lower the dpi later if you decide you want a coarser screening effect.

FIGURE 10.10 Use 720 dpi for your first attempt, and then experiment with other settings later.

FIGURE 10.11 A close-up view of the diffusion dither dot pattern that will block the light and correct open bite.

FIGURE 10.12 The final image we'll use to expose the Solarplate.

To print the digital file to the plate:

The steps in this section may look similar to those in Chapter 7, but there are some important differences; please pay close attention. For this example, I'm using an Epson 3880 printer and prefer the Matte Black inks. I work in a 60- to 70-degree room with very low humidity most of the time. If your studio is hotter or more humid, you may need to move the density control up or down a bit. Keep in mind that you can't wash the ink off a Solarplate if the print is wrong, so I like to do a nozzle check or clean the print heads (check your printer manual for instructions) before each print, and also test my image on a smaller plate before I print on a big one.

We'll need to create a template out of mat board that allows us to print full bleed on the plate and that also supports the plate as it goes through the printer, protecting the print head from hitting the steel edge if the platen gap setting is incorrect. The template also serves to keep pressure off the solar plate. First, we'll do a test run of the image placement so we know where to cut out the template hole, and then we can move on to making the template.

1. Cut a sheet of 4-ply white mat board the full width of the printer and several inches longer (I use 16" x 23" for my 12"x 12" panel).

2. Pull out the front-loading tray from the printer (**Figure 10.13**). This will raise the pizza wheels.

3. On the printer itself, set the platen gap to its widest setting. For the Epson 3880, this lets you print on media 1.5 mm thick.

> CAUTION: *Some print drivers automatically reset the platen gap back to the standard setting after each print. Since you can't control this, make sure you check that setting every time before you print. You may damage your printer if you forget to do this when printing on thick media! Make sure you read your manual and follow all instructions. Solarplates are within spec for the 3880, but still require you to set the proper printer settings.*

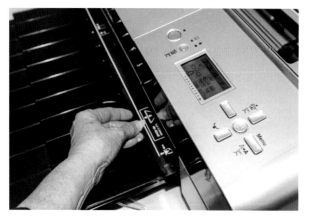

FIGURE 10.13 Pull out the front-loading tray so you can load media.

4. Place a support at the front and back of the printer the same height as the media loading slot, and then feed the mat board into the front slot, passing it past the white line on the front load tray. Grab the back edge of the board and align the front edge to the white line on the extended tray. Press the load button and the printer will measure the mat board.

 HINT: If the back gripper rollers are preventing you from pushing the template through the front, press the load button to release them.

5. Make a copy of your image, and then either delete the center of it, or set it to be very faded (to save ink).

6. In the Photoshop Print Settings dialog box, first choose Printer Manages Colors. *Note that it is only in this process that I allow the printer to manage colors; I manage it myself in all other processes in my books*! In Color Matching, select Printer Manages Colors. Center the image on the page, and uncheck the Center Image option. Change the Position Top to 3" (**Figure 10.14**).

FIGURE 10.14 This is the only time I ever let a printer manage colors.

FIGURE 10.15 Make sure you set the color controls in both places.

7. In Print Settings, under Color Matching, select EPSON Color Controls (**Figure 10.15**).

8. Select the Print Settings button. In the new window, create and select a custom paper size the same as your mat board (not your substrate), with margins of zero. Set the Page Setup to Manual – Front and your Media Type to Ultra Premium Presentation Paper Matte. The Print Mode should be Advanced B&W Photo with Color Toning Neutral. Check Flip Horizontal if you didn't flip the original image in Step 1 (**Figure 10.16**).

9. In Advanced Media Control, set Density to +38 and Drying Time to +50 (**Figure 10.17**). In Printer Settings, set your Output Resolution to SuperPhoto 1440 dpi printing.

> *TIP: Save these settings as a preset to use for all direct imaging to Solarplates.*

10. Print the entire image to the mat board. You can then delete the copy of your image so you don't accidentally print it rather than the real image to the plate instead! Eject the mat board and allow it to dry.

FIGURE 10.16 These screenshots are settings from Photoshop CS6 on OSX Lion, so yours may look a bit different.

FIGURE 10.17 Before printing, double-check that you have all the settings correct.

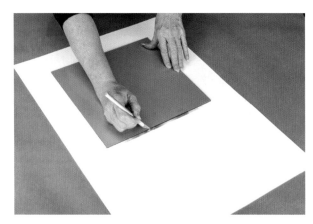

FIGURE 10.18 Instead of measuring with a ruler, you could use a 12" x 12" square of acrylic plastic and cut around it.

11. Use a ruler and mat knife to cut out a square in the center of the printed image just large enough to drop the plate into (**Figure 10.18**).

The Solarplate is very sensitive to light, so you *must* do these next steps in a room with either a safe light or a very dim light. When the plate is exposed, you should have a piece of black paper (light passes through white paper) covering it (**Figure 10.19**). Also, the Solarplate has a surface that you can easily mar, so be very careful handling it.

12. ☽ Remove the Solarplate from the black plastic wrapper and place the plate face down in the opening you cut in the mat board. Tape around the edges to hold the plate in place (**Figure 10.20**). Tape a second layer to give added support. Turn the board over and brush off any lint or dust with canned air or a Rocket Blaster—don't use your hand!

FIGURE 10.19 Even with the black paper, you still need to work in safe or dim light.

FIGURE 10.20 Press the tape firmly so that it doesn't catch in the printer.

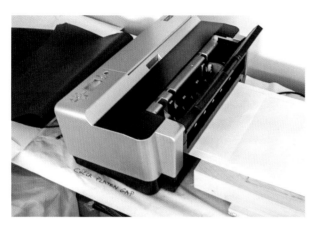

FIGURE 10.21 You must fool the printer into measuring the entire width of the template.

FIGURE 10.22 Keep the plate surface covered when it's out of the printer—and make sure you print in dim light!

13. ☽ Set the platen gap on the printer to its widest setting. To ensure that the printer measures the width properly, you *must* place a piece of black paper over the plate surface, and then a piece of white paper on top. Feed the combined metal and template into the printer the same way you did in Step 4 (**Figure 10.21**).

14. ☽ Press the load button and the print head will measure the paper. When that's done, you can remove the white sheet of paper completely. However, just pull the black sheet out to the edge of the back of the printer, using it to protect the unexposed plate from light (**Figure 10.22**). We'll also protect the unexposed plate as it emerges in the next step.

15. ☽ Print your image the same as you did for the earlier test. Watch as it begins to exit and use a second piece of black paper to shield the emerging plate from the light. Continue to adjust the black paper on both the front and back of the printer to cover the plate surface while it's printing.

HINT: If the plate needs to dry, or if the sun isn't right for exposure, you can place the plate in a light-tight wooden box (with its inside painted black) until you are ready to expose it (Figure 10.23).

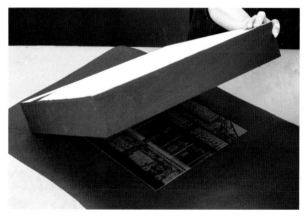

FIGURE 10.23 Make sure no light leaks into the box.

To expose and finish the plate:

Now we're ready to expose the plate either using sunlight or a UV light.

1. ◗ Keep the plate covered while taking it to your light source.

2. ◗ Remove the black cover sheet and, using your timer, expose it to the source for two minutes (**Figure 10.24**). Cover the plate and take it back inside into dim light.

3. ◗ Back in your light safe room, place the plate into a tray of 70-degree tap water and let it rest there until the unexposed polymer and ink dissolves—that usually takes about one minute.

4. ◗ Use a very soft brush and gently wash the surface—do not press the brush into the polymer; it's still soft (**Figure 10.25**)!

5. ◗ Rinse the plate under running water. You should be able to see the finely etched image at this point.

6. ◗ Gently blot the image completely dry using clean newsprint paper. Make sure you don't rub the surface; just switch to a new piece of paper when the old one gets wet (**Figure 10.26**).

FIGURE 10.24 The longer the exposure, the lighter the final printed image will be.

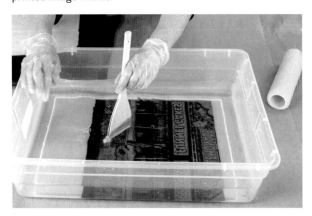

FIGURE 10.25 Be careful—the surface is still soft, so don't damage it.

FIGURE 10.26 Blot the image dry without rubbing.

7. Place the plate back in the light source for 15 minutes to fully expose the emulsion to UV light. This hardens the entire surface and readies the plate for printing (**Figure 10.27**). Once you complete this step, the plate is no longer sensitive to UV light, but I still keep mine in a dark drawer when not actively printing.

To print the edition:

You'll need access to a good etching press to print with the polymer plate we've just created. Most communities have printmakers who share press facilities, so look for groups or schools that work in traditional printmaking.

I use traditional etching inks from Graphic Chemical & Ink with their Easy Wipe compound (an ink modifier for easier distribution and wiping of inks). For cleanup, use mineral or vegetable oil followed by soap and water. You can also use the newer water-based inks from Akua, which work very will on dry Copperplate paper. In this example, we'll print on damp Rives BFK printmaking paper, which is made from 100% cotton, has a nice smooth surface, has deckle edges, and uses only soft sizing. Deckle tear the paper to size (see Chapter 2) if you'd like to retain the rough edge.

1. Dip one sheet of paper in water and place it in a large plastic bag, and then place a dry sheet on top of the wet one. Based on the number of prints you intend to make for your whole edition, continue interleaving wet and dry sheets of paper to allow the moisture to evenly dampen the sheets (**Figure 10.28**).

2. On a sheet of glass, squeeze out a bead of ink and then add about 30 percent of that amount of Easy Wipe. Use a plastic scraper to mix the two ingredients together thoroughly (**Figure 10.29**).

FIGURE 10.27 It's important to harden the plate completely before printing with it.

FIGURE 10.28 You want the paper to be just thoroughly wet; do not over-soak it.

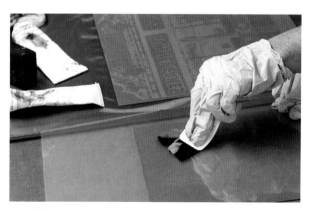

FIGURE 10.29 Mix enough ink for several prints if you're doing an edition.

FIGURE 10.30 Getting just the right amount of ink takes a bit of practice.

FIGURE 10.31 Use gentle pressure—this is about removing excess ink, not polishing the plate.

FIGURE 10.32 Make sure you clean the edges or you'll have a line around the image.

3. The completed polymer plate has a steel back, so use a magnetic sheet to hold it on to your tabletop or work surface while inking it.

4. Spread the ink mixture across the plate in even strokes using your rubber squeegee (**Figure 10.30**).

5. Make a ball of soft tarlatan cloth and use it to do the first wiping of the ink from the plate (**Figure 10.31**).

6. For the second wiping, switch to clean newsprint wrapped around a chalkboard eraser. Wipe until you have a good tonal range (**Figure 10.32**). Wipe the excess ink from the edges of the plate with another piece of clean newsprint.

7. Remove a sheet of the wet paper, place it between sheets of newsprint, and gently blot the excess water from the surface. Repeat with dry newsprint until there's no water shine on the surface.

8. I use another magnetic sheet with ruler marks on the bed of the etching press to hold the plate to the bed of the press. Place the inked plate face up on the magnetic sheet on the bed of the press. Then place the damp paper centered over the plate and gently lower it.

9. Pull the print through the etching press (**Figure 10.33**), and then carefully lift the print off the plate. Place the print on a flat surface to dry. Repeat Steps 2 through 9 as necessary for the remainder of your edition.

10. Clean the plate with mineral or vegetable oil, and then wash it off with soap and water. Once it's completely dry, apply a light coat of the oil to the surface to protect the polymer from drying out, and store it in a plastic bag in a dark place until needed for additional prints.

> HINT: An alternative to Solarplates is the ImageOnHD polymer plate. You must mount this plate on a PETG plastic sheet or metal panel before using it. The process steps are basically the same, except you'll use sodium carbonate dissolved in water to wash and develop the plate after exposure. Don Messec has explored this process in detail at www.makingartsafely.com (*Figure 10.34*).

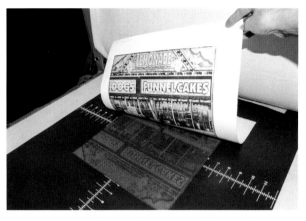

FIGURE 10.33 A ruler-marked magnetic sheet on the press bed also helps center the paper on the plate.

FIGURE 10.34 Don Messec's work is another great example of using Solarplates.

Conclusion

The range of photographic detail in this Solarplate printing process is remarkable—very similar to that found in traditional etchings. My personal taste is towards a coarser, more graphic look, so you'll need to experiment to see what you like best. This medium opens the door to including abstracts, hand-drawn images, or other compositions within the digital file, and to integrating monotypes with digital photopolymer gravure processes.

This is one of the most enjoyable processes I've created for this book—it's nice to be back in the print studio again, and there's something about the physical process of printing on an etching press that I'd been missing. If you've never created work this way, it's a rewarding and enlightening (no pun intended) experience that will push the boundaries of what the digital photographer can create (**Figure 10.35**).

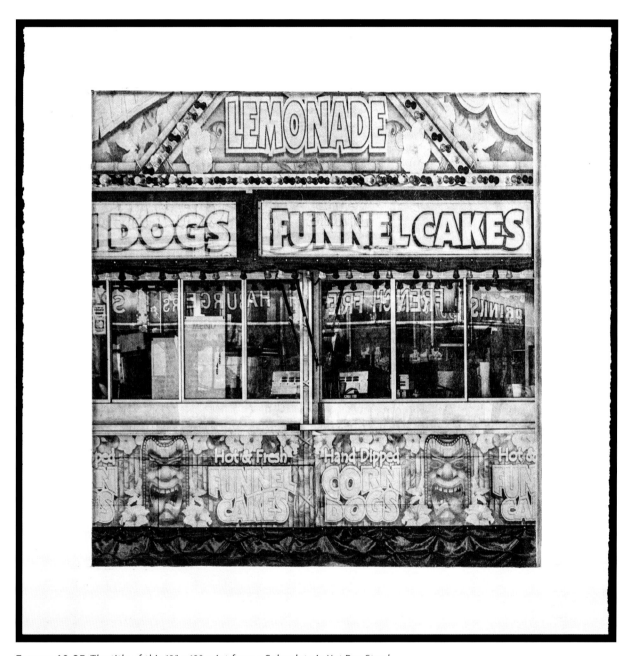

FIGURE 10.35 The title of this 12" x 12" print from a Solarplate is *Hot Dog Stand*.

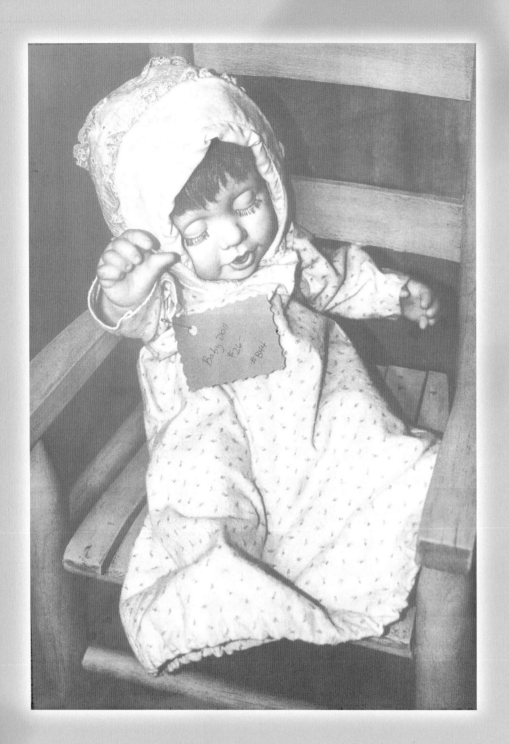

CHLOROPHYLL EMULSION PROCESS

While researching historical photographic methods, I came upon William Herschel's processes that used a light-sensitive emulsion created from plants. He created his anthotype images when he coated paper with the juice extracted from leaves, and then exposed them to sunlight to bleach out the emulsion. Because these images continue to bleach out when exposed to light (since there is no way to *fix* the emulsion as there is with traditional photography), there are very few vintage examples left in existence.

I love the fine texture and natural feel of these images, but the simple compositions were of a leaf or other object silhouetted on the surface. I wanted more complex images, so I struck upon the idea of using a digital positive image printed on transparent film to expose the emulsion. Then, to overcome the limited lifespan (those images continue to be photosensitive), I used modern technology to scan the hand-made print back into the computer to use as a digital plate when creating an edition.

The methods I found for extracting the juice in a usable form gave poor results. I ended up discovering a new method to extract the chlorophyll from plants using grain alcohol. But let me assure you that the ephemeral quality of the image is the result of the process, and not of too many martinis!

About the Chlorophyll Emulsion Process

The basic process in this chapter is to collect fresh leaves, process them into an emulsion, coat the paper with that emulsion, place a positive transparency over the paper, and then expose it to the sun to create your *master plate*. Then you'll scan the image back into the computer to create a digital plate and print the edition (**Figure 11.1**).

You can also do this process using everything from berries to grass clippings, and flowers to leaves. The trick is to figure out the exposure time for the particular material you're using. Even leaves from different trees, or from the same tree picked at different times of the year, can have different exposure times. One thing that doesn't appear to work is chlorophyll supplements purchased from the health food store—there's something about the processing that's done that removes the photosensitivity of the material.

FIGURE 11.1 Detail of an original chlorophyll print that I then scan and use as a digital plate to create my edition.

For this example, I'm using Epson inkjet coated Smooth Fine Art Paper, which is an ideal choice because it's water resistant when dry. The inkjet coating on the paper keeps the emulsion close to the surface and lets you achieve a deeper color. This precoat allows you to coat the original exposed image with a UV-protectant postcoat (see Section 5 for more details) so you can then exhibit it for short periods under UV-protective glass, but you'll want to keep it out of direct sunlight as it will definitely fade over time.

For this process, I print on a premium transfer film (**Figure 11.2**) that has a thicker coating. This extra coating holds more ink and provides a wider range of contrast than regular transfer films. Just make sure you use a profile that uses Matte Black ink rather than Photo Black.

For a current and updated list of products and resources (since products may change from time to time), you can check the book's website: www.thelastlayerbook.com.

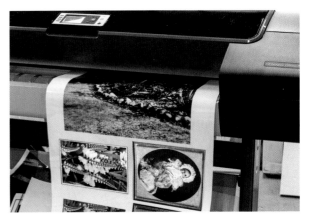

FIGURE 11.2 For these images, we'll use a digital positive rather than a negative.

MATERIALS NEEDED

⚐ 190-proof grain alcohol (Everclear is one brand) (**Figure 11.3**)

⚐ 91 percent isopropyl alcohol (also called rubbing alcohol)

⚐ Fresh, dark green leaves

⚐ Aluminum foil

⚐ Art paper

⚐ Image printed on clear inkjet coated film

⚐ Glass sandwich or light box

TOOLS NEEDED

⚐ Safety equipment

⚐ Protective gloves

⚐ Food dehydrator

⚐ Food processor or blender

⚐ Scale that measures in grams

⚐ Quart canning jars

⚐ Blender

⚐ Coffee press (also known as a French press)

⚐ Dark storage for coated papers

FIGURE 11.3 Grain alcohol works best for this process.

HINT: *You'll want to use an art paper that has a very smooth surface so that there will be good contact with the film. I like to use the Epson inkjet Smooth Fine Art Paper, but you can also use Lana Aquarelle 140lb Hot Press, Arches Bright White, Arches Platine, Arches 88, TH Saunders, Rives BFK, or even bridal polyester satin and get good results. You can't, however, use stone paper, as it won't absorb the emulsion.*

ALCOHOL NOTES

Grain alcohol that is 151 proof or vodka do not work for this process, but you can get a decent emulsion using 91 percent isopropyl alcohol. The color won't be as bright, but you can compensate by using double the amount of plant material. Using 70 percent or 99 percent isopropyl alcohol does not work properly.

You can also use denatured alcohol for this process, but the fumes are terrible. I'd suggest you do that only if you can't find 190-proof grain alcohol locally or online. If you do use denatured, just make sure you do it in a very well ventilated area (outside is best) and wear an appropriate respirator—that's not something I use in my home studio!

See Chapter 2 for more information on the different types of alcohol, always wear appropriate safety equipment, and use in a well ventilated area away from ignition sources.

As always, keep these emulsions out of the reach of children and pets. These alcohols can be dangerous if ingested, so follow all instructions and warnings on the labels. This is not a process for children.

FIGURE 11.4 Strip the stems and veins off the leaves (as well as any branches or twigs); otherwise the emulsion may not be as rich a color as you'd like.

To prepare the chlorophyll emulsion:

1. I suggest using fresh, dark leaves the first time you try this process—I'm using linden tree leaves in this example (**Figure 11.4**). Pick a good pile of leaves. You can freeze fresh leaves until you're ready to dry them. In the winter, you can also use spinach, kale, or chard from the grocery store. Organic produce seems to work the best.

2. Dry your leaves in a food dehydrator, using as little heat as possible, until they're crisp (**Figure 11.5**).

FIGURE 11.5 You can use a mesh bag with a fan blowing on the leaves, or lay them out on screens, in the dark, to dry them as well, but I find that the dehydrator works best.

FIGURE 11.6 Use an old food processor to chop up the leaves.

3. Chop your dried leaves in a food processor (**Figure 11.6**) until they look like dry parsley flakes. Store the chopped leaves in a lightproof airtight container until you need them.

4. Using your scale, measure and place 70 grams of dried chopped leaves in a quart-sized canning jar along with 600 grams of 190-proof grain alcohol, which should just fill the jar. Carefully pour this into a blender, and process it until you have a leaf smoothie (**Figure 11.7**).

> *HINT: You can also use frozen blueberries instead of leaves—just defrost them, and then put them in the food processor and add the alcohol (no need to dehydrate them). A pint of berries in a quart jar filled with grain alcohol and allowed to steep for several days makes a coating that is deep wine red on polyester paper and purple on the Epson paper. I've also tried using marigold flowers, which produce a yellow image but with very low contrast. These other emulsions can take two to three days or longer to develop when using a light box with black lights, so be patient with the exposure.*

FIGURE 11.7 Make sure you wear eye protection and keep the lid on tightly while blending!

FIGURE 11.8 A canning jar seals tight so the alcohol will not evaporate.

FIGURE 11.9 A French coffee press is perfect for filtering the chlorophyll emulsion.

5. Pour the smoothie mixture back into the quart canning jar and seal tightly (**Figure 11.8**). Wrap the jar in two layers of aluminum foil and store in a dark, lightproof place (an old ice chest works great—like the one from Chapter 5 when you're not cooking plates). It will take about two days to extract the chlorophyll.

6. Pour the mixture into a French press (**Figure 11.9**) to filter out all of the plant matter, and then pour the liquid in another foil-covered canning jar and cap tightly. I've kept the solution for a couple of months without a problem. If you prefer, you can wait to strain it until you're ready to use it.

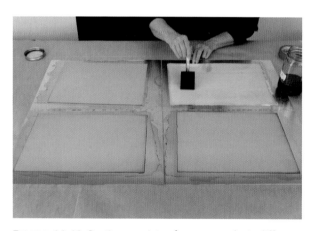

FIGURE 11.10 Coating a variety of papers results in different shades of green.

To coat the paper:

1. ☽ Lay your paper on a smooth, non-absorbent surface. I use a metal sheet that's larger than the sheet of paper.

2. ☽ With a sponge brush, paint a single coat of the chlorophyll mixture on the paper. Work quickly so it doesn't dry (multiple coats may cause image imperfections), and make sure that the sheet is evenly coated (**Figure 11.10**). Apply enough of the mixture to evenly soak the paper.

> *HINT: Wear gloves when coating the paper or you'll have very green fingernails for days!!*

3. 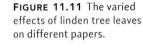 Carry the metal sheet and place it in a dark cabinet overnight to dry. This needs to have some ventilation so that the wet paper dries (you can't use a plastic box or bag), and make sure that nothing touches the paper surface.

4. Store the dry sheets in a drawer out of the light. They will store for several weeks, but over time the sensitivity does change; make sure you adjust the exposure accordingly—that's something you'll figure out as you do more of these.

*TIP: I recommend coating a number of kinds of paper so you learn how the emulsion looks on different ones (**Figure 11.11** and **Figure 11.12**).*

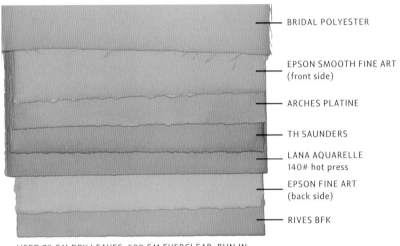

BRIDAL POLYESTER

EPSON SMOOTH FINE ART
(front side)

ARCHES PLATINE

TH SAUNDERS

LANA AQUARELLE
140# hot press

EPSON FINE ART
(back side)

RIVES BFK

USED 70 GM DRY LEAVES, 600 GM EVERCLEAR, RUN IN BLENDER, ONE COAT BRUSHED ON ONE SIDE

FIGURE 11.11 The varied effects of linden tree leaves on different papers.

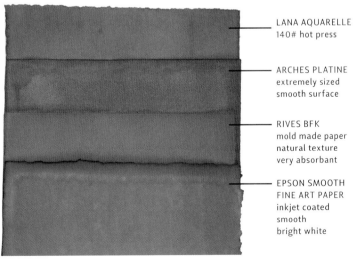

LANA AQUARELLE
140# hot press

ARCHES PLATINE
extremely sized
smooth surface

RIVES BFK
mold made paper
natural texture
very absorbant

EPSON SMOOTH
FINE ART PAPER
inkjet coated
smooth
bright white

BLUEBERRIES BLENDED WITH EVERCLEAR GRAIN ALCOHOL (190 PROOF)

FIGURE 11.12 Blueberries give a very different result on different papers.

To prepare the digital file:

The steps in this process are similar to those for the Solarplate process in Chapter 10, but with some important differences, so make sure you read carefully. Both processes use a film positive made from a digital image (**Figure 11.13**).

1. As with the solar plates, you need to make a decision whether you want to flip your image in the print driver or in the source file. I generally like working with images right side up, and flip them horizontal only when I print, but the danger is that you may forget and end up printing un-flipped! You must flip the image horizontal when ready to print, however, so that the ink side of the film is placed in contact with the paper for exposure.

2. Crop the image to the desired size and resample the file to 360 dpi (**Figure 11.14**). You can either bleed the image off the edge of the paper (by making the image ¼ to ½ inch larger than the paper), or reduce the size to leave a blank border.

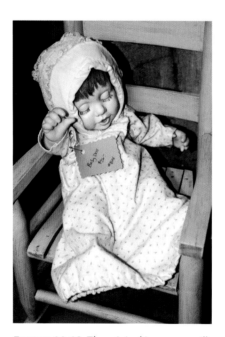

FIGURE 11.13 The original image we will modify to create our digital negative.

FIGURE 11.14 Resample the file to be 360 dpi at the size you want the final piece to be.

3. Adjust the RGB image to grayscale using the Black & White settings. By doing this instead of an initial grayscale conversion, you'll be able to change the value of the colors to get sharper detail and better contrast (**Figure 11.15**).

4. Once you've adjusted the image to your desired result, convert it to grayscale (**Figure 11.16**).

FIGURE 11.15 Use Photoshop adjustments to get the level of detail and contrast you desire.

FIGURE 11.16 With a digital positive, dark areas retain the color of the paper's emulsion and highlights bleach out when exposed to light.

5. If you have a high contrast image, you may need to apply a linear adjustment curve to preserve the highlights as the dark areas develop. This will open up the darkest areas to develop faster and bring down the highlights to develop slower. You can adjust the setting either up or down to get the best results (**Figure 11.17**). Unfortunately, there are no rules that work for every image, so you'll have to experiment. There will be times, such as with a low-contrast image, that the adjustment curve may be unnecessary.

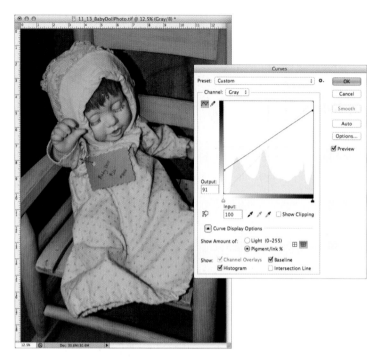

FIGURE 11.17 By saving a version of the image now, you can lower the dpi later if you decide you want a coarser screening effect.

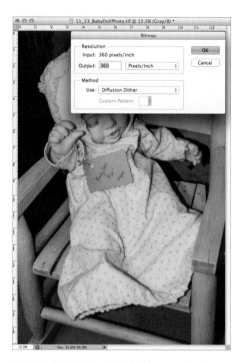

FIGURE 11.18 Use 360 dpi for your first attempt, and then experiment with other settings later.

6. Now convert the image to bitmap by setting Diffusion Dither at 360 dpi (**Figure 11.18**). This lower dpi works best for this process (**Figure 11.19**).

7. Convert the image back to grayscale using a Size Ratio of 1 (**Figure 11.20**). If you want to flip the image yourself (not in the Print dialog box), this is a good time to do it.

8. Print your image on your clear film using a profile that uses Matte Black ink. Allow it to dry for 24 hours before using.

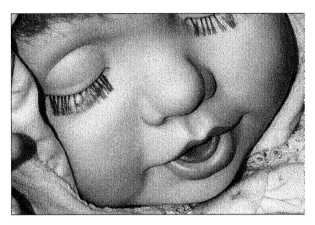

FIGURE 11.19 The enlarged detail showing the dot structure of the final digital file.

FIGURE 11.20 The final image we'll use to expose the chlorophyll paper (right).

To expose the paper:

1. Place the film shiny side down on your work surface (the side with the ink should be up). Next, lay the paper on top of the film so that the coated side is touching the film.

2. Tape the back side of the paper to the film along one edge using clear tape (**Figure 11.21**). This allows you to pull back the film and check the exposure underneath.

3. ◗ Place the paper and film in a glass sandwich as described in Chapter 9 and carry it to your light source.

FIGURE 11.21 Taping the film to the paper allows you to check the exposure without misaligning the image and the positive.

FIGURE 11.22 Watch out for fingerprints on the glass of your light table.

FIGURE 11.23 Be careful that you do not move the film where it lies on the paper or you'll get a blurry image.

FIGURE 11.24 You can also do the reverse of this by painting black on only a small section where you want it to bleach out less.

4. ☽ If you've built a light box with a glass top, place the paper with the film attached face down on the glass top. Place a black foam pad on the paper, and then use a sheet of glass to hold it in contact with the light table glass (**Figure 11.22**). If you're using the sun as a light source, tilt the glass so that it directly faces the sun. You may have to adjust the position as the sun changes its angle. Expose the sandwich to the light source—the one in this example took 90 minutes in the sun, and a similar exposure took four hours on a light table.

5. The time to expose the print will vary; a few minutes too long at the end will ruin the print, especially in the strong Colorado sunlight. Carefully lift the film to check the exposure underneath (**Figure 11.23**).

6. If you have a perfect exposure but some shadow details are still a bit dark, you can do a hands-on dodge. Take a piece of clear film, and paint the whole thing black with black acrylic paint except where you want additional exposure (**Figure 11.24**). This will protect the highlights and midtones from becoming overexposed. Place this in front of the image and continue to expose the image until it's just as you like it.

> **HINT:** In regular photography, dodge and burn are reversed because the paper gets darker the more you expose it. In this process, it becomes lighter with greater exposure. Don't let that confuse you and do the opposite of what you want!

7. ☽ Once the exposure is complete, take the sandwich inside and place the print in a dark environment until you're ready to scan or photograph it.

To finish the work:

At this point your two choices are to scan or to photograph the print. The original work you've created does *not* have a long lifespan unless kept in a dark vault. It will continue to change as you expose it to the light. After I scan or photograph the original, I can then print editions of the image—it still preserves the organic quality that you can't create digitally. If you're going to use a scanner, select all the settings before placing the image in the bed; the scanner light is very strong and can cause the print to change if you have to scan it multiple times! Once the image is in digital form, I store the original print in a dark plastic bag in a closed print cabinet or an archival print box.

If you want to exhibit or sell the original, check out Section 5 for some suggestions on how to postcoat and protect it. Fully disclose that it's a light-sensitive image, and how to care for and store the print. I don't sell my originals but instead follow the process I've shown here of making plates that I'll use to scan and print my final archival prints. If you want to keep the printmaking tradition of destroying the plate after making the edition, you can leave it out in the sun (or shred it into the recycle bin).

Conclusion

The process of creating these prints is just cool (**Figure 11.25**). Using something that nature provides, in a creative process like this, is an adventure. As I experimented with this process, I started off on a hunt for trees with bigger (and more) leaves that I could use—just don't defoliate your backyard for the sake of art! The results are beautiful when they work, and still fascinating when they don't.

So why go to all this trouble, when in the end, you still have a digital image that you just print? I do it simply because I've yet to find a way directly in the computer to create the subtle richness of the natural exposure. And it'd be nowhere near as much fun as blending up leaves, berries, and flowers. Besides, if enough of us start doing this, the challenges of grass clippings in landfills may be solved!

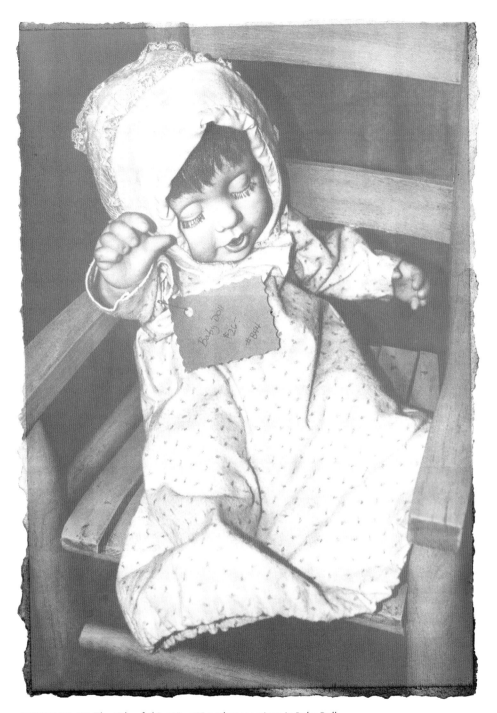

FIGURE 11.25 The title of this 13" x 19" anthotype piece is *Baby Doll*.

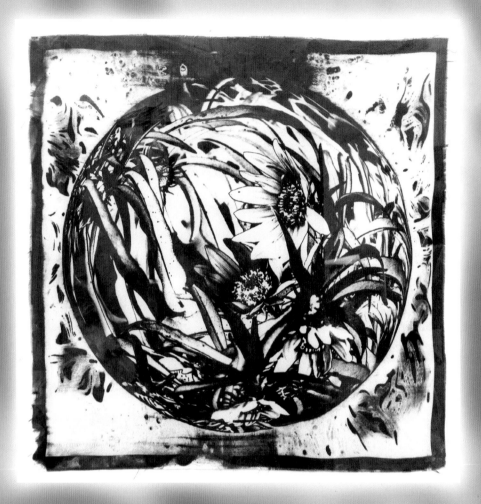

12

FLOW BLUE FABRIC PROCESS

must have inherited my love of collecting antiques and bits of interesting junk from my grandmother—at least that's how I explain my overstuffed studio. I remember visiting her when I was young, and looking at the rich colors of the depression-era glass and flow blue plates. I fell in love with those blurry blue florals and landscapes fused to snow white porcelain.

The original flowing images were the result of an attempt to hide flaws in the mass production technique. These dishes were mass-produced using a transfer paper that caused the seams of the tissue to show in the image. By making the blue dye flow across the surface, the defects were hidden. To top it off, the plates my grandmother collected were rejects from the process because the blue had actually flowed too much—an accident that resulted in a highly desired collectable. In the process I'll show you here, we'll be using a light-sensitive emulsion to replicate that same look but with a twist—we'll do it on fabric.

For a current and updated list of products and resources (since products may change from time to time), you can check the book's website: www.thelastlayerbook.com.

About the Inkodye Process

Inkodye is a light-sensitive emulsion that binds to natural materials like cotton or silk. When painted on fabric, it can be exposed to sunlight or another UV light source to make a print, much like the chlorophyll emulsion in Chapter 11. Inkodye was used in the 1950s for alternative photographic processes using traditional negative film transparencies. Back then, the idea of digital negatives and computerized studios were the realm of science fiction!

FIGURE 12.1 Inkodye is available in blue, red, and orange—and you can even mix the colors together.

FIGURE 12.2 A large flow blue platter that inspired me to create this process.

When I came across the current Inkodye product (**Figure 12.1**), I wondered if it had the potential to mimic the flow blue china (**Figure 12.2**) from my Grandmother's house, or even classic cyanotypes, without the use of industrial chemicals. Sure enough, I figured out how to make it work. While Inkodye also comes in red and orange, it's the blue that lured my creativity, so that's what I'll show in this example. As I write, I'm working on a new body of work using this process for a future show—it has become one of my favorite processes.

Part of the process involves scrubbing the substrate surface pretty hard to remove the unexposed emulsion. While something like stone paper would work, plant-based papers would simply dissolve. But I think the best surface for this is a natural fiber fabric with a smooth, tight weave, which is what we'll use for this example. I've tried pima cotton, bamboo cloth (which is highly sustainable), heavy satin silk, and smooth muslin. My experiments with synthetic fabrics have been unsuccessful.

For this process, I print on a premium film that has a thicker coating. This extra coating holds more ink and provides a wider range of contrast than regular films. To keep the number of different films in my studio under control, I use DASS Premium Transfer

MATERIALS NEEDED

- Prewashed and ironed natural fiber fabric
- Distilled water
- Synthrapol detergent
- Washing soda laundry booster
- Premium film
- Isopropyl alcohol
- Inkodye (blue works best)
- Paper towels
- Cleaning paste
- Clean newsprint

TOOLS NEEDED

- Safety equipment
- Iron
- Small paint roller
- Black acrylic plastic sheet larger than your fabric
- Blue painter's tape
- Light-safe room
- Soft rubber brayer
- Lint-free rags
- Light-proof bottle
- Sheet of low-iron glass
- Large clips or clamps
- Sunshine or other light source
- Washing machine

HINT: If you can find old 100% muslin sheets at estate sales, they'll work great —the years of washing have created an ideal surface for this process.

HINT: I've had luck using Inkodye on stone paper, but only with the blue color—the red and orange wash off too easily. If you want to give this a try, make sure you use a Mayer rod to get a uniform coating across the stone paper, and let it dry completely before exposing it. After exposure, leave the stone paper in a tray of soapy water and washing soda for several hours to help the unexposed emulsion melt away.

Film (even though we're not transferring anything), but you can also use other premium films (that don't transfer) like Pictorico Transparency Film. Just be sure to use a profile that uses Matte Black ink rather than Photo Black.

Make sure you read and follow the instructions and safety warnings on the Inkodye bottle.

To prepare for the exposure:

1. To prepare the fabric, wash it with ¼ cup of Synthrapol and ¼ cup of washing soda (**Figure 12.3**) in a warm water, full washer load, and then iron it until flat and wrinkle free.

FIGURE 12.3 Washing soda helps remove the factory sizing from the material—particularly in hard water.

2. Print your digital negative (not a positive!). Size this negative as you desire to either leave a border on your fabric, or full bleed off the edge. Use the multiply layers method that I talk about in Chapter 9 to ensure that you make a dense negative. Do not convert the image to a bitmap because the error diffusion pattern would create exposure in the dark area of the negatives and cause tints in the white—continuous tone negatives work the best. Allow the negative to dry completely.

> **TIP:** *For the Epson 3880 printer, I set the Color Density to 38% and the drying time per pass to 50 (**Figure 12.4**). This seems to give me a rich layer of ink. I suggest doing a test exposure on a small piece of fabric to see if your settings produce a dense enough image. If you get tints in the white areas, it's too thin. That can be an issue with printer settings, or it means your film doesn't have a thick enough coating. You can try having your image printed on a laser copy machine—laser pigments are denser than inkjet pigments, and since we're not transferring the image, it works just fine. You can also stack two negatives together.*

FIGURE 12.4 My settings for the Advanced Setting drop-down menu for my Epson 3880.

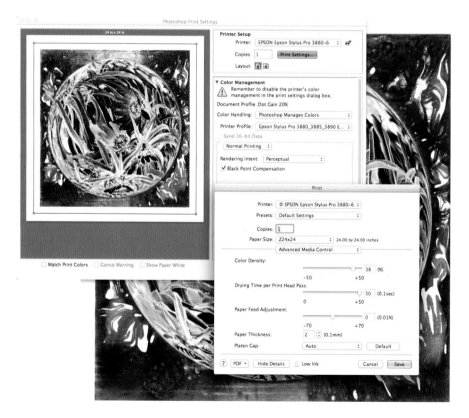

3. Take a ¼"-thick piece of black acrylic plastic sheet (such as the Plexiglas brand available from most plastic supply stores) that's larger than your fabric and sand it until the shine is gone. We need this to lay behind the fabric to prevent light from reflecting up onto the back of the fabric and exposing the image, which would cause lost detail in the final exposure (**Figure 12.5**). After sanding, use a lint-free cloth and isopropyl alcohol to clean all the dust and body oils off the sheet.

4. Cut your fabric so that it's one inch smaller in each direction than the sheet (for example, for a 20" x 30" sheet of plastic, cut the fabric to 19" x 29").

5. ☽ These next several steps need to be done in a light-safe room. Check the top to make sure it's on tight, and then shake the container of Inkodye to mix the emulsion.

> *TIP: The Inkodye is concentrated so you can use it straight from the container or thinned up to 50 percent with distilled water. It's a concentrate, so I like to thin it using two parts dye to one part distilled water; it's then easier to spread and saves money on supplies. Store your thinned mixture in a light-proof bottle. As always, wear safety glasses and gloves when working with this product.*

6. ☽ Place the fabric on the black acrylic sheet, and pour on some of the emulsion (work in batches). Spread it across one half of the fabric with a plastic scraper, rubber brayer, or credit card (**Figure 12.6**).

FIGURE 12.5 Use a sheet of black plastic as a backing for the coated fabric.

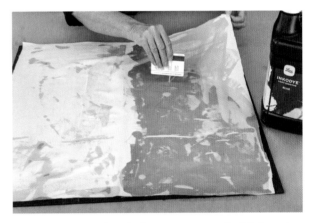

FIGURE 12.6 Use the Inkodye to wet mount the fabric to the plastic.

FIGURE 12.7 This is a good way to avoid wasting the Inkodye and avoid puddles.

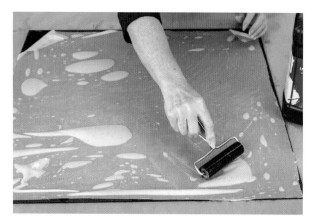

FIGURE 12.8 Use a brayer to spread the emulsion.

7. ☽ To help spread the emulsion, fold the dry side of the fabric on top of the wet half, and use the roller or scraper to press the sides together (**Figure 12.7**). This soaks up any excess emulsion—just be careful not to press too hard at the fold or you'll get a permanent crease!

8. ☽ Unfold the cloth and add enough emulsion to spread on the whole surface. Use the roller to smooth out any air pockets, and then use the scraper to lightly smooth and remove any excess emulsion. Be careful not to stretch or wrinkle the fabric (**Figure 12.8**).

9. ☽ Use a dry, lint-free cloth to do a final rub and soak up any excess emulsion. You can also blot off any excess solution with clean newsprint. The fabric should feel damp, but not soaking wet, and should cling to the acrylic sheet.

> *HINT: ☽ If you have a laminator or etching press, you can place several layers of news-print over the damp fabric and then run the stack through the press to calendar the fabric and remove excess dye. Or you can use a roll-ing pin for the same effect: This step spreads the liquid through the fibers and smooths the fabric which helps create a sharp image. Just be careful to not get crease marks in the fabric.*

10. ☽ Place the sheet in a light-proof container that has some ventilation and allow it to dry a bit. If the Inkodye is too wet, the image will bleed.

To make the exposure:

1. Prepare a light-proof container filled with cool water, one tablespoon of washing soda, and a teaspoon of Synthrapol. You'll use this in a while to transport the exposed fabric to the washing machine.

2. ❭ Lay your negative over the fabric, keeping the non-printed side toward the fabric to prevent the ink from bleeding onto it. This is why we don't flip the image before printing (since it's ink-side up). Place a clean sheet of ¼" tempered low-iron glass over the negative and clamp it to the acrylic, forming a glass and plastic sandwich. If you're using a light table (like I am in this example), tape one edge of the film to the plastic (**Figure 12.9**).

3. Carry your sandwich to your light source. If you're using the sun, tilt it until it's perpendicular and allow it to expose—in Colorado in the summer, 10 to 15 minutes is enough time for the blue dye. If you're using a light table, place your sandwich face down on the table and lay a heavy sheet of glass on top of the stack to get good contact with the tabletop and expose it to the light (**Figure 12.10**). I exposed the blue dye for 17 minutes on my light table.

> *HINT: You can make a second, small image as a test sample image at the same time as your large one. Use this to open and check the exposure, which prevents your large one from being disturbed. While you're checking the small sample, block the large image from light with a light-proof cloth or paper (or turn off your light table)—a minute or two of over-exposure can ruin the piece.*

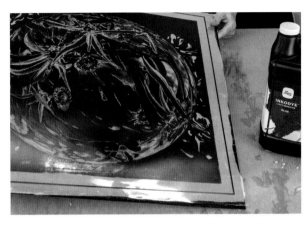

FIGURE 12.9 Taping the film to the plastic helps make a nice sandwich for the light table exposure.

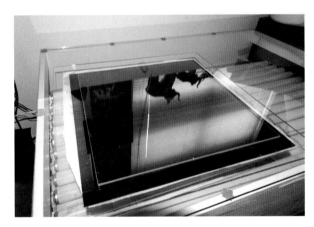

FIGURE 12.10 Your exposure time may vary depending on your table—and even how old your bulbs are.

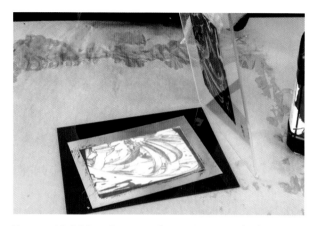

FIGURE 12.11 I prefer to use the test image to check progress so I don't risk moving the fabric on my real image.

HINT: Exposure time can vary by color—I find that the blue takes about 30 percent longer than the red.

4. When using the blue dye, it turns gray magenta as it exposes. Look at the edges of the fabric that are not under the film—they usually turn a bright cobalt blue, which is a good indicator that you're done (**Figure 12.11**).

5. Quickly remove the fabric and place it in your light-proof container from Step 1, and then transport the fabric to your washing machine.

6. Fill the washing machine with warm water for cotton or cold water for silk, and then dump the container with the liquid mixture and fabric into it. Run the material through two wash cycles to remove the excess emulsion (use the same detergent in both). Remove the fabric (**Figure 12.12**) and let it dry. I also run another empty cycle in my washing machine to remove any remaining dye.

7. Iron the dry material from the back side to set the dye and smooth the fabric (**Figure 12.13**). It's now ready to mount to use as a collage element in a larger work.

FIGURE 12.12 Remove the fabric from the washer and hang it evenly to air dry.

FIGURE 12.13 On your iron, use the correct heat setting for your fabric and press it flat.

HINT: *If you use a positive by mistake to make an Inkodye print, it's not a loss. Just scan the exposed fabric and then invert it in Photoshop to get the positive image. I made this error with the photograph in* **Figure 12.14**. *After inverting the image, adjusting the contrast, and de-saturating it, I ended up with a very cool look—it reminds me of a gum bichromate photographic print. In this case, the mistake became a plate for creating another work.*

FIGURE 12.14 The fabric negative became a plate to make an edition of inkjet prints.

Conclusion

This is a simple process that can make unique photographic images on fabric (**Figure 12.15**). There's no end to the potential uses—from wall hangings to folding room dividers, and handmade books to scrolls. You can even put a child's face on a silk kite so they can soar in the air! The print is permanent and the fabric remains soft.

You can also get interesting effects by painting on the emulsion with a brush, rather than applying a smooth even coat as we did here. After putting safety glasses and gloves on my grandsons, I let them paint fabric with *invisible paint* and then did the exposures. The partial images that came through were very creative, and a fun way to introduce them to a photographic process.

FIGURE 12.15 This 24" x 24" flow blue fabric piece is titled *Daisy*.

GALLERY OF WORK: TRANSFORMED BY LIGHT

The Garden

8" x 10". Solarplate Etching. I used a 300 dpi bitmap screening to give a coarser look to the image. After printing this on Rives BFK printmaking paper using burnt umber ink, the final print reminds me of a collagraph print made from a cardboard and paper plate.

Toy House

13" x 19". Chlorophyll Emulsion. I created this original chlorophyll print on Arches Platine paper using a four-hour exposure on a light table. I like the character of a light-sensitive emulsion exposure for this image—the grain matches and enhances the appearance of the house, which had been outside and weathered for years.

Poached Kebab

30" x 40". Solarplate Etching by Dan Welden. Dan did this two-color work in Guanlan, China, where he had very little reference to exposure times. He worked directly on the Solarplates with etching ink: rolling, painting, and removing. Once exposed, he washed the plate to the bare metal to create an ideal relief image. Then he printed the black first, followed by a transparent yellow over the black on the lower portion and an opaque yellow on the perimeter.

Carriage

13" x 17". Chlorophyll Emulsion. I created this chlorophyll print on Lana Aquarelle using a two-hour exposure in the sunlight. I combined a photograph of a doll in a carriage with a scan of an oval vintage tintype union case to create this complex image.

Boots

13" x 19". Chlorophyll Emulsion. I found these boots on display at the historic Graue Mill in Illinois, and created this print on TH Saunder printmaking paper using a two-hour exposure in sunlight. I find that historic images are a great fit for the chlorophyll emulsion process.

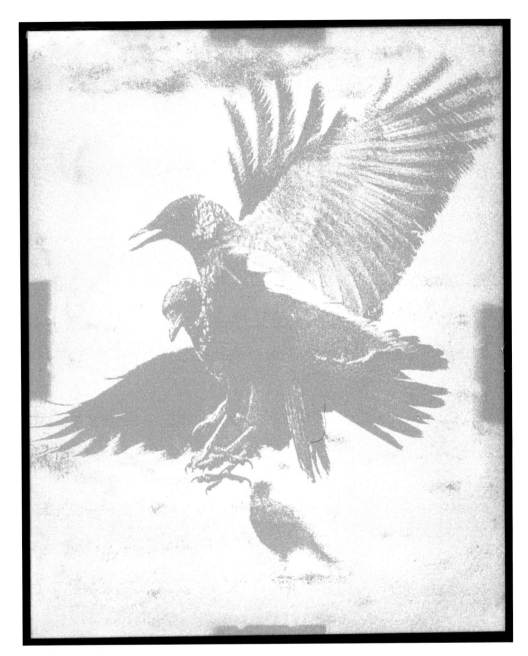

Black Bird Flight

8" x 10". Chlorophyll Emulsion. I created this chlorophyll print on Epson Smooth Fine Art Paper using linden leaf emulsion. I like how the clip marks from the sunlight exposure adds to the composition.

Turkey Dinner

11" x 14". Flow Blue Process on Baby Sateen Cotton. The fine, delicate cotton was perfect to show off the very old doll house furniture. The smooth cotton I used to create this Inkodye image makes it easy to get good contact with the negative during exposure.

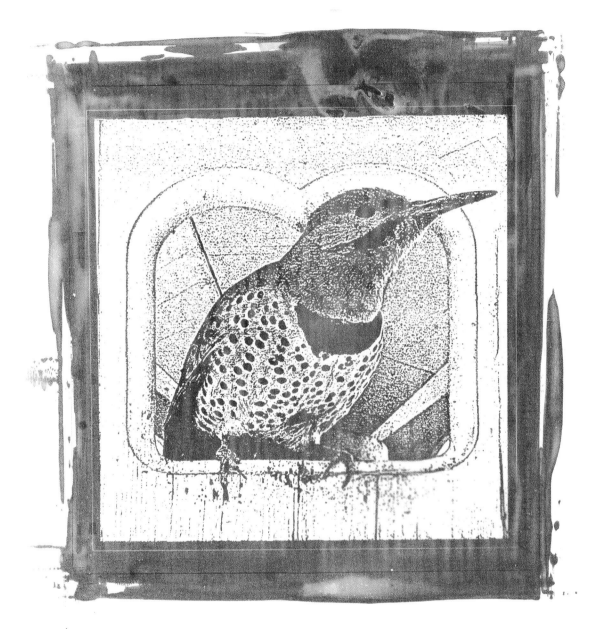

Woody

8" x 10". Flow Blue Process on Stone Paper. I have a BirdCam in the back yard that takes photographs of birds, like this woodpecker, when they come to feed. Even though it's a low-resolution camera, this process lets me use an image that would otherwise be just a snapshot. Now if I could just get that bird to stop drilling into our chimney!

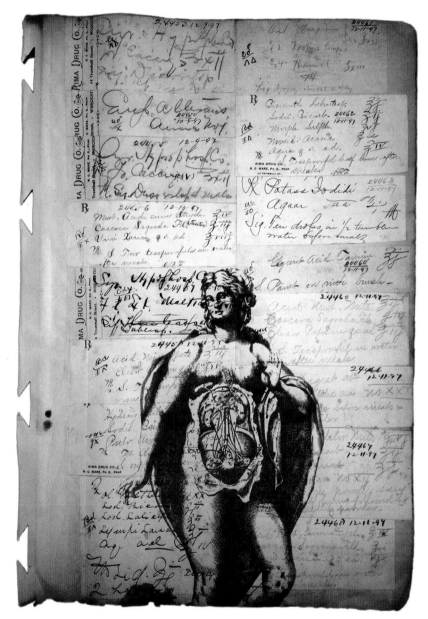

PreScribe

11.5" x 17.75". Solarplate Etching by Dot Krause. Dot printed the figure in this image on a Solar-plate using a digital positive scanned from one of the rare books at Harvard Medical School Countway Library during her Artist-in-Residency. She printed the final image with an etching press onto a page taken from a prescription ledger kept by a pharmacy in the late 1800s. Each page of the original ledger is unique, because each is covered with copies of small prescription pieces glued to the individual pages. This image is part of an edition of ten.

A Dad

8" x 10". Chlorophyll Emulsion. I created this image using maple leaves for the emulsion. These type of leaves make an image that's a bit brown in tone. The image captures a dad and his son in a playful moment on a sunny day.

CREATIVE SUBSTRATES

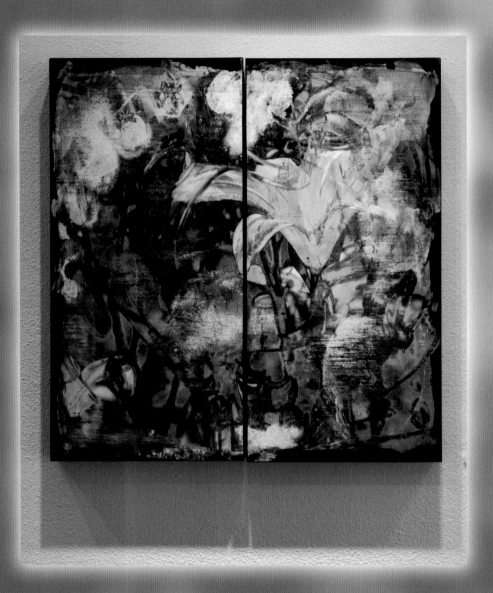

14

INTRODUCTION TO CREATIVE SUBSTRATES

So far, we've talked about placing images on a variety of substrates, but now we're going to step it up a notch. In this section, I've included techniques for working with images in new and creative ways. We'll learn how to place images on flexible substrates, and even how to place them directly onto glass. This latter idea became the pearloid process, as I call it, and is one of my inventions that I'm particularly proud of. I've dug into my own history as a painter and layerist to leverage those basic techniques to create unique, complex works of art.

In this chapter, I'm going to share some basic information about the variety of techniques we'll use in this section. Keep these techniques in mind when you read the individual processes, and see what serendipitous thoughts arise, and what creative ideas you can invent for adding these techniques to your studio.

For a current and updated list of products and resources (since products may change from time to time), you can check the book's website: www.thelastlayerbook.com.

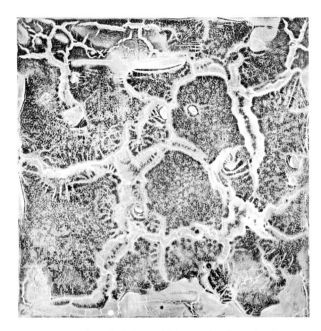

FIGURE 14.1 Detail of the multi-layered surface that I created to transfer a single image onto the surface.

FIGURE 14.2
Chart showing the sequence for creating mixed media layers.

Layering

For many of these processes, we're going to be layering in the real world, so you'll have materials that come from fabric and grocery stores, art supply companies, and even the local thrift shop. In some of the processes, your selection tool is a pair of scissors and your eraser is a tub of paint (**Figure 14.1**)!

Think of layering an image like building a cake. Each layer of a cake is held together with frosting (the best part of a cake!). When layering transfers, SuperSauce Concentrate acts like frosting to seal and separate the previous layer, and also to provide a foundation for the next SuperSauce Solution transfer. In **Figure 14.2**, the gray layer is the substrate, the red layers are SuperSauce Concentrate (frosting), the blue layers are SuperSauce Solution which hold the patterned layer (the image), and then in the end there's a yellow topcoat.

With layering, it's important to plan ahead a bit so that you can figure out what parts of your image will show through. This is where we have an advantage over a traditional painter we can layer our images printed on transparent film, and move and arrange them without making permanent decisions about where they will go. Though if you choose to replace some of the blue and patterned layers with an acrylic painting, you'll still have to think and plan ahead.

When combining media with digital prints, the classic rules of mixing media still apply. Strive for *fat over lean*—that is, keep your oil-based layers on top of water-based media. Since SuperSauce is a water-based product, you can't use oil-primed canvas for a transfer (it may look like it works, but over time, the

image will flake off or crack). You can use oil paint over a SuperSauce transfer, but once you do, you can't do more layers of transfers over the oils. If you want to interleave transfers and paintings, you'll need to use acrylic paint or other water-based media.

Dealing with Emulsion

When we transfer images to a substrate, the emulsion from the transfer film is left on the surface. If we don't deal with this layer, we can end up with a crackled or crazed surface when we put the next layer on top. For waterproof substrates like stone paper, we'll actually be washing the emulsion off the surface once the transfer is dry (**Figure 14.3**). For more delicate surfaces, we'll need to add a sealant layer of Super-Sauce Solution over the emulsion before we add the frosting layer of SuperSauce Concentrate.

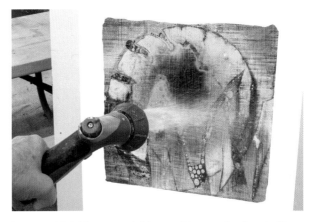

FIGURE 14.3 The excess inkjet emulsion can be rinsed off with water.

Flexible Substrates

As you might guess, any material that can receive a transfer and can be folded or conforms to a surface falls in this category of flexible substrates. Some examples are aluminum foil, lightweight spun bonded polyester, nylon bridal tulle, very fine silk, baby sateen cotton, silk, or cotton organza (**Figure 14.4**). Transfers to these materials can be standalone art, or used as collage elements in other works. When applying them to other surfaces, you'll need to add a pressure-sensitive adhesive like Rhoplex N580 painted to one of the surfaces. After it dries, you apply the flexible substrate and press it firmly into the surface.

FIGURE 14.4 You can use a wide variety of flexible substrates as complete works or for integration into collages.

Mica Pigments

In some of these processes, we'll be working with powdered mica pigments. These are so fine that they're almost lighter than air, and even a sneeze will send a cloud of them flying. They must not be inhaled and are very irritating to the eyes, so always wear appropriate filter masks, gloves, and eye protection—I also wear a plastic raincoat to keep powder off my clothes. To mitigate some of these problems, I store the powders in Nalgene bottles with a small amount of distilled water to keep the powder damp. After I'm done filling the bottles (outside), I hose them off. If you do spill the powder, wipe it up right away with a wet paper towel with some acrylic medium on it. The medium will bind the mica to the paper towel.

FIGURE 14.5 I keep test cards around to decide what color I like best for a particular pearloid.

I use both cosmetic and art supply grades of mica. The cosmetic grades are usually smoother and come in many more shades of color. Your local art supply store should have art grade pigments, and you can check out www.theconservatorie.com for cosmetic grade pigments.

I make 6" x 6" test cards of my mica colors so that I can hold them under a transparency to see what the final pearloid will look like. Just pour some of the mica in a cup, add some polymer gloss medium, and paint the cards (**Figure 14.5**). Once dry, I store them in a plastic bag to keep them clean.

Conclusion

If it sounds like this section is a bit of a grab bag of tools and techniques without necessarily being a complete process, you're right. These concepts can stand on their own or be combined in ways that you (and I) have never imagined (**Figure 14.6**). This is the time to try all your crazy ideas and materials. Chances are you'll stumble across some amazing ways to work as a result of taking your digital tools back into the hands-on studio. Once your images are printed on your film, leave the computer behind for a while—besides, SuperSauce makes your mouse really sticky!

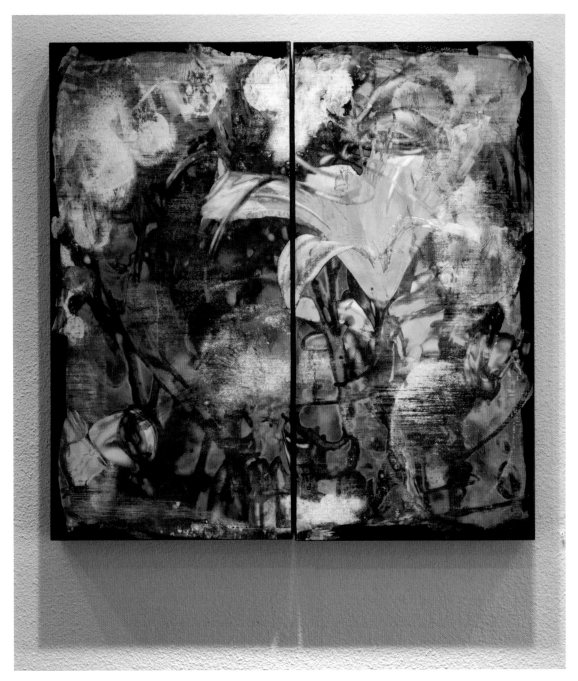

FIGURE 14.6 This 36" x 36" piece titled *Together in Time* is on a birch box that has multiple layers of transferred images and acrylic paint.

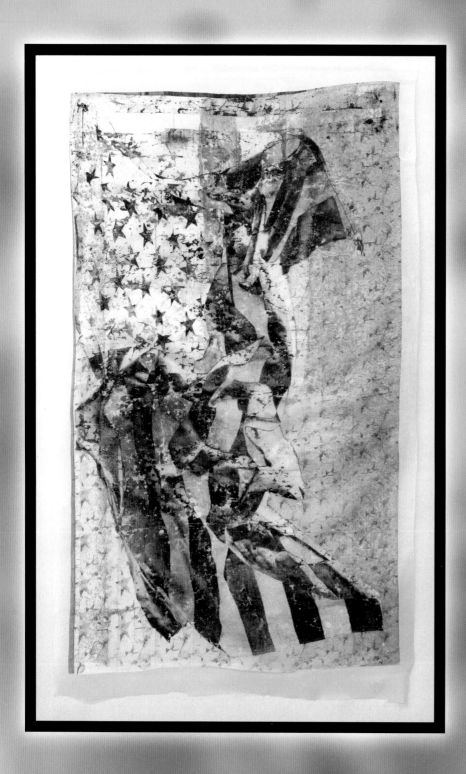

15

TRANSFERS TO FLEXIBLE SUBSTRATES

O f all the questions I'm asked, the most common is how to transfer an image to a strangely shaped surface. One of those questions came in while I was writing this book, just at the time I was thinking about how to make more interesting layered collages; I took it as an opportunity to do some experiments. The results were so exciting that I decided to include them here. You can use these substrates as is, as part of a collage, or even molded and glued to other objects to create photographic sculptures. I can see making lampshades, room dividers, window coverings, and wall hangings. Think about a transfer to thin silk hanging and blowing gently in the breeze, like a scene frozen in fog—the only limit is your imagination.

We'll make two transfers in this chapter: one to aluminum foil and the other to silk habotai. The same general process works for other substrates as well, so I'd encourage you to experiment.

For a current and updated list of products and resources (since products may change from time to time), you can check the book's website: www.thelastlayerbook.com.

FIGURE 15.1 Aluminum foil is available in many colors.

About Transfer to Foil

This process is easier to do when using extra heavy-duty aluminum foil. This weight is usually found in 24-inch wide rolls. A nice foil is Reynolds 711 that's used in beauty shops to do hair coloring. I particularly like the beauty foil because it has small perforations in it. These make it easy to mount to other surfaces, since air passes through them helping to press the foil to the substrate. Regular kitchen foil has gotten a lot thinner over the years, so it works best for very small pieces. You can also use colored foil from floral supply stores, or the foil used to wrap food (like burritos from my favorite Mexican restaurant—I recycle the wraps in my art). Pretty much any foil will work (**Figure 15.1**).

MATERIALS NEEDED

- ⚠ Extra heavy-duty aluminum foil
- ⚠ SuperSauce Gloss Concentrate
- ⚠ SuperSauce Gloss Solution
- ⚠ Printed transfer film
- ⚠ Rhoplex N580
- ⚠ Paper towels

TOOLS NEEDED

- ⚠ Safety equipment
- ⚠ Polypropylene or polyethylene work surface
- ⚠ Rubber brayer
- ⚠ Sponge paint roller
- ⚠ Sponge brush
- ⚠ Cardboard tube
- ⚠ Paint roller with fluffy cover
- ⚠ Five-minute timer
- ⚠ Paint brushes

To transfer to aluminum foil:

1. Lay your polyethylene or polypropylene work surface on a table and place a sheet of foil on the plastic (**Figure 15.2**). You can use either side, but I'm using the dull one in this example. Use a rubber brayer to press the foil flat against the surface.

2. Apply a thin, fine stippled coat of the SuperSauce Gloss Concentrate using a sponge roller and allow to dry thoroughly. This should look like a mist of paint (**Figure 15.3**).

3. Apply SuperSauce Gloss Solution over the dry concentrate with a sponge brush, being careful not to rub too hard over the dry surface. Make sure it's spread evenly in all directions (**Figure 15.4**).

4. We're going to use a modified process to roll down our image. Roll the image around the cardboard tube with the ink side out, and then place it at the edge of the aluminum foil.

FIGURE 15.2 Try not to wrinkle the foil. That comes later.

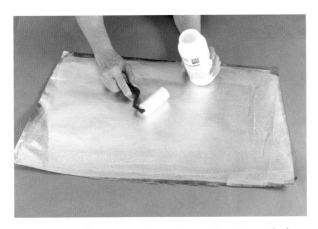
FIGURE 15.3 If you see ripples in the coating, it's too thick.

FIGURE 15.4 Brush the solution for several minutes so that it doesn't puddle.

FIGURE 15.5 The film may need to be peeled off using two hands so it doesn't tear the foil.

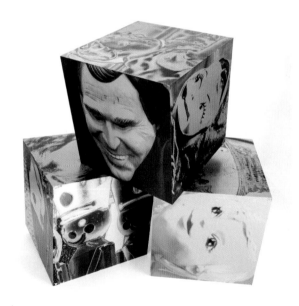

FIGURE 15.6 You can even mount foil to cubes like these.

5. Roll the film down onto the surface, being careful to avoid getting air bubbles under the film. Smooth the film into full contact with the foil using your clean, dry, fluffy paint roller.

6. After four to five minutes (which is longer than usual for a transfer), lift one corner of the film and carefully remove it from the foil (**Figure 15.5**). Let the foil dry overnight.

7. Now you have a few options. You can place the foil under running water and gently wash off the excess inkjet emulsion (don't rub the image—just let the water do the work). This gives you a final image that looks like it's part of the metal. Or you can quickly apply a light coat of SuperSauce Gloss Solution to the image. Make sure you use a light touch with the sponge brush and do not scrub into the image. Repeat this coating once a day for four to five days. The multiple layers of solution make a sturdy, foiled image with a nice luster finish.

8. The foils can be mounted to birch boards, boxes, or Econolite, or shaped to any form by using a layer of Rhoplex N580 as a glue (**Figure 15.6**). See Chapter 14 for more information.

About Transfer to Silk

I've used silk in my art for years, but it's been only recently that I started transferring to silk; I find that I like the results a lot. Now in the digital world, direct imaging, iron-on transfers, and SuperSauce transfers are regular features in my studio—there's a different quality to the final image (**Figure 15.7**).

FIGURE 15.7 Silk habotai (5 mm thick) is perfect for making light-weight hangings.

MATERIALS NEEDED

- Silk habotai, 5 mm
- SuperSauce Matte or Gloss Solution
- Printed transfer film
- 91 percent isopropyl alcohol
- Quart wide mouth canning jar
- Paper towels
- Baby shampoo

TOOLS NEEDED

- Safety equipment
- Polypropylene or polyethylene work surface
- Double-sided tape
- Strips of wood or metal lattice
- Clothespins
- Steam iron
- Blue painter's tape
- Cardboard tube
- Sponge brush
- Paint roller with fluffy cover
- Five-minute timer
- Heavy clips
- Two easels or a place to hang the fabric

To transfer to silk:

For this process, I recommend that you use an image at least an inch smaller around than your silk so that you have room to remove the silk from the film and let the edges release. You can try doing this full-bleed, but you may have some challenges peeling the silk off the film without damaging the image.

HINT: Since light passes through the fabric, I like to saturate the image. I do so in Photoshop before printing the image using Image > Adjustment > Hue/ Saturation and then increasing Saturation by 15%. Either Matte Black or Photo Black inks will work for this process.

1. Lay your polyethylene or polypropylene work surface on a table and spread the silk on it (**Figure 15.8**).

 *HINT: If you have a large image, attach a one-inch strip of wood lattice or metal to opposite sides of your fabric using double-sided tape (**Figure 15.9**). This allows you to lift it without it folding over on itself and damaging the image. Make sure the strips are long enough to hang the final image in a doorway to dry. Clip clothespins to the bottom of the fabric so it hangs straight and does not blow and stick to itself.*

2. Thin the premixed SuperSauce Matte or Gloss Solution by adding two parts of the regular solution to one part 91 percent isopropyl alcohol. This makes it easier to spread on the thin fabric.

3. Wet a paper towel with tap water and use it to wipe the inkjet emulsion off your film right up to the edge of the image. This will give a better release from the edges of the fabric. Allow the film to dry.

FIGURE 15.8 Lightweight silk will not lay flat on the table, so tape down the edges with blue painter's tape or place a weight on the edges.

FIGURE 15.9 Attach a strip of lattice or metal to one edge of the fabric with double-sided tape.

4. Cut the silk to size and then steam-iron it to remove any wrinkles. Avoid tearing the fabric to size because torn edges will not adhere flat to the work surface when applying the SuperSauce Solution. Any wrinkles or creases will remain in the final image (if you want those, then skip the iron!).

5. Place the fabric on the work surface and tape it down in steps, working alternate sides until it's tight and smooth. Or you can lay boards around the sides to hold it down.

6. Again, we're going to use a modified process to roll down our image. Roll the image around the cardboard tube with the ink-side out, and then set it aside.

7. Use a sponge brush to spread the diluted Super-Sauce Matte Solution on the fabric. It should be completely wet and visually look like it's adhering to the work surface (**Figure 15.10**). Make sure there are no bubbles under the fabric, and no puddles of the solution on the surface.

8. As soon as the fabric is evenly wet, position the film on the tube at the edge, and firmly roll it down onto the fabric pushing out any air pockets under the fabric. Use a clean, dry, fluffy paint roller to smooth the film into firm contact with the fabric, and continue pushing out any air bubbles that might be trapped (**Figure 15.11**).

9. Wait three minutes and then lift one corner of the film. Pull it off very slowly, and if you see any bubbles form, you can push the film back down quickly and pop them. This usually cannot be done in other types of transfers. If you're getting a lot of bubbles, try again with more solution or a thinner solution.

FIGURE 15.10 Make sure the silk is damp but not soaked—no puddles.

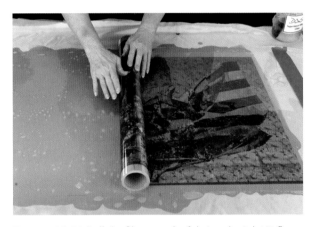

FIGURE 15.11 Roll the film onto the fabric—don't let it flop down at the end.

FIGURE 15.12 Immediately lift the wet fabric off of your plastic work surface. If it starts to dry, it will become gummy and could stick to the table.

HINT: You can hand embellish the final work with gold and silver paint or other craft materials, or even sew it into a vest or light jacket.

10. Once you remove the film, immediately lift up the fabric (**Figure 15.12**) and hang it from a clothesline (this is another reason to leave a border and cut to size later). Make sure you don't let it fold over on itself (you may need help with larger pieces). It helps to put heavy clips on the bottom edge of the fabric so it hangs straight. Let the silk dry overnight.

11. Hand wash the fabric in lukewarm water with a capful of baby shampoo (which keeps any loose pigment from staining the fabric). So that you don't damage the ink or SuperSauce, without squeezing gently swish the fabric around to remove the inkjet. If you used Matte Black, you may find that some of the ink rinses out a bit.

12. Rinse the fabric and hang it dripping wet to dry—do not squeeze out the water or dry it in a dryer! Afterwards, place the fabric face down, place an old sheet over the silk, and iron it from the back side (not the front side—the iron will stick!) to adhere the image completely to the fabric. Use a silk setting on the iron. The final fabric will be a little crispy like taffeta—you can occasionally wash it by hand, like any other fine fabric, but don't throw it in a washing machine with your old blue jeans.

Clean up your work surface with a little alcohol on a paper towel when you're done.

Conclusion

Now comes the hard part of knowing what to do with these cool pieces? There's no end to the ideas—vests, jackets, flags, or even a simple scarf.

And that simple scarf is where I got the original idea for this transfer (**Figure 15.13**). While stuck on a cruise dodging a hurricane (before the waves grew to 35 feet) I was exploring the ship and saw some beautiful Hermès scarves stretched on linen and mounted under glass. My very next thought was, "I bet I could do that with a transfer to a silk scarf."

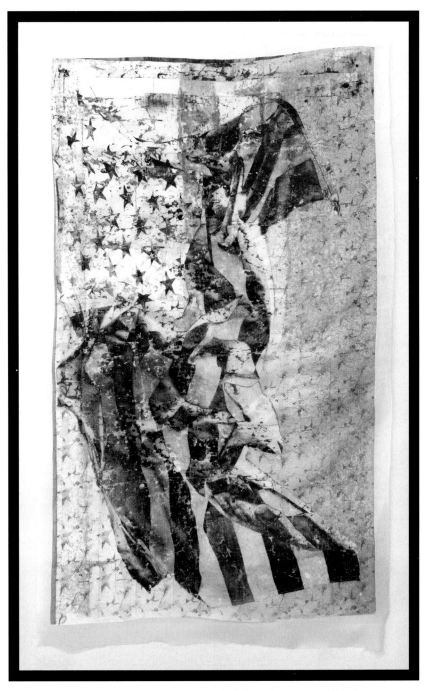

FIGURE 15.13 This 30" x 50" silk hanging titled *Altered Nation* is perfect for an image of a flag.

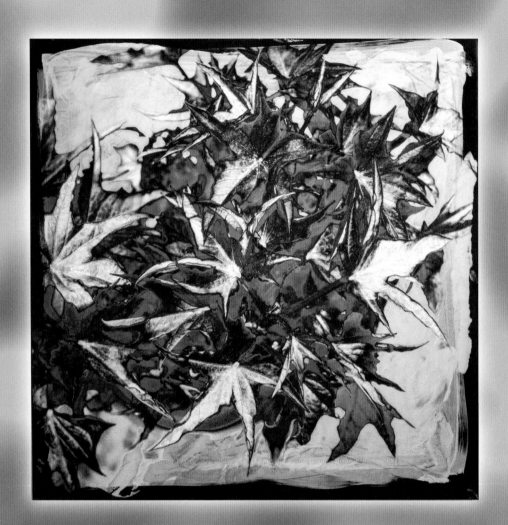

16

MIXED MEDIA LAYERED TRANSFERS

Fine art and photography have a long history of working together. Artists have been combining traditional art with photographs via silkscreens or cutting up newspapers and magazines for use as collage materials since photography was invented. I remember Robert Rauschenberg's technique from the 1960s in which he used lighter fluid to float the ink off of newspaper and magazine paper. Now there's a much easier way to transfer images using SuperSauce.

Best of all, by using transfer film it's now possible to layer multiple layers of photographs and acrylic paint together, giving an unlimited potential to develop a complex composition, as you can see in *Sweet Dream* to your left. Just make sure you follow the rules about layers in Chapter 14—oil-based media goes on last (and is your last layer).

For a current and updated list of products and resources (since products may change from time to time), you can check the book's website: www.thelastlayerbook.com.

About the Mixed Media Layered Transfer

HINT: If you thin gesso, make sure you use an equal amount of acrylic medium and water. Water alone will cause the surface to crack and craze over time. Polymer Medium (Gloss) has the best adhesion for these processes, and Liquitex also makes a clear gesso that's very useful when working with multiple layers.

In this first of two examples, I'll show you how to create a work with alternating layers of photographic transfers and traditional media on art canvas (**Figure 16.1**). While you can purchase pre-stretched canvas, I find that the best results come from stretching your own. Doing it yourself gives you a firmer surface as well as lets you control the quality of the surface—inexpensive pre-stretched canvases are fine for student work, but they're rarely professional grade (**Figure 16.2**). Oil-primed canvas won't work (remember the layering rules). If you do decide to buy a pre-stretched canvas, make sure you add one coat of Liquitex Gesso as a base layer.

FIGURES 16.1 Many layers of paint and transfer make up the surface of this birch box (shown in detail here).

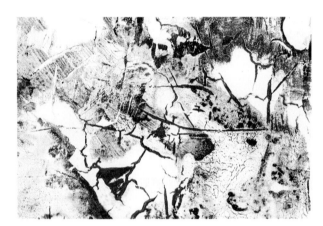

FIGURE 16.2 Stretching your own canvas lets you control exactly the surface on which you'll work.

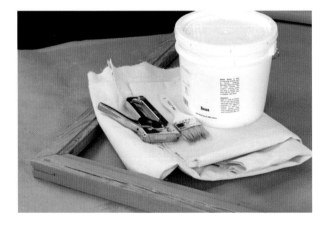

MATERIALS NEEDED

- Liquitex Gesso (both white and clear)
- Water
- GOLDEN Polymer Medium (Gloss)
- SuperSauce Gloss Concentrate
- SuperSauce Solution
- Printed transfer film
- A selection of artist paints, not oil-based
- Strong tea
- Blank transfer film
- Rhoplex N580
- Behr Venetian Plaster, premixed white

TOOLS NEEDED

- Safety equipment
- Paint brushes
- Fine sandpaper
- Sponge paint roller
- Cardboard tube
- Paint roller with fluffy cover
- Five-minute timer
- Plastering trowel
- Fan

HINT: Use SuperSauce Gloss for all the layers—you'll get better results. If you want a more matte look, you can apply one last layer of SuperSauce Matte Solution at the very end.

To do a mixed media layered transfer:

1. If you haven't already applied a fresh coat of gesso (thinned with equal parts of water and acrylic medium, if necessary), apply it now—make sure the coat is thin and smooth (**Figure 16.3**). You can use either white or clear, depending on the final look you're after. Once this is completely dry, lightly sand the surface and then apply a second coat. Once the second coat is dry, lightly sand it again, and then dust it off.

2. Use your sponge roller and apply a fine base coat of SuperSauce Gloss Concentrate to the canvas surface. Allow it to dry completely.

FIGURE 16.3 Make sure there aren't any puddles of gesso on your canvas.

FIGURE 16.4 Apply a coat of SuperSauce Solution until the surface is wet but not puddled.

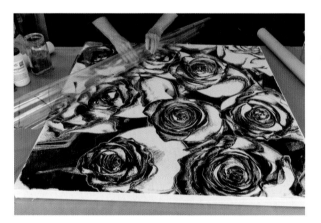

FIGURE 16.5 Remove the film slowly from porous surfaces and watch for bubbles in the emulsion; press the bubbles back down using the film, if necessary.

3. Prepare your image using an alignment board. Use your sponge brush and apply a thin coat of SuperSauce Solution to the canvas surface. Make sure you don't rub too hard into the coating of concentrate. When working with layers and a porous surface like canvas, you may need to add more solution and brush longer than in some of the other processes—just keep adding solution until the surface is wet but without puddles (**Figure 16.4**).

> *HINT: When perfect alignment in not necessary, you can skip the alignment board process and instead roll your print, ink side out, around a cardboard tube, using the tube to help you roll the film down onto your substrate.*

4. Roll the print down onto the surface and then wait three to five minutes (the time is approximate, so you'll just have to experiment a bit). Just before removing the film, use your fluffy paint roller on the film to gently press it into the canvas—it pushes the soft emulsion into the weave of the canvas. Carefully peel back one corner of the film and lift it off in one slow, gentle, and smooth motion (**Figure 16.5**). If bubbles in the emulsion appear, you can roll that bit of the film back down and press it into the canvas to remove the bubbles.

5. Allow the canvas to dry completely, and then use your sponge brush to apply a layer of SuperSauce Solution to bind the first image to the canvas. Allow this to dry overnight. This is important—you can apply traditional water-based media to this sealing layer but they may craze if you apply them directly to the transfer layer without sealing it first.

6. Now let's try adding some hand-coloring to our image. Here I'm using acrylic transparent paint and coloring in the roses (**Figure 16.6**). You can add whatever color you'd like at this stage, but make sure that the paint is left as a thin layer (I'm using acrylic paint here, but it's more like a watercolor than an oil paint—no thick, goopy brushstrokes).

> *HINT:* *You can tint white paint with strong tea to create a buff-colored paint. This lets you "erase" portions of the underlying image at any point in the layering process with a toned color.*

7. After letting the paint dry overnight, you can repeat Steps 2 through 6 (**Figure 16.7**). Keep doing these steps (allowing each layer to dry completely in between), erasing portions of the image as you need to, until you feel it's done. I usually know my image is complete when there's nothing left to erase (**Figure 16.8**).

> *HINT:* *You can also use the silk fabric or even the foil transfers as collage materials in your final work. If using silk, you can paint both sides of the fabric with a layer of polymer gloss medium after you've done the transfer and then let it dry. This makes it waterproof so that the colors don't bleed through. Use Rhoplex N580 to adhere the silk or foil to the canvas—just let it dry and then press it into place. When you have a surface that's not smooth, though, future transfers can be difficult, so this works best as the last layer on the surface.*

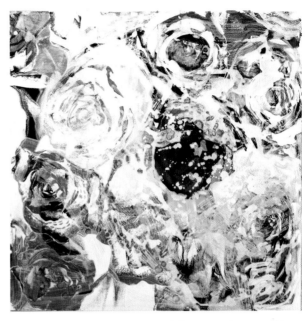

FIGURE 16.6 Paint any sections of the image that you'd like.

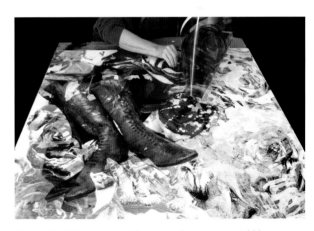

FIGURE 16.7 You can add as many layers as you'd like.

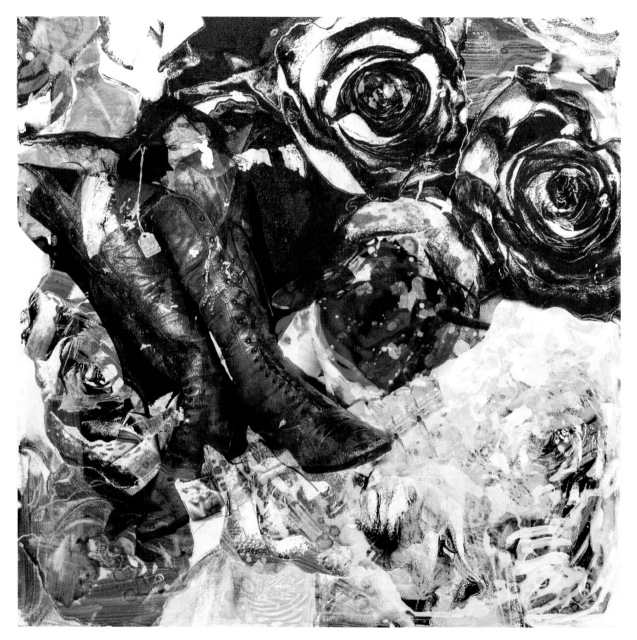

FIGURE 16.8 The final 36" x 36" mixed media layered canvas is titled *Old Boots*.

Birch Box Mixed Media

I really like making three-dimensional works of art—it gives a physicality to the piece that adds to the depth of the image. One technique that I use (and that makes hanging the work really easy because no frame is required) is layering images and painting onto a birch box (**Figure 16.9**). You can find these at many hobby and craft stores, or a local woodworker can make them for you.

For this process, we'll be creating a very textured last layer surface and then transferring a single photograph onto it. When working this way where the final surface is undetermined until you're done texturing, you should have several images preprinted on transfer film. You can select from them once you've created your surface. As with the canvas, you can do multiple alternating layers.

To make a birch box mixed media transfer:

1. Make sure that your box is sanded to a smooth surface and is dusted completely. Dilute gesso with water and acrylic medium until it's a bit watery. Apply a smooth coat to the surface (**Figure 16.10**) and allow it to dry, and then apply a second layer and let that dry.

FIGURE 16.9 I love working with birch or other smooth wood panels—the natural texture is a great surface for complex compositions.

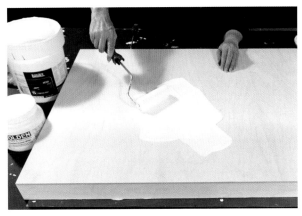

FIGURE 16.10 Watch out for puddles—you want a smooth coating without globs.

2. Prepare a blank sheet of transfer film for application to the surface (for this one, I just roll it around a cardboard tube—no need for perfect alignment).

3. Apply a coating of SuperSauce Concentrate to your surface with a sponge brush and allow it to dry completely.

4. Apply a layer of SuperSauce Solution to the surface using your sponge brush—make sure it's a complete layer, but avoid puddles.

FIGURE 16.11 This type of plaster texture is sometimes called *knock down*.

5. Roll the blank film down onto the surface, and then wait three minutes. Carefully peel off the film (watching for bubbles) as you transfer the blank emulsion to the surface. This clear emulsion layer will help the plaster (that we'll apply next) to crack, an effect we're looking for. Allow the surface to dry completely.

6. Using a plastering trowel, apply a thin layer of the white Behr Venetian plaster (which comes premixed from your local home center) to the surface. Spread it evenly, and then dip the trowel in water and smooth the surface so that it looks like stucco (**Figure 16.11**). You can either work towards a completely smooth surface, leaving it a bit rough from the applications, or even add cut marks directly into it as an artistic element. We'll sand it down to an even level in a later step.

7. Point a fan at the box and let it dry overnight. The fan helps cause the plaster surface to crack as it dries unevenly. By the next morning, the surface should have cracked and slid on the emulsion surface to create a unique texture.

8. Take your box outside, and put on appropriate safety equipment (particularly eye and breathing protection). Use a random orbital sander to sand the surface (**Figure 16.12**) so that it's even (cracks are OK, ridges are not).

FIGURE 16.12 Don't breathe the plaster dust—I do this outside to be safe.

9. Use your sponge brush and apply an even coating of SuperSauce Concentrate to the entire surface. Allow it to dry completely (I prefer overnight, as the plaster may absorb some of the moisture from the concentrate and take longer than usual to dry).

10. Now use your sponge brush to apply a coating of SuperSauce Solution, and then transfer your first print to the box (**Figure 16.13**). You can use either an alignment board or the cardboard tube shortcut for this layer, depending on how perfect you want it to be. Allow this layer to dry completely.

11. In this example, I'm not going to seal the inkjet emulsion just yet. Instead, I'm going to apply a wash of white paint mixed with a bit of tea to form a crackle pattern over the emulsion (**Figure 16.14**). Allow this layer to dry completely.

12. Repeat Steps 9 and 10 to transfer your second print to the box.

13. Again, we're going to hold off sealing this layer and use the properties of the slippery emulsion layer to make a richly patterned surface. Mix white gesso with strong tea, and apply a very transparent wash over the surface (**Figure 16.15**). Allow the box to dry. The gesso is more absorbent than the acrylic paint I used in Step 11 and will dry to a flat finish.

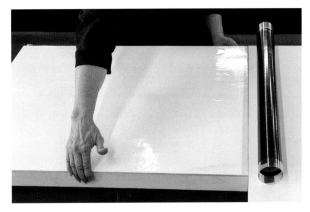

FIGURE 16.13 I keep a selection of images, and will choose which one to transfer as I see how the surface is evolving.

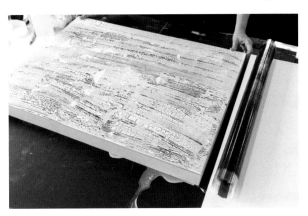

FIGURE 16.14 The white wash makes a cracked surface as it dries.

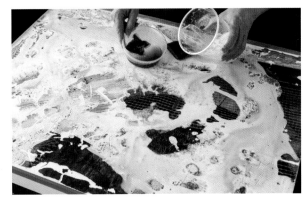

FIGURE 16.15 I finally found a use for those half-drunk cups of tea in my studio!

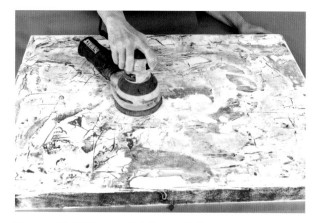

FIGURE 16.16 The multiple layers of plaster, images, and washes create this visually rich and complex texture.

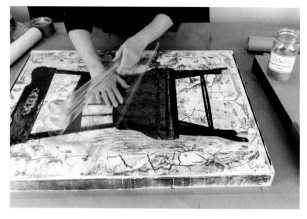

FIGURE 16.17 Layering the final image is always exciting—removing the film is like unwrapping a Christmas present; you never quite know what's inside.

14. Using the same precautions as Step 8, sand the box until you have enough of the textured surface and colors left to achieve your creative vision (**Figure 16.16**).

15. Repeat Steps 9 and 10 to transfer your last image to the surface (**Figure 16.17**) and allow it to dry completely.

16. You can rinse off the top layer of emulsion with water to create a softer final layer, or leave it in place for a crisp look. After the box is totally dry, you can finish it with any of the postcoats in Chapter 20. If you don't wash off the emulsion, you'll need to apply a final layer or two of Super-Sauce Solution (either gloss or matte works) to fully seal the surface as a final varnish.

Conclusion

This style of working is a great way to use up old scraps of film—prints that didn't quite have the right color, or ones cut in half when the roll ran out. It's very similar to layering in Photoshop, but it's in the physical world. I'm always amazed at how this hands-on work carries back to composing images on the computer—and sometimes I'll even photograph a partially completed work to help me decide what to do next.

I've built up a library of interesting digital textures to use in my layers—photographs from ice on my trees to castles and volcanic rocks are sitting in my files waiting for that aha moment as the work develops. Even if you don't use the painting techniques, the ability to layer images directly on the substrate still provides a great way to create original works (**Figure 16.18**).

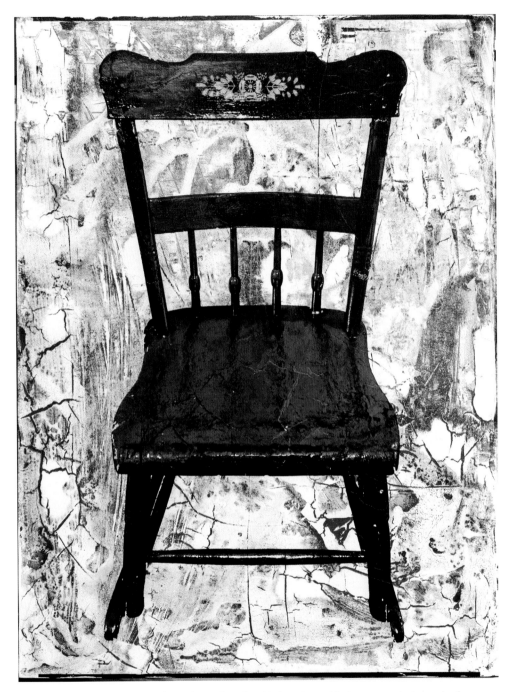

FIGURE 16.18 While I was making the surface for this box, I stumbled across a photograph of a heavily painted red chair I'd had for years. It was a perfect match to complete this 24" x 32" piece titled *Red Chair*.

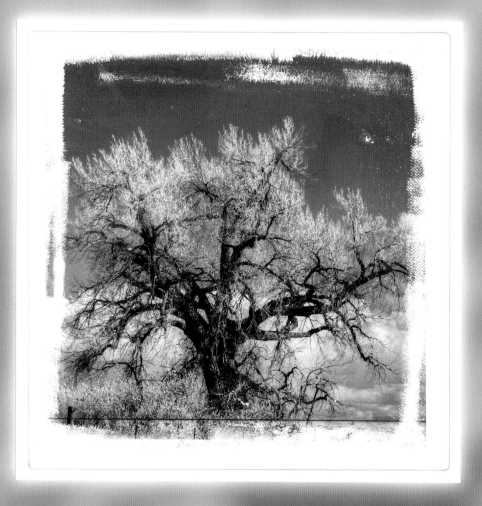

17

STONE PAPER
MONOPRINTS

While you could technically call any inkjet transfer a monoprint, I prefer to reserve that term for more complex works of art. Creating *monoprints* is a classic printmaking technique where a matrix is used to create an image on a smooth surface that then allows each print to contain slight differences. The matrix is like a plate—it's the repeatable part of the process. In our case, that's the digital file. But what you do to the matrix for each print is what makes it a monoprint.

Monoprints are often made in editions, since the source image is the same, but each print in the edition is slightly (or very) different. For example, we may take the film that we've printed and cut it into a series of different shapes—the image is the same, but the final result after the transfer is very different. In this chapter, I'll show you how to create an edition of monoprints on stone paper using a new technique to make the ink look soft and almost paint-like, as you can see in *County Cottonwood* on your left. I'll also share some work by another artist who combines these stone paper monoprints with classic monoprint techniques and builds hybrid works.

For a current and updated list of products and resources (since products may change from time to time), you can check the book's website: www.thelastlayerbook.com.

About the Stone Paper Monoprint Edition

For this process, I'm going to use stone paper, but you can use other printmaking papers (just skip the washing step!). I like this particular paper because it's inexpensive, has a gesso-like surface, and works with almost any art media. Stone paper is also waterproof (which allows that washing step), stays flat, and can even hold a slight embossing from an etching press. Best of all, it's made from stone—no trees, so it's an eco-friendly alternative to fiber-based papers (**Figure 17.1**).

The surface is naturally matte, so we'll use the matte SuperSauce. Don't use gloss because when viewing the piece at an angle, you'd see a difference in the sheen between the transferred and untransferred surfaces.

> *HINT: Because they last forever, I prefer to use plastic or acrylic templates cut on a laser at a trophy or engraving store, but you can instead cut a template out of mat board, polyethylene, or polypropylene plastic. If you cut your own, don't damage the inside corners; otherwise, you won't get as crisp a result. Ask for a radius corner if the trophy shop cuts it for you (**Figure 17.2**).*

FIGURE 17.1 Stone paper is ideal for making monoprint inkjet transfer editions.

FIGURE 17.2 We'll use a template to mark the place for the image and trim lines on our paper.

MATERIALS NEEDED

- Stone paper
- Printed transfer film
- SuperSauce Matte Solution
- Paper towels

TOOLS NEEDED

- Safety equipment
- Hard, smooth work surface
- Template cut from acrylic, mat board, or plastic sheet
- Pencil
- Drafting tape
- Sponge brush
- Paint roller with fluffy cover
- Five-minute timer
- Pin
- Scraping tools
- Texture papers and fabrics
- Rags

HINT: Use real drafting tape for this process, not blue painter's tape; the painter's tape pulls small portions of the surface off the stone paper.

To create an edition of stone paper monoprints:

Our goal is to create a small edition of monoprints quickly and efficiently. We'll be making several prints of a single image and of a uniform size (using 20" x 30" paper for a smaller finished print in this example). When we wash off the emulsion, the final prints will have a dead flat sheen and look almost like a painting—photographs have a very unique quality when presented this way.

1. Place your stone paper on your work surface, and then lay the template on top of it. With a pencil, trace around both the inside and outside of the template. For this example, my image has a 13" x 13" opening for a 12" x 12" image. We'll use the outer line to trim the paper when we're done (**Figure 17.3**).

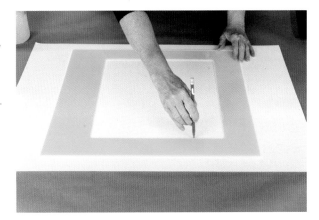

FIGURE 17.3 Draw a light line; if you intend to leave the line there as part of the finished work, draw it darker.

FIGURE 17.4 Don't use blue tape here—it will damage the stone paper.

FIGURE 17.5 You can also experiment with different patterns of SuperSauce to leave other parts of the image blank.

FIGURE 17.6 Make sure you don't damage the ink when coating the film—you'll need to work pretty fast.

2. Remove the template, and then carefully place your printed transfer film (ink side down) over the opening and center it in the square. Tape one end of the printed film to the paper with drafting tape (**Figure 17.4**).

 > **HINT:** *Make sure you center the image—not the film—in the square!*

3. Fold back the image off the surface. Use your sponge brush to apply a coating of SuperSauce Matte Solution in the center of the square until you have a nice smooth coat without any puddles (**Figure 17.5**).

CREATIVE EDGES: There are several ways you can create edges for the print. One way, as I'm showing in this example, is to make a ¾-inch gap inside the pencil line allowing for a section where SuperSauce Solution is not applied. This will result in a rough edge. For a second idea, you can paint under the full image for a crisp edge. Finally, you can even get more creative and cut the film into an interesting shape, perhaps even using another template. In this case, you'll need to paint the SuperSauce directly onto the film itself, but be careful not to damage the ink (Figure 17.6). Then you'll position the film on the paper by hand (Figure 17.7) and press it into the surface with the paint roller.

FIGURE 17.7 Don't move the film once you've put it down on the paper.

4. Carefully roll the film down onto the stone paper. Lightly run across it with the paint roller to bring the film into full contact with the solution. Immediately remove the drafting tape.

5. Wait three to four minutes, and then lift one corner of the film and remove it in one slow, smooth motion (**Figure 17.8**). Pop any bubbles in the surface with a pin, and then set the print aside to dry overnight.

6. When the print is dry, it will have a glossy surface because the inkjet emulsion is on the surface. Washing off the excess emulsion from the print makes the surface look more like paint—a very different look than a direct inkjet print. To remove the emulsion, take the print to a large tub and wash it off under running water (**Figure 17.9**). Don't rub the surface—just let the water do the work. After two or three minutes, all of the emulsion should be gone. Lay the print flat to air dry.

7. Trim the print to the outer line on your template.

8. Repeat these steps for each additional print in your edition. Remember that imperfections are part of this process and contributes to why we call these monoprints rather than just regular prints.

I created some washed monoprints using scanned images of aged aluminum plates and gave them to my friend Virginia Wood. She applied oil paint to an acrylic sheet and prepared an image that would blend with the inkjet monoprint. Then using a laminator, she pressed the oil paint onto the sheet to create a different monoprint (**Figure 17.10**). Doing this made her curious to see if oil-based pastels would work on the inkjet transfer surface, and it turns out they work wonderfully (**Figure 17.11**). I don't use that media myself, so it's always a treat to see how another artist extends these processes to express her own creative voice.

FIGURE 17.8 Remove the film, and then don't forget to sign and number your first print in the edition.

FIGURE 17.9 Nothing in my home is safe from being adopted for use in my art—the bathtub is a good place to wash stone paper monoprints, like this one later used as a base layer for a mixed media monoprint. Just make sure you clean the tub thoroughly afterwards.

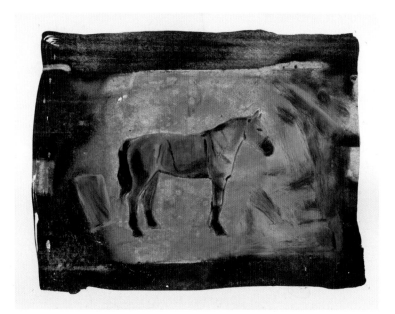

FIGURE 17.10 This 16" x 24" oil on a monoprint by Virginia Wood is titled *The Stables*.

FIGURE 17.11 This 16" x 24" pastel on a monoprint by Virginia Wood is titled *Haystack*.

Conclusion

Planning ahead isn't exactly one of my strong points, and I always look for alternate routes and paths to get me to where I need to go. Like the time I took a wrong turn at the Frankfurt airport, and had to go through security twice. I barely made my flight (they closed the door as I walked through it), but ended up in the right place in the end. That mirrors how I work—even when I'm frustrated and think I'm at a dead end, something unexpected happens that takes me in a new direction, and ultimately where I want to go. Monoprints are an easy and fun way to create an edition or a series of work using a single image, but with each having the unique characteristics of a hand-created work (**Figure 17.12**).

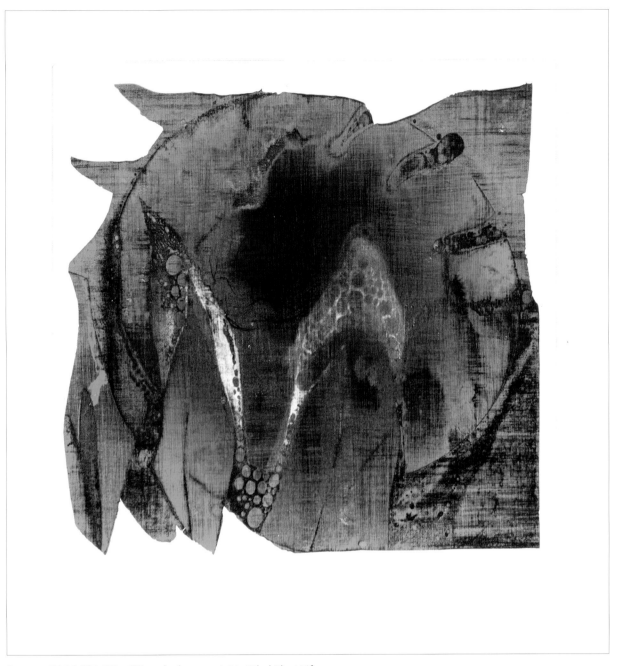

FIGURE 17.12 This 12" x 12" washed monoprint is titled *Plant Life*.

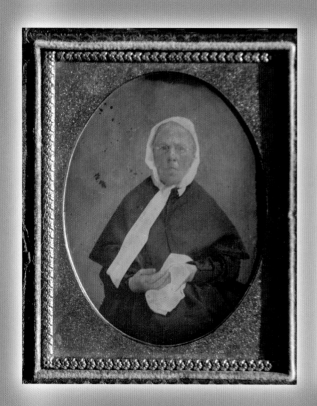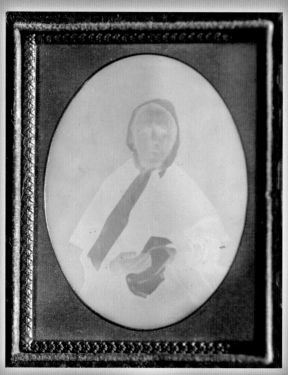

18

PEARLOID TRANSFER TO GLASS

O f all the historic photographic processes, I find the daguerreotype the most intriguing. As you tilt the photograph from left to right, the image flips between negative and positive on a mirrored surface, seen in the two views of the image to your left. Holding one of these and manipulating it is a fascinating experience. Unfortunately, the process to create a real one is very involved and uses some toxic chemicals. I have tremendous respect for photographers who still make them—it's a labor of love.

I took inspiration from those old photographs when developing the pearloid process. We'll use an interference, in this case gold mica, in a second backing layer of gelatin, so the image shifts appearance when viewed from different angles. There's nearly an unlimited selection of these mica pigments available for use—see Chapter 14 for more information.

As wonderful as the quality of this book is, there's no way to actually capture the sparkle and beauty of these pieces—the original really is the only way to fully appreciate the work.

For a current and updated list of products and resources (since products may change from time to time), you can check the book's website: www.thelastlayerbook.com.

About the Pearloid Transfer Process

The pearloid process is the most difficult and unforgiving process in any of my books or DVDs. Getting the gelatin to adhere to the glass is a multi-step, multi-day process that must be done correctly. It avoids dangerous chemicals, but the steps must be followed carefully.

Temperature and humidity are critical to make this work as well, so you must have an accurate infrared thermometer, and work in a room that you can get down to 68 degrees with low humidity for the gelatin to set up properly (winter in Colorado works great—Orlando in the summer, not so much). In my studio, this is a seasonal process, so you may want to plan ahead.

While many processes in this book may work with optional brands or kinds of materials, please pay attention to those I list in this chapter. I've spent a lot of time, effort, and money trying different options—no need for you to go through all that, too! In this process, I use the inkjet precoat that I developed specifically to adhere to glass—using other brands will likely not work properly.

I strongly suggest you start small, as you will make mistakes—maybe with an 8" x 10" image and work up to larger sheets. The largest I've made is a 30" x 40", which required an assistant to move (it gets very heavy). Going larger than that is impractical as the glass is too heavy to frame and ship to exhibitions.

When buying glass, choose ¼-inch thick low-iron tempered glass, and make sure you specify "no logo" or it will be etched with a tempered logo and will show in the final art. The low-iron glass doesn't distort the colors like window glass does, and tempering keeps your fingers where they belong—on your hands—if something goes wrong! I like having glass polished with a pencil edge (a smooth and polished rounded edge that resists chipping) so I can display small work unframed on an easel (**Figure 18.1**).

FIGURE 18.1 The smooth, pencil-polished edge gives a sophisticated look that allows the work to be displayed unframed on an easel.

Now after all my comments, is this process worth it? Yes! When you see one of these pearloids in person, it's like no other work you've ever held.

Unlike the other processes, this one is broken down into steps you'll do on each day of the process.

MATERIALS NEEDED

- Plastic drop cloth
- Distilled water (artesian or tap water does not work)
- Low-iron tempered glass
- Clorox Clean-Up Cleaner with Bleach
- Cleaning paste (see Chapter 2)
- Viva paper towels
- Good, fresh duct tape (Bron is the brand I use)
- Printed transfer film
- DASS Universal Inkjet Precoat II or Triangle CristalBond D007
- Photographic ossein or pork gelatin (food grade gelatins do not work)
- ¼" foam core cut the size of the glass
- Box for support
- Mica pigment

TOOLS NEEDED

- Safety equipment
- Very level work surface
- Several pairs of protective gloves
- Wedges
- Measuring cups
- Glass Pyrex quart container
- Terrycloth towel
- Overhead radiant heater or Toastess Warming Tray large enough to heat your glass panel evenly
- Four wide-mouth quart canning jars
- Stick or paint brush handle for burnishing
- Microwave
- Laser infrared thermometer (required for this process)
- Fine strainer
- Aluminum foil
- Single-edged razor blade
- Walnut Hollow Creative Versa Tool featuring Versa-Temp temperature control
- Sheet of 1"- or 2"-thick foam insulation, 2" smaller than the glass
- Sheet of Econolite or similar rigid material larger than the glass
- Hairdryer

HINT: Because this process is very particular, I suggest that your first attempts be with the DASS Transfer Film I developed—I know that it works. Use the premium film for a more perfect transfer, and the classic film for a more antique, rugged look.

HINT: Triangle CristalBond D007 is an Aqueous UV-Protective Acrylic Urethane ClearCoat that dries crystal clear. It's available from DencoSales (www.dencosales.com) by telephone special order (it's not listed on their website). CristalBond and DASS Universal Precoat II are the only adhesives I've found that dry clear—acrylic mediums are not suitable for this process.

HINT: Ossein and pork gelatins have different looks with the different adhesives. Run some test to see what effect you like best. My personal favorite is to use pork gelatin with the DASS Universal Precoat II as the adhesive.

FIGURE **18.2** Let the gelatin swell for 20 to 30 minutes.

FIGURE **18.3** Let the glass air-dry to avoid getting streaks on it. Don't worry if you get hard water spots on it—the cleaning paste in the next steps will take them off.

To prepare your materials, Day One:

This first day is a prep day, to get all your materials set and ready to go.

1. For each square foot of glass that you're going to coat, the recipe for the gelatin mixture is 2 cups of distilled water and 4 tablespoons of pork gelatin or photographic grade ossein gelatin (we add the adhesive to this on Day Two). In this example, I'm using an 18" x 18" sheet of glass, which requires a double-batch. Place the appropriate amount of distilled water in your Pyrex container and then add the appropriate amount of gelatin. Set the mixture aside to swell (**Figure 18.2**).

2. Cleaning the glass is the most important step in the process. Both the sides and edges of the glass must be cleaned—if the waterborne coating is going to stick successfully, it must be able to hold a vertical sheet of water on the surface. If the water breaks or beads up, the emulsion may fail. While wearing gloves, give the glass a good long scrub with a terrycloth towel and Clorox Clean-Up Cleaner with Bleach. You'll literally hear a squeaky clean sound when it's done.

 > *HINT: For larger sheets of glass, you can do this with a garden hose outside.*

3. Rinse the glass and hold it up vertically to see if water runs smoothly across the surface. Once it's clean enough, stand it on end in a drying rack and allow it to dry (**Figure 18.3**). If one side of the glass squeaks more than the other, that's the side you want to use. From this point on, you should handle the glass only with gloves; otherwise, you'll have to clean it again.

4. Place the dry glass on cups over the warming tray and thoroughly scrub the glass on both sides and the edges with the high-quality cleaning paste from Chapter 2. Do this three times (**Figure 18.4**).

5. Take a few minutes to clean up your workspace.

6. For this example, I'm using the warming tray (available on Amazon.com; I use the larger 1000-watt version). Place the tray on a table and make sure it's completely level. Set down two canning jars on each side of the warming tray and place a sheet of clean glass on the tray.

7. Use the Viva paper towels (which have very little lint) to wipe off all the dust from the glass.

8. Use duct tape to make a well around the glass. Let half the width fold under the glass, and then bend it around to form a well. Make sure the cut ends meet on an edge, and not at a corner. Use a stick or paintbrush handle to burnish the tape to the glass.

9. Now add a second layer of tape (**Figure 18.5**), making sure that the seams are in a different place (to prevent leaks). For large sheets, you may need a third layer. This should keep the gelatin from leaking out, but accidents happen—that's why having good-quality duct tape is important (the glue on the cheap stuff melts with the heat). I like to work with a container nearby (and over a big cookie try) to catch the gelatin if the tape springs a leak.

10. Print your image using a Premium Luster profile for Photo Black inks, or an Enhanced Matte profile for Matte Black inks. If your image is very dark, I suggest using the Photo Black as you'll get better results. Check your printer manual and slow down the print head to allow the print to dry between passes. Set your print aside and allow it to dry at least overnight (do not work with wet prints for this process).

FIGURE 18.4 After cleaning with the paste, make very sure you don't touch the glass with your hands or you'll have to start all over.

HINT: *When using cleaning paste on glass, always make the paste using Daniel Smith precipitated chalk. Fredrix marble dust will cause the paste to scratch the glass.*

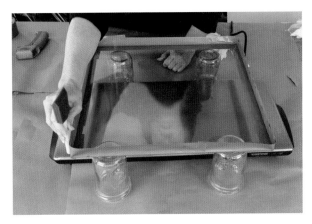

FIGURE 18.5 Make sure you burnish the tape firmly to the glass.

11. Take your gelatin, now bloomed, and warm it in your microwave to between 135 and 138 degrees (but no warmer!). Keep a close watch on the temperature; if it goes over 140 degrees, the gelatin is ruined and must be thrown out. If you have a large amount to do, use a slow cooker rather than the microwave to have good temperature control. Stir it occasionally while checking the temperature, but make sure you don't cause bubbles to form.

12. Remove the melted gelatin from the heat and allow it to cool overnight. This will drive the air out of the liquid and keep the bubbles to a minimum.

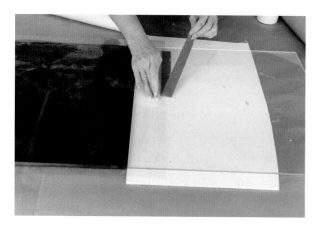

FIGURE 18.6 Prepare your image to roll up on an alignment board (ink-side out) before you pour the gelatin.

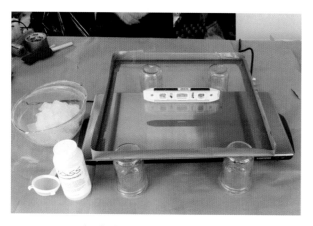

FIGURE 18.7 Check the level of the glass while warming it.

To apply the print, Day Two:

When you apply the print, you'll use the alignment board method from Chapter 3, but instead of one board you'll use two other sheets of glass or boards the same thickness as the one you're working on (**Figure 18.6**)—you need one to match the height of the glass itself, plus a second one to match the height of the gelatin layer. You'll need your image to be rolled ink-side out onto a cardboard tube and resting with one end taped to your alignment board. Get that set up before you begin.

1. Turn on the warming tray to heat up the glass. Check the temperature using your infrared laser thermometer and turn off the tray when the glass reaches 110 degrees. Watch this carefully—if it gets too hot, not only can the tape fail (and you'll get gelatin all over the floor) but the heat can break down the gelatin. I love this brand of tray because it's designed to stay hot for hours once the desired temperature is reached. Double-check that your glass is level—it's very important that you have an even coating of gelatin (**Figure 18.7**).

2. In a slow cooker or microwave, melt the gelatin a second time by heating it to 120 degrees (no hotter!). Don't stir it or you'll get bubbles.

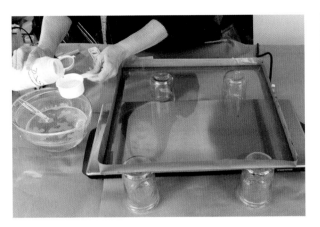

FIGURE 18.8 Carefully stir the adhesive into the gelatin—don't create bubbles!

FIGURE 18.9 Pour the warm gelatin through a strainer so that it flows evenly over the warm glass.

3. Add 2 tablespoons of DASS Universal Precoat II or CristalBond D007 per cup of liquid gelatin to aid in adhesion to the glass (**Figure 18.8**).

4. Check to make sure both the gelatin solution and the glass are still between 100 and 110 degrees; this is the temperature you want as you begin to pour. To avoid getting bubbles in the mixture as you pour, place a strainer in the center of your glass, and then pour the gelatin through the strainer (**Figure 18.9**). Move the strainer around the surface of the glass to get an even coat. Pour the last half cup of gelatin onto a piece of aluminum foil with the edges folded up to hold the gelatin—we'll use that to test how it's setting up without damaging our print.

5. Use a hair dryer set on hot or a Rocket Blaster (**Figure 18.10**) to pop any bubbles on the surface (hold the hair dryer up high so you don't blow the gelatin off the glass!). Carefully pull the hot tray out from under the glass so the gelatin will begin to cool.

FIGURE 18.10 Bubbles will mar the final work—pop them with a hairdryer or a Rocket Blaster.

HINT: If you have problems with fine bubbles in the liquid, you can leave the hot tray under the glass (but unplugged). This will slow down the cooling process, which then allows more bubbles to escape. If necessary, as you pour the gelatin use fine silk or nylon as a strainer to remove foam.

FIGURE 18.11 Carefully cut the corners of the tape, and then pull down the sides to break it from the gelatin.

FIGURE 18.12 Go slowly and let the knife melt-cut the gelatin—if you see the gelatin move, you're going too fast.

6. Now is the time to enjoy a lovely beverage or picnic lunch. It'll take between two and three hours for the gelatin to cool and set up. Check the temperature with the infrared thermometer. Once it reaches 65 degrees or lower, touch the test patch on the aluminum foil. If it sticks to your fingers, it hasn't set yet.

> *HINT: Don't rush—if the temperature is more than 65 degrees, it'll definitely be sticky. You can't cool this faster by putting it in the fridge, either—we need a nice, slow cool down. And you don't want to move the glass anyway—it can damage the gelatin layer.*

7. Once the surface is set, remove the duct tape by slicing it at the corners. Pull the tape straight down, not sideways, to break it from the gelatin (**Figure 18.11**). It's very important at this stage not to separate the mixture from the glass. Go slowly, and be careful.

8. Warm the Versa Tool knife, with the hobby knife blade installed, to its highest setting—use the infrared thermometer (not your fingers!) to tell when it's hot. The gelatin will be ragged and uneven where the tape was removed—we have to trim it or the transfer will fail. Hold the hot knife at a 45-degree angle to cut off that ragged edge—the heat from the knife will melt and reseal the gelatin (**Figure 18.12**). Let the heat do the work, rather than trying to cut it with the blade. Do this on all four edges, but don't try to wipe liquid gelatin from the glass.

9. Once the melted edge is set up again, carry the glass to the clean, flat surface where you have the alignment board set up. The gelatin surface is now higher than a single sheet of glass, so you'll need to use a piece of foam to bring them to the same level.

10. Roll the transfer down onto the gelatin using the alignment board method in Chapter 3. Wait three minutes, and then carefully lift one corner and slowly pull the transfer film off in a smooth motion (**Figure 18.13**). It's important that you don't pause, and that you hold the last corner of the film so it doesn't flip and damage the gelatin surface.

11. In a low-humidity environment, this will dry overnight by itself. If it's too humid, you can use an overhead fan to circulate the air, but don't allow a fan to blow directly on the transfer. If your edges fail, it's because the corners dried too fast and pulled up off the glass. It's best to let it dry as much on its own as possible.

To apply the pearl layer, Day Three:

Now we're going to add the pearl layer that makes this image so special.

1. Put the glass on a box to support it off the table (don't do this on a warming tray that's warm—we don't want to re-melt the gelatin!). Make sure that the box is level, so that if we tip the glass to spread the next layer of gelatin, it'll spread out evenly when we set it back down (**Figure 18.14**).

2. Use a hobby knife or razor blade to carefully remove any hard gelatin on the edge of the glass, and then apply a duct-tape well again, using the same method as on Day One (**Figure 18.15**). Avoid touching or damaging the gelatin layer already on the glass.

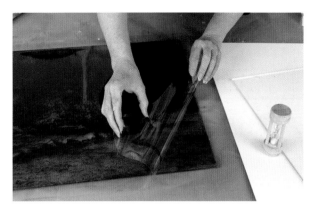

FIGURE 18.13 Wait three minutes, and then carefully remove the film.

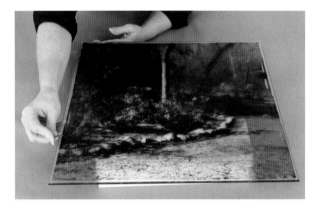

FIGURE 18.14 A box smaller than the glass is easy to level.

FIGURE 18.15 Create another duct-tape well around the glass and burnish the tape down tight to the glass (try not to push it into the dry gelatin layer).

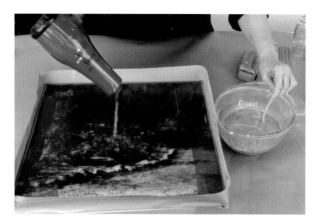

FIGURE 18.16 If the surface is cold, warm it with a hair dryer just before pouring the second layer.

FIGURE 18.17 Quickly pour the gelatin and mica mixture onto the dry gelatin layer.

3. Mix up the same amount of gelatin you did in Step 1 on Day One, using the same method. Once the batch cools to 110 degrees, add the adhesive to the new batch of gelatin as you did in Step 3 on Day Two. We don't need to let this batch set overnight, as bubbles are less important in this layer. Mix it well, and while it's warm, add 2 or 3 heaping teaspoons of your mica pigment and stir it in gently. If foam forms on the top, skim it off.

> *CAUTION: Remember the safety precautions when using mica powder—and never reheat gelatin containing mica in the microwave. I also premix the mica in a bit of hot water while outside to keep the dust under control.*

4. Make sure the surface of the dry layer is at least 70 degrees—if it's too cold, the next layer may set too fast (**Figure 18.16**).

5. Let the solution cool to between 100 and 110 degrees, and then give it one last gentle stir (the mica pigment settles pretty quickly). This time, we're going to pour the solution directly onto the surface (without a strainer as that could filter out the pigment) (**Figure 18.17**). Tip the glass to make it flow evenly around the surface, and then quickly lower it back to the level surface. If you get bubbles, use the hot hair dryer or Rocket Blaster to pop them—just make sure you don't disturb the even mica layer (it should drop to the bottom pretty quickly). Pour a test patch like you did before so you can tell when it's set without damaging the real piece.

6. Now is the time to enjoy another lovely beverage or picnic lunch. Follow Steps 6 through 8 from Day Two, letting it cool, and then removing the duct-tape well and trimming the edges as before (**Figure 18.18**). This time, however, trim the edges at 90 degrees, not at the 45-degree angle you made previously.

7. As before, in a low-humidity environment this will dry overnight by itself. You can use an overhead fan to circulate the air, but don't allow a fan to blow directly on the transfer.

FIGURE 18.18 Be careful not to cut the edges at an angle or you won't have a pearl border around your image.

To do a final cleaning, Day Four:

And now we're almost done! From this point on, treat these works like an encaustic wax work. Don't transport them in a hot car or hang in direct sunlight or other hot locations. Likewise, keep them from freezing. I've been making these for six years and haven't had any issues, but they do require a little care.

1. Use a fresh, sharp razor blade (cold) to clean off any dried gelatin from the edges—be careful not to cut into the image layer.

2. Clean the front of the glass with a barely damp towel to remove excess gelatin, and do a final cleaning with the cleaning paste. Do not use any sort of spray cleaner directly on the glass that could run under or get on the gelatin—dampen the cloth, not the glass.

HINT: I always include care instructions when selling pearloid works (or any other of my works that require special handling). When shipping these, I also try to avoid doing so during the hottest parts of the year, and instead ship them overnight in the fall and spring.

Conclusion

When I first exhibited my pearloids, the immediate reaction was that I'd done something similar to a daguerreotype. It was so exciting that my invention had worked, and that I'd captured the allure of the original process without any of the nasty materials. The best part is that by changing the color of the mica pigments, you can make works that are reminiscent of those antique prints, but with colors that were never before imagined.

I never tire of looking at these—the light striking the mica reflects back an ever-shifting image, almost like sunlight on aspen leaves moving in an autumn breeze. The minerals bring a luminosity to the image—it's truly transformed by the light (**Figure 18.19**).

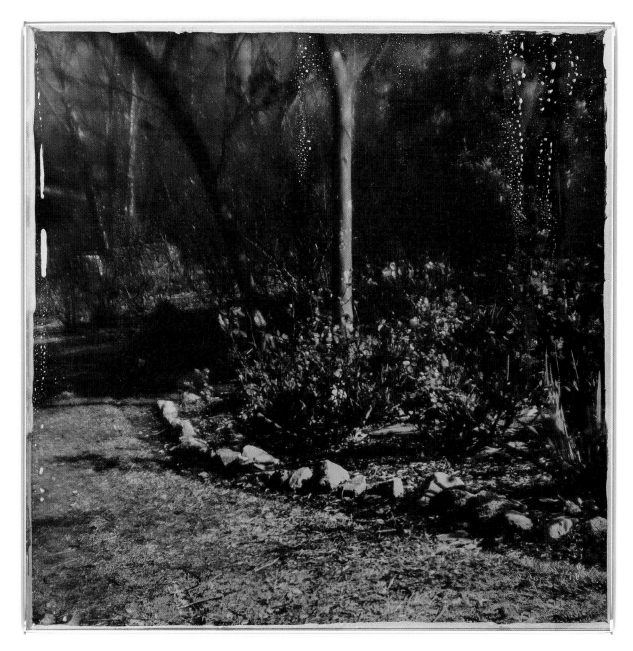

FIGURE 18.19 I used a Holgamod lens on a D800 to take the picture that became this 18" x 18" work titled *Garden Path*. The 24K golden glow pearl pigment behind the photograph creates a warm glow that I couldn't achieve any other way.

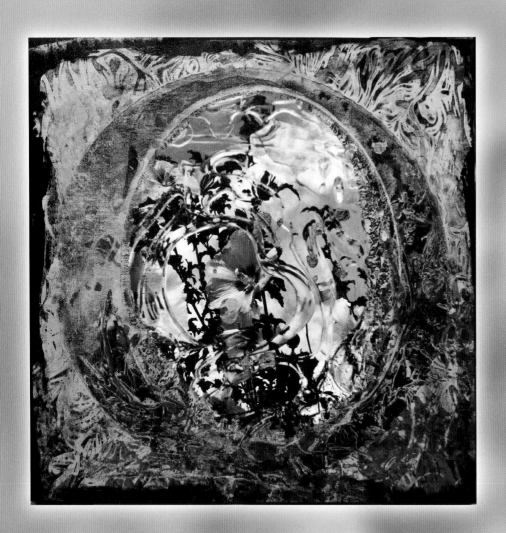

Gallery of Work: Creative Substrates

Silver

28" x 40". Pearloid on Low-Iron Glass. I took this photo with a flash as large snowflakes fell on a warm winter night, when the moon glow made the snow sparkle. The pearloid process is a perfect match for the moment captured here.

Veiled

13" x 19". Pearloid on Low-Iron Glass. A quiet moment before the wedding, the silhouette against the sunny window came to life. As the light reflects off the sparkling background used for the second layer of gelatin behind the sepia-toned image, the magic is captured.

Twitter

12.5" x 19.5". Pigment Transfer on Found Object. I found a stash of old printing plates from the early 1900s. After filling in the zinc plate with matte gel medium to make a smooth surface, I transferred a print of a simple image—it was a perfect match for the plate. The original texture of the plate shows through the translucent gel medium, which has dried to a wax-like appearance.

Party Girl

20" x 30". Pearloid on Low-Iron Glass. I'd had this Kewpie doll stored in my flat file for years, until one day I notice how the color and surface of the doll were similar to some gelatin fresco surfaces I was experimenting with. I combined the images in Photoshop, and then used a high-light gold mica in the second gelatin layer. When the light changes, this image shifts from a rich gold tone to a pearl white.

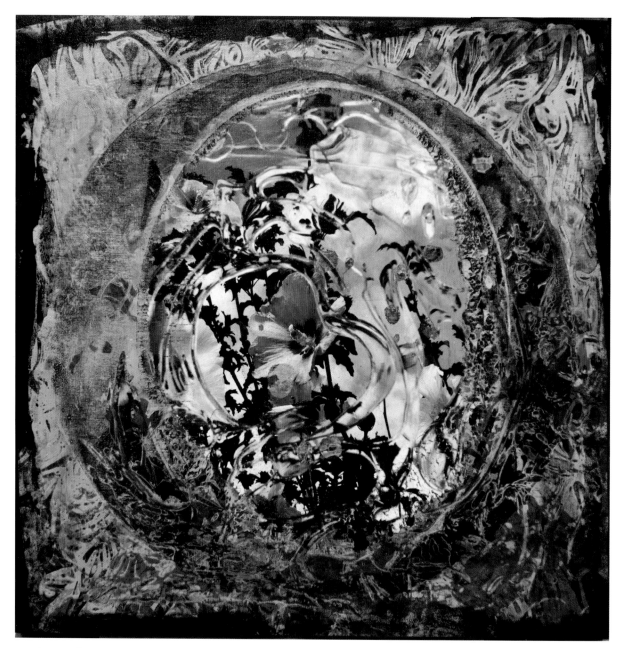

Enchanted

36" x 36" x 3". Pigment Transfer on Acrylic Paint. I started this piece a bit differently—using a birch box painted with black gesso. I then added white areas using a lift-off technique, and transferred the image. I love how this ended up looking like a painting rather than a transfer.

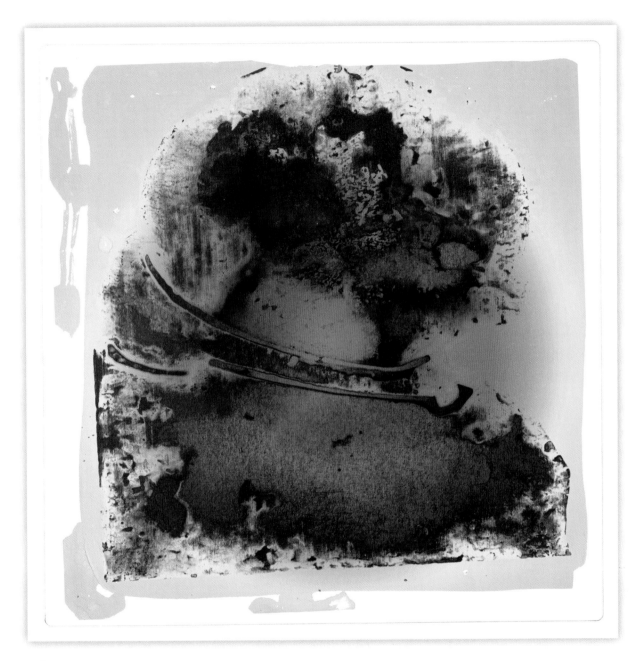

Tide Water

12" x 12". SuperSauce Transfer on Stone Paper. I'm always amazed at the wide range of abstract images and colors that can be pulled from the patterns of naturally aged surfaces. In this case, washing the final print made the colors look like they'd come straight from the artist's paint box.

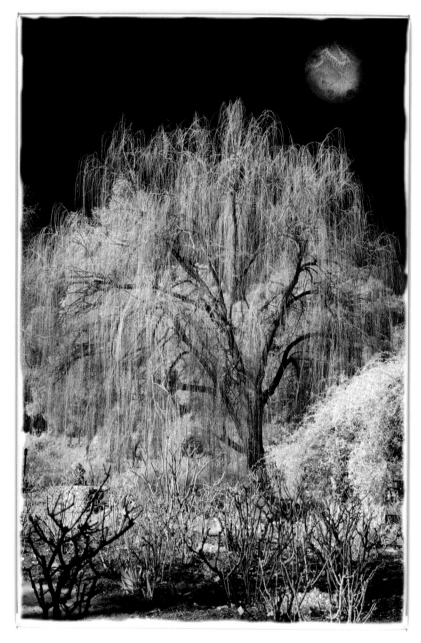

Moonrise

26" x 40". Pearloid on Low-Iron Glass. I created this image from an infrared photograph taken in a botanical garden in California. I made the image of the moon by freezing gel medium on a round metal tray and then scanning in the material and adding a bit of color. For the back gelatin layer, I used my secret stash of special sparkle product (there are some secrets I still keep!).

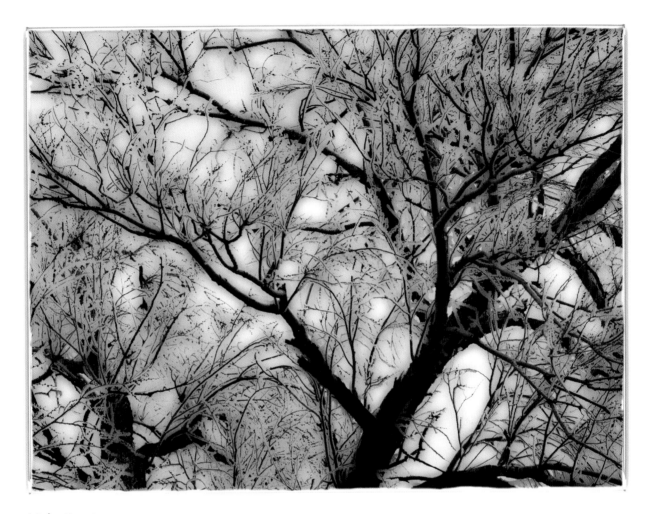

Light Frost

28" x 40". Pearloid on Low-Iron Glass. A couple of years ago, I was caught in a foggy ice storm. While there wasn't enough visibility to drive, I did have my camera, so I took some pictures of what looked like white frozen fog. Through the magic of Photoshop, I extracted this image—and was stunned at the result. I never would have thought there was so much color in the digital file—the final result is absolutely captivating.

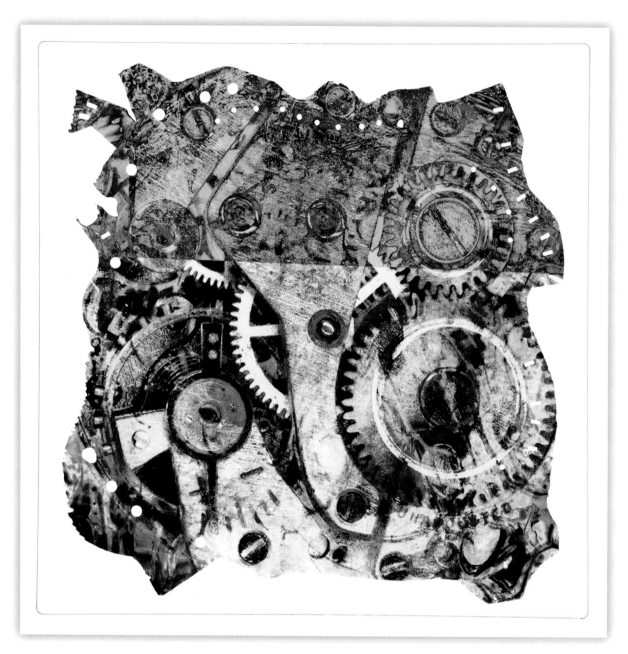

Time Stops

12" x 12". SuperSauce Transfer on Stone Paper. I created this image in Photoshop using scans of watch parts and adding a textured pattern from an aged aluminum plate. I printed the image and then cut out the shape with scissors and a paper punch. Finally, I applied the SuperSauce directly to the film for the transfer, making sure I didn't have excess sauce outside the image margin.

Ember

18" x 18". Inkjet Transfer to Venetian Plaster. I transferred a piece of film that had been printed a solid saturated orange, and then after it dried I piled on black Venetian plaster. I used the eraser end of a pencil to cut the scroll pattern, and then pressed a plastic screen firmly into the wet plaster surface. It was a treat to see this the next day—it looks like glowing volcanic embers. Sometimes simple makes a big statement!

Ripple

36" x 36" x 3". SuperSauce Transfer on Black-Painted Birch Box. I've been experimenting with hand-made filters that I hold in front of a camera to capture a uniquely distorted image. By turning the filter as the photograph is taken, I can get results in a moment that would take hours to duplicate in Photoshop (it's always better to get it right in the camera). When combined with the transfer processes, I'm guaranteed to have a unique look to my final image.

Moss

12" x 12". SuperSauce Transfer on Stone Paper. I created this image in Photoshop by using a scan of one of the aged plates for texture. After transferring the image and washing the stone paper, I ended up with this classy abstract image.

SECTION V

FINISHING UP AND NEW WORK

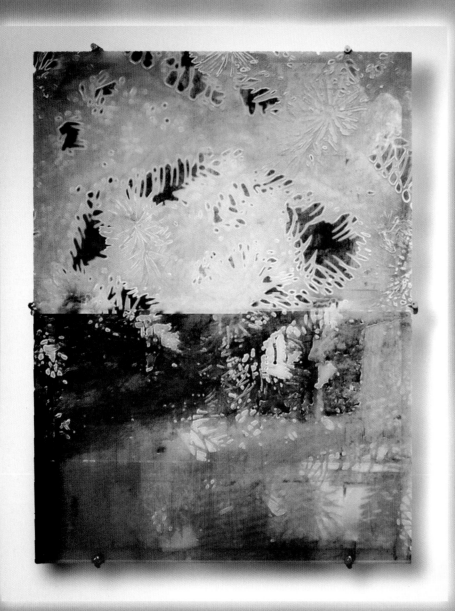

20

POSTCOATS AND FINISHING

f the substrate is the last layer of a cake, then the postcoat is the frosting, and the finishing is the plate on which it's served—those last few details can make the difference between a good work and a great one. And while we don't like preservatives in our cake, you need them in your work to ensure that it's archival and will last long enough for generations to enjoy it.

Part of this means deciding on a postcoat chosen from the several types I discuss here. The other part of this traditionally meant framing your work, but after spending thousands of dollars on frames that were destroyed in shipping, I've shifted my presentation style to a more modern, simple, and elegant one, as seen in *Mill Pond* to your left (those classic museum-style heavy frames just don't match my work!).

For a current and updated list of products and resources (since products may change from time to time), you can check the book's website: www.thelastlayerbook.com.

If you've read *Digital Alchemy*, some of this chapter will be familiar, though there are updates and special considerations for the new processes in this book.

Postcoats

You'll need to apply a protective coating to aqueous inkjet prints because the inks are water soluble, as are most of the inkjet precoats and papers (stone paper is an exception). Framing most of these works under glass does help protect them, but there are a couple of tricks to remember for more complete protection.

For direct imaging, make sure that you give your prints plenty of time to dry. If you immediately frame a fresh print, over time the glass will fog due to the outgassing of the inks. Also, if you apply a postcoat too quickly, the inks may fog over time.

One nice thing about the transfer process is that you can print the film in advance (even months, if you're using the DASS film), which allows all the gasses to escape. Then all you have to do before mounting is wait for the substrate to dry completely. If you do transfer a fresh print, you'll need to allow about four hours for the gasses to escape.

Last, UV light is the enemy of all artwork, and digital prints are no exception—particularly those from the photosensitive processes. Many postcoats have a UV protectant that can mitigate the effects and protect against fading.

SuperSauce Solution

SuperSauce Solution, either Matte or Gloss, is a universal varnish for any work where the ink is on the surface (which means you won't use it with the pearloid).

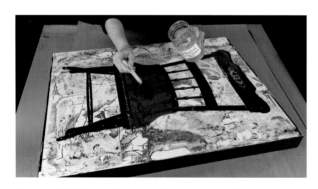

Apply the first coat quickly with a sponge brush, but avoid over brushing, as it will dissolve the image! This leaves the surface with a soft satin glow, and as a bonus, bubbles in the original transfer will mostly disappear as it dries. After a couple of weeks of drying and hardening, I apply a light coat of Renaissance Wax Polish, which keeps moisture out of the prints in humid climates. I've even applied up to five layers of SuperSauce Matte Solution to achieve a very soft image (**Figure 20.1**).

FIGURE 20.1 SuperSauce Solution and wax polish on metal plates.

Wax

Encaustic wax can add visual depth to an inkjet print, but you can use it only on rigid absorbent surfaces, and it does not protect the image against UV light (**Figure 20.2**). When used over a mixed-media composition like the Birch Box Mixed Media variation in Chapter 16, it will impart a rich warmth to the image. The mellow satin finish protects the inks from contaminants and moisture. You can even use the encaustic wax as an adhesive to build layers of thin, printed collage paper images on birch panels (but that's another book).

FIGURE 20.2 Encaustic wax medium is melted in a small electric crock pot.

I prefer a very smooth finish, so I use the hot Colorado sun as a studio tool. After applying the liquid wax, I let it harden inside. Then I take the panel outside and let the direct sunlight melt the wax again (you could use heat lamps on a cold winter day). The wax will flow flat in the sun, after which I carry it back inside and let it cool on a level surface. In a couple of days, I buff it with a lint-free cloth until the surface is smooth and sealed.

Gamblin Cold Wax Medium is a nice substitute if you don't want to melt wax, but it's not quite as smooth as encaustic wax. Just spread on a thin layer, allow it to dry, and then buff it with a lint-free cloth. If you like the look of wax but want something more heat resistant, you can apply a layer of GOLDEN Soft Gel Medium Matte to the surface. It's hard to tell the difference between that and wax.

HINT: You might have guessed that this postcoat can melt again. In normal situations you'll be fine, but be careful about leaving such artwork in a hot car on a summer day.

Aerosol Sprays

There are two sprays that I use for my postcoats, both of which have UV protectants included in them. Krylon makes the most widely used spray varnishes for artwork. The crystal clear, non-yellowing spray is available in gloss, satin, and matte finishes. I find that it works best first to apply a coat of gloss to seal the surface, and then apply the satin or matte as a second coat.

FIGURE 20.3 Krylon Crystal Clear and Preserve Your Memories II are excellent postcoats.

Preserve Your Memories II is a wonderful product that I use often, but it's available only in a gloss finish. You can get it as a non-aerosol pump or a paintable liquid, which gives you some nice options when working with more complex surfaces. The coating is perfect for sealing aged metal transfers or metal that you've imaged directly. I use Preserve Your Memories II for a gloss finish, and then if I want a matte or satin finish, I'll use the Krylon sprays (**Figure 20.3**).

These sprays are a good choice for any print or transfer surface—just make sure that your work is completely dry before applying them.

Acrylic Gels

GOLDEN Artist Colors makes a special set of Digital Ground topcoats. These are very light and spread like warm butter, which allows you to apply them without the brush touching the image itself. They're water based, so as you apply them, don't be so aggressive that you move the printed ink or the transferred surface. Just go slow, use a soft touch, and be careful. These topcoats have additional UV protectants in them, and you can even use them to create a brushed texture over a final image (**Figure 20.4**).

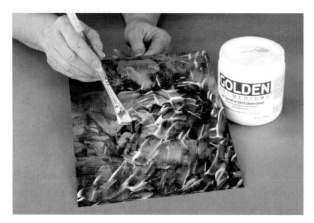

FIGURE 20.4 These topcoats are so light and fluffy that they don't damage the surface of a digital print.

Liquid Laminates

There are many options in the category of liquid laminates, but one of the best is GOLDEN MSA. This is a self-leveling product that's removable when applied to a nonporous surface. With a built-in UV protectant, it's a good choice for use on canvas or other fabric. The only drawback is that you thin it using mineral spirits

(make sure, as always, that you read and follow all safety precautions). GOLDEN MSA works well over most of the paintable precoats, but if you're putting it on metal, use the Hard MSA instead. You can use the Hard MSA varnish on metal plates that have been printed after coating with a paintable precoat, and it works very well to seal the direct imaging on the back side of glass (**Figure 20.5**).

Laminates

For tiles and small boxes, I like to use Polyurethane Resin 7840 from GOLDEN Artist Colors Custom Lab (**Figure 20.6**). You won't find this in most retail outlets (it's one of their professional products), but you can purchase it directly from GOLDEN at www. goldenpaints.com. This is a great water-based alternative to the two-part resins that many artists use (that stuff is nasty—I was really happy to find this product!).

You can try the widely used film laminates for prints on paper. First, mount the image on metal, gator board, or another rigid backing using a double-sided laminate. Then, place a second over-laminate across the entire surface. I see this used often in commercial applications where durable protection is needed. This technique, often called *plaque mounting*, is generally not used for fine art photographs, but I have used it for the posters for my fine art exhibits. Make sure you pick a laminate that contains a UV protectant if you're going to hang the poster in sunlight.

> HINT: *You can laminate the front of the print to the back side of clear acrylic sheet or glass using optically clear adhesive. It takes a lot of practice to do this right, however, so check with your local photo shop and see if they'll do it for you.*

FIGURE 20.5 I use GOLDEN MSA varnish on my direct-imaged metal plates.

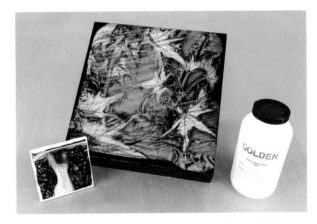

FIGURE 20.6 Polyurethane resin gives a hard gloss finish to the work.

UV Acrylic Sheets

The most common way to present a photograph is framed under glass (either with or without a mat). I recommend that you always use UV-protective acrylic sheets rather than actual glass, unless you've used a postcoat that includes a protectant. This was the only option available in the early days of digital printing. Once Encad introduced pigment inks in 1997, it became less critical, but it's still the only product I use when presenting framed work under "glass."

Acrylite AR OP-3 is an acrylic sheet that filters out roughly 98 percent of UV light. What's really cool is that one side is scratch resistant (I tried to sand it with hardly an effect), so you can actually transfer to the other side and have your protection and your final work as a single substrate.

For processes that have the photosensitive emulsion as part of the final work (like a work from the flow blue process, though not a print from a Solarplate), it's critical that you protect the final piece from UV exposure. And of course, the original chlorophyll prints are highly reactive to UV light, so much so that I don't recommend exhibiting them even with protective plastic—98 percent isn't good enough!

Mounting and Installation

Over the years, my framing techniques have become simpler, which to me only adds to the elegance of a piece. I can float Dibond or mill finish aluminum panels on a plain birch frame to highlight that the surface is thin metal, or place a pearloid with a pencil-polished edge on an easel to show that it really is just glass. This simplicity also allows the purchaser to install the piece or frame it to match their collection—no need to waste time and energy on reframing work.

I consider the presentation of the work as part of the entire package. When I'm working on a commissioned project, I'll go visit the intended installation site and consider that as part of my overall design.

For works that are on glass or clear acrylic, I've started mounting them on a backlit panel. A ¼-inch thick LED light pad goes in the back of the work. The soft illumination uses just four watts of power per running foot and will last for many years (**Figure 20.7**).

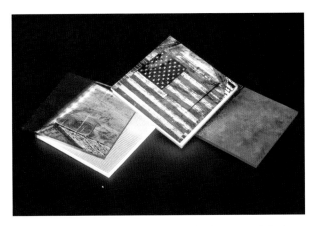

FIGURE 20.7 Light pads are very popular because of the low energy required to illuminate transparent work.

FIGURE 20.8 The light boxes behind the art create the appearance of a window.

A similar technique is to build a light box that becomes part of the work. This is a good option if you're selling your work in a gallery and don't know how it will be displayed, or if your customer is a bit more budget minded. I use fluorescent T-8 5500K bulbs with electronic ballasts to avoid the hum that other fixtures have. For an exhibition, I installed this group of fish images in these deep boxes (**Figure 20.8**).

Work on metal is elegant when the metal sheet is just mounted on a wooden frame. These frames are very inexpensive and quick to assemble (**Figure 20.9**). You can leave them natural, paint them black, or even transfer images to them! I've created these so that they're the same size as the metal sheet (which looks like a box), or so that they're smaller and offset, allowing the metal plate to float off the wall.

I hate wasting frames (they're expensive!), but they do get damaged from time to time. I've started covering damaged frames with aged foil left over from the

FIGURE 20.9 Inexpensive open frames are available from many hobby stores.

FIGURE 20.10 I like reusing damaged (or ugly) frames by making them part of the artwork itself.

FIGURE 20.11 Cases like these turn art into heirlooms.

cooking processes. Just paint Rhoplex N580 on the wood and burnish down the foil with a firm foam roller to make the frame part of the art (**Figure 20.10**). You can even do this with foil that you've transferred images to. Just apply a topcoat of SuperSauce Solution and let it dry before you apply the foil to the frame.

Original tintypes were placed in union cases to protect them. Modern Day Antique (www.moderndayantique.com) makes cases that replicate this very special display option (**Figure 20.11**). This is a good choice to show off an original chlorophyll print, as it keeps it safe from UV light when it's closed. I'd still suggest adding a UV-protective coating or acrylic sheet in front of the print itself while the case is open.

As an alternative for work made on Dibond, you can display it unframed for a clean and contemporary look. While you could do this with mill finish aluminum, the finished edge on the Dibond has a much nicer look (Econolite probably can't be displayed this way—you'd see the honeycomb structure). I installed *Barclay*, shown in **Figure 20.12**, in a lobby using edge grip mounts. For an installation like this, a frame would have had far too much focus in the constrained space.

Work on metal panels can be mounted directly to the wall with standoff bolts inserted into the piece itself. In the example in **Figure 20.13**, Karin Schminke's image is highlighted with a strong spotlight to enhance the shadow effect of the image.

You can also create a tapestry or tiled effect by hooking metal panels together with clips or chains and hanging the art from a rod (**Figure 20.14**).

FIGURE 20.13 Karin Schminke integrated the installation into the work itself when she made this 36" x 36" piece titled *Watersong #1.*

FIGURE 20.12 This 4' x 6' image on metal is light weight and installed directly on the wall to highlight the substrate.

FIGURE 20.14 A drill press helps ensure that the holes are drilled in the same spot in each panel.

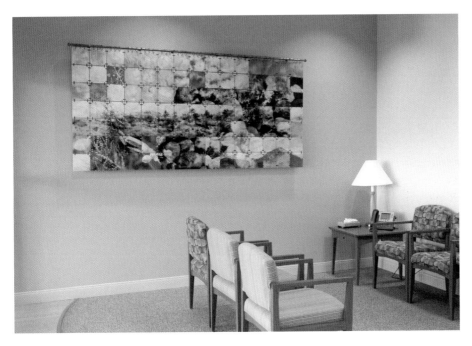

FIGURE 20.15 Use a thin coating of DASS Universal Precoat II to mount silk to glass.

You can mount the flow blue fabrics using full strength DASS Universal Precoat II to adhere the back side of the fabric to a sheet of tempered glass (**Figure 20.15**). It holds tightly when dry, but can be removed with water, allowing you to reuse the glass another time. This pre-coat has a special additive to make it stick to glass, so others may not work.

Last, for the easiest of all presentations, I make a painted or transferred image surface on birch boxes, and then cut out an oval and install the art inside the box from the back. I liked the idea of the union cases for tintypes, and wanted something similar for larger works (**Figure 20.16**).

FIGURE 20.16 You can make the frame part of the artwork.

Conclusion

Presentation and finishing of mixed media and digital work is not difficult and does not need to be expensive. With a bit of advance planning, much of the work can incorporate the frame as the art. Only works that are on paper need the protection of traditional glass and framing. As most of these processes in this book use different substrates, you can get really creative with your presentation—and besides, skipping the glass and framing can drop the price you need to charge and open up broader markets to sell your work. After all, most galleries sell less work that is displayed under glass because of the glare under the bright gallery lights, so why not get creative, save money, and boost sales all at once!

No matter how you choose to display your work, keep it in mind as you're creating the work. The final product is a combination of the materials, techniques, presentation, and, most important, your skill, talent, and artistic vision (**Figure 20.17**).

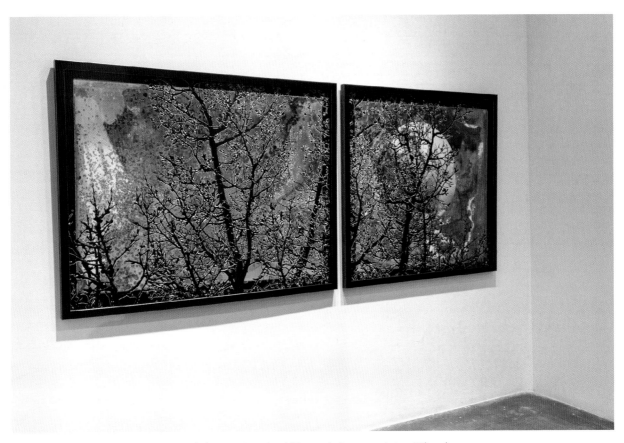

FIGURE 20.17 This 47" x 112" piece titled *Super Moon* is a UV-cured pigment print on Dibond.

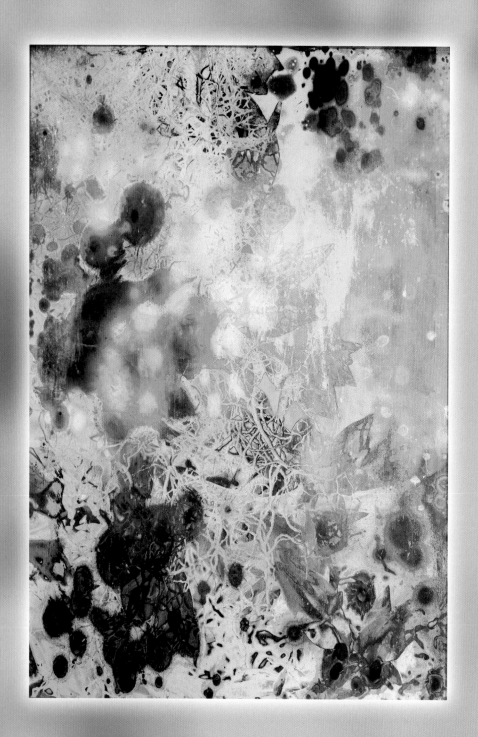

GALLERY OF WORK:
NEW TECHNIQUES

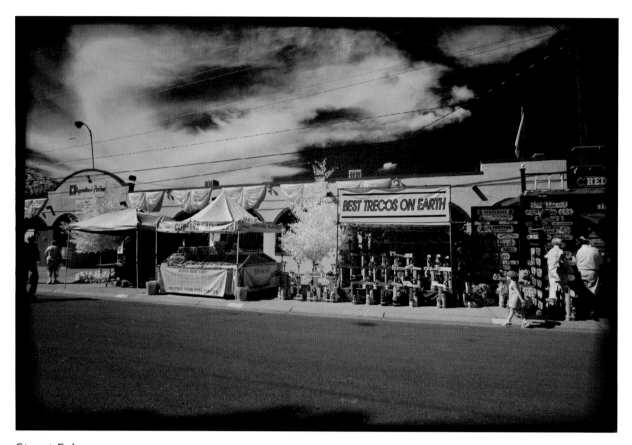

Street Fair

18" x 27". Metallic Solvent Ink on Photo Paper. I took this infrared photo at the state fair. By printing silver metallic under the images as a screened bitmap layer, I achieved a sparkling gold effect. I love the illusion of creating an orotype, based on early 20th century orotones, with its luminous golden glow.

NOTE: Some of the images in this chapter, including Street Fair, *deal with the latest in new technology that I've applied to my art. For more information on these processes, register your book at www.peachpit.com/LastLayer to download a free bonus chapter titled "New Technology and Future Directions."*

Forest Floor

40" x 60". UV-cured Pigment on Dibond. I took a few leaves and enlarged them in Photoshop to the size of the entire canvas, and then combined them with an underlayer of abstract color. The two together create an organic composition both simple and rich.

Garden Glass

40" x 60". UV-cured Pigment on Dibond. I took the original image for this piece as the sun came out after a light rain. The stones and pebbles at the edge of a pond sparkled in the fresh sunlight. After creating the image in Photoshop, I deconstructed it to dark and light layers. I then added a layer to create a mist of white ink over the entire image.

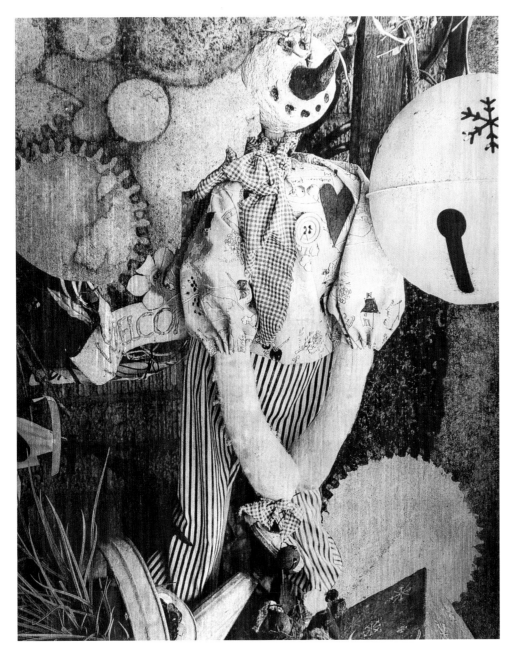

Fiber Doll

8" x 10". Fiber Laser Engraving on an Aged Aluminum Plate. I love photographing at antique malls and flea markets—they're ideal places to find heaps of junk with rich textures, perfect for the fiber laser.

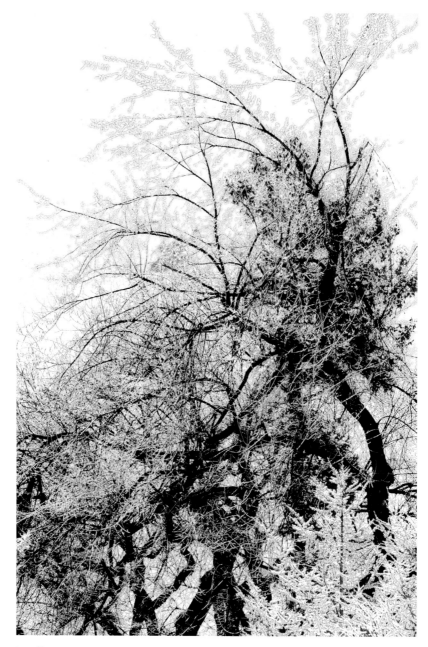

Ice Storm

40" x 60". UV-cured Pigment on Dibond. I printed this image on aluminum using thick and thin layers of ink to create the feel of small bits of paper glued to the metal surface. This ink collage is an area of work I'm really enjoying as I explore it.

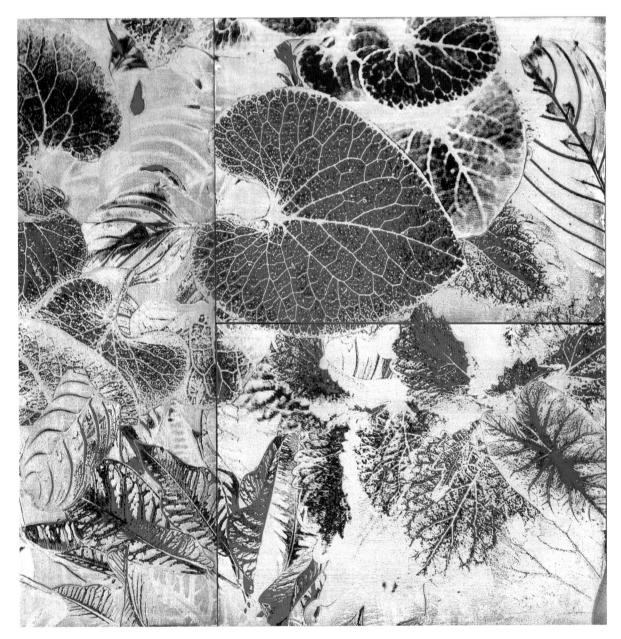

Granite

36" x 36". Laser Engraving on Birch Box. I created a modular image from five birch boxes to which I'd transferred the green and black leaves. I then painted the entire image with white paint, and converted the original file to a bitmap image that I sent through the laser. The engraving through the paint went just deep enough to reveal portions of the pigment transfer.

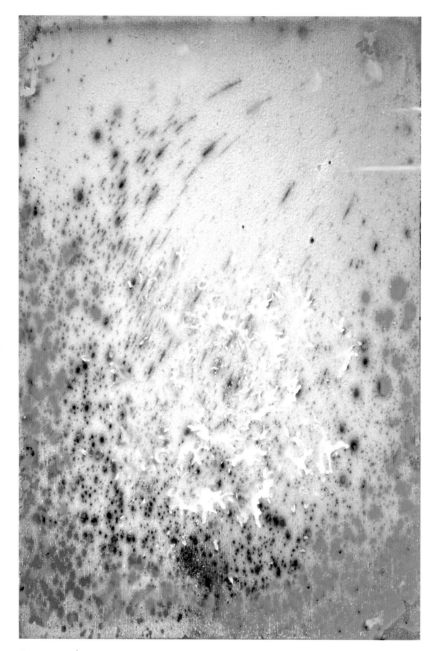

Ocean Kale

40" x 60". UV-cured Pigment on Dibond. I love travelling to the beach, and often capture the essence of water washing over the sand in my work. I used multiple layers of white UV ink to make the white flowers protrude above the lower layers of ink, giving a three-dimensional quality to the digital image.

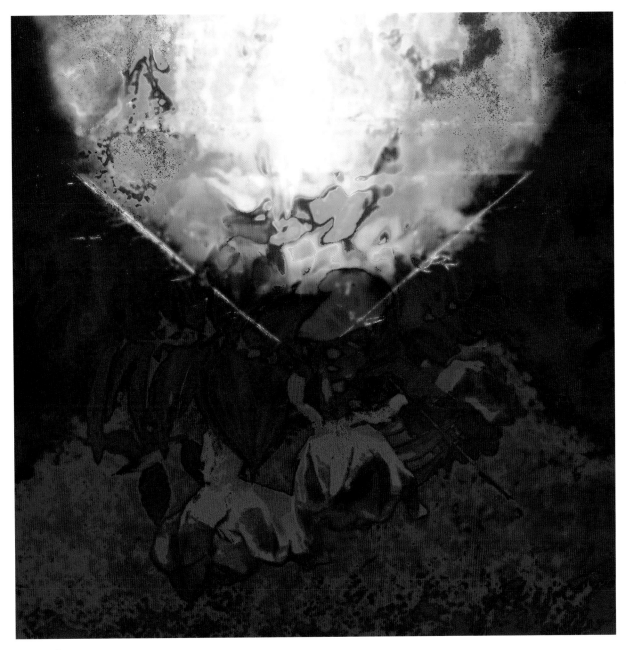

Moon Rose

36" x 36". UV-cured Pigment on Dibond. I made this image from several photos I took of roses that were frozen at the end of autumn. The moonlit night made the colors particularly intense, so I used the UV ink to print thick layers of color to create a surface like enamel. The layers are so thick that they cast their own shadow, adding to the ink collage illusion.

Exponential Growth

54" x 54". Laser Engraved Paint on Baltic Birch by Karin Schminke. In this work, Karin captured the excitement of discovery and sense of vibrancy she experiences when in her garden. She etched the surface of painted Baltic birch panels using a laser, and also used the laser to cut out sections of the panel completely. She mounted the etched and cut panels on 25 of her hand-made wooden frames, whose box-joint patterns echo those in the image itself.

Breeze

72" x 72". UV-cured Pigment on Laser-Cut Acrylic. I grew up in a house that had one of these bean trees, and it was my job to pick them up off the sidewalk—I made a penny a piece! When I found a similar scene, it brought back memories, so I took a photograph of them, and made this piece from three layers of stacked laser-cut acrylic, imaged on a UV printer and mounted on Dibond. My mom had a good laugh when she saw it.

Index